Georgia O'Keeffe

Georgia O'Keeffe

BLACK DOG & LEVENTHAL PUBLISHERS

NEW YORK

First published in the United States of America by
The Viking Press (A Studio Book) 1976.
Published in Penguin Books 1977.

Published by

Black Dog & Leventhal Publishers, Inc.
151 W. 19th Street
New York, NY 10011

Distributed by

Workman Publishing Company
708 Broadway
New York, NY 10003-9555

Printed and bound in Hong Kong

ISBN: 1-884822-29-0

h g f e d c b a

Library of Congress Cataloging-in-Publication Data

O'Keeffe, Georgia, 1887-1986.
 Georgia O'Keeffe.
 p. cm.
 Originally published: New York : Viking Press, 1976.
 ISBN 1-884822-29-0
 1. O'Keeffe, Georgia, 1887-1986--Catalogs. I. Title.
ND237.O5A4 1995a
759.13--dc20 95-375
 CIP

Acknowledgments for the original edition

I wish to thank William Einstein, a painter who died some years ago, for urging me in the early thirties to write about my painting.

He went away and I forgot about it until Virginia Robertson found the writing a few years ago and encouraged me to continue.

Juan Hamilton has helped me with this book for the last three years and has taken care of many details, from collecting the paintings and arranging the photography to working with the color proofs and layout.

The majority of the transparencies were made by Malcolm Varon, and the printing of the reproductions was supervised by Bert Clarke.

David Bell of The Viking Press made many trips across country in an unusual effort to help put the book in its final form.

Thanks also to Alexander Girard and Barbara Rose for their ideas and advice.

Georgia O'Keeffe

The meaning of a word—to me—is not as exact as the meaning of a color. Colors and shapes make a more definite statement than words. I write this because such odd things have been done about me with words. I have often been told what to paint. I am often amazed at the spoken and written word telling me what I have painted. I make this effort because no one else can know how my paintings happen.

Where I was born and where and how I have lived is unimportant. It is what I have done with where I have been that should be of interest.

My first memory is of the brightness of light—light all around. I was sitting among pillows on a quilt on the ground—very large white pillows. The quilt was a cotton patchwork of two different kinds of material—white with very small red stars spotted over it quite close together, and black with a red and white flower on it. I was probably eight or nine months old. The quilt is partially a later memory, but I know it is the quilt I sat on that day.

This was all new to me—the brightness of light and pillows and a quilt and ground out beyond. My mother sat on a bench beside a long table, her back turned to me. A friend called Aunt Winnie stood at the end of the table in profile. I don't remember what my mother looked like—probably because she was familiar to me. Aunt Winnie had goldish hair done high on top of her head—a big twist of blond hair and lots of curly bangs. My mother was dark with straight hair and I had never seen a blond person. Aunt Winnie's dress was thin white material, a little blue flower and a sprig of green patterned over it. The bodice was close-fitting with long tight sleeves, the skirt straight and plain in front and very full and puffed and ruffled at the back— a long dress touching the ground all around, even trailing a little extra long at the back.

Years later I told my mother that I could remember something that I saw before I could walk. She laughed and said it was impossible. So I described that scene—even to the details of the material of Aunt Winnie's dress. She was much surprised and finally—a bit unwillingly—acknowledged that I must be right, particularly because she, too, remembered Winnie's dress.

My next memory must be of the following summer—the first memory of pleasure in something seen with my eye and touched with my hand. There was a good-sized lawn all around our house. There was a long entrance drive with a high arborvitae hedge. I don't remember walking across the grass but I remember arriving at the road with great pleasure. The color of the dust was bright in the sunlight. It looked so soft I wanted to get down into it quickly. It was warm, full of smooth little ridges made by buggy wheels. I was sitting in it, enjoying it very much—probably eating it. It was the same feeling I have had later when I've wanted to eat a fine pile of paint just squeezed out of the tube.

My mother came and snatched me up—her arm around my middle— my head and feet hanging down. I was most uncomfortable and I didn't like it. But I remember the strange expression on her face—something not exactly annoyance with me. I suppose she was frightened because I was in the perfect place to be run down by a horse or vehicle coming around the corner of the high hedge.

The first thing I can remember drawing was a picture of a man lying on his back with his feet up in the air. He was about two inches long, carefully outlined with black lead pencil—a line made very dark by wetting the pencil in my mouth and pressing very hard on a tan paper bag. His nose and eyes were worked out in profile—a bit too big for the rest of him. I tried to draw him standing and bending over. The fact that I tried to draw him bending over makes me think that I must have drawn many figures standing straight before my effort to make this one bend. I worked at it intensely— probably as hard as I ever worked at anything in my life. There was something wrong about his knees. I couldn't make the legs bend right at both hips and knees. When I had the man with his legs only bent at the hips, he just wasn't balanced right. I turned the paper bag around and saw that he did look right as a man lying on his back with his feet straight up in the air. That was a surprise! I thought it a very funny position for a man, but after all my effort it gave me a feeling of real achievement to have made something—even if it wasn't what I had intended. I kept the little drawing for a long time.

The idea of drawing the man may have been connected with my dolls. I had big dolls—the one that would go to sleep was particularly beautiful to me but I seldom played with her. She seemed too beautiful to handle and was too large for me to want to make things for—so she usually hung on the bathroom

door. I had a whole family of small china dolls—the largest about three inches tall. They all had arms that moved, and some of them had legs that moved. They had little-girl bodies and long golden hair. I sewed unusually well and made wonderful dresses for them like dresses I found in pictures or like some that were made in the house.

In time I made a house for the dolls. Making things for the dolls and the house is the principal amusement that I remember from my childhood. I had the house arranged so that I could fold it flat to carry it about. It was made of two thin boards about eighteen by twenty-four inches. I sawed a slit a little over halfway up each board, then I could fit the slit of one board into the slit of the other and make a house of four rooms. It was really just the partitions between four rooms but that satisfied me.

In the summer I took the dollhouse outdoors to a shady place between some hemlock and apple trees and arranged a park to go with the house. I cut the grass with scissors, left weeds tall for trees, made walks with sand and little stones, had a large pan of water for a lake with moss on the edge of it. An old shingle cut to resemble a boat floated on the lake. It had a white sail. However, the doll family gave up water pleasures after one of the little girls was ruined trying out a bathing suit in the water. Her arms and legs and hair all came off when I let her go bathing.

It was the idea that they should go boating on the lake that made me think that I should have a man doll—a husband for the principal lady and a father for those little girls with the lovely long golden hair. I took one of my girl dolls and began trying to dress her to look like a man. I cut and sewed and sewed, trying to make her a pair of long trousers. The legs were fat little-girl legs. It was too discouraging. The best man I could fix was so fat that I didn't like him. My father was lean, and I certainly couldn't have a fat man with long curly hair—and if I cut the hair the stitching that held it together would show. When my very fat man sat down on one of the nice silver chairs with pink velvet upholstery, his legs stuck straight out in front of him. So the man was given up. I just played he was always around but we never saw him.

I believe that during the years when many children draw a great deal, I was busy with this doll family and house and garden. I wonder if I drew a man lying on his back, only bending his legs at the hips, because my dolls only bent their legs at the hips. I wonder, too, why I drew the man. Though I can

remember cutting paper-doll women, I can't remember ever trying to draw a woman at this time and I never made any attempt to draw my dolls.

One year my two younger sisters and I took drawing and painting lessons from a woman in Sun Prairie. She had us each get a *Prang Drawing Book*. There was something about the perspective of a cube, and I remember once shading a sphere—copying it from the book. I did a drawing of a spray of oats that I thought was pretty good, compared with the drawing in the book.

The next year we were taken into town for painting lessons every Saturday afternoon. The teacher had us copy pictures that we chose from a stack she had in a cupboard. We painted with watercolor. I only remember two of my copies—one of Pharaoh's horses in sepia and one of large red roses. It was the beginning with watercolor.

By myself at home, I once copied a lighthouse from the geography book. I had never seen a lighthouse, but I drew one on a long point of land extending into the sea. Of course, I had never seen the sea either, but that didn't matter. The paper was too empty so I drew a horizon line and then I put in some palm trees. I had never seen a palm tree—but I had looked at them with interest in my geography book. Two or three palm trees went waving in the air. The sky was still empty so I drew in the sun. I painted the sun yellow, the sky and waves blue—left the lighthouse white. My great difficulty was with the sun. It was only a yellow spot with a little pink in its rays. It looked dirty instead of bright and shining. The more yellow and pink I put on, the darker I made it. I didn't know how else to paint the sun so I left it an unsatisfactory dirty yellow and pink. Then I made another lighthouse painting —this time with a cloudy sky. With the cloudy sky I could make the sun seem a little brighter.

One winter night about this time, I stood at the window upstairs looking out at a tall pointed spruce tree in the yard, and across the road a burr oak tree, black against the snow. Far across the field was the smaller outline of another big oak—beyond that a soft line of the woods. It is my first memory of night and snow—bright moonlight night and snow. I started to draw by the light of the lamp what I could remember of what I saw as I had looked out the window. When it was drawn, I didn't know what color to paint it. The bare trees were black against the snow in the moonlight—but dark blue had something

to do with night. I put a little dark blue in the black of the tree. The distant trees were very difficult. So was the decision to make the strip of sky a sort of lavenderish grey. That was the color it seemed to be. I had left a big bare space of paper between the near tree and the far trees and woods. It was bare white paper—supposed to be snow—and at night snow isn't white, but it must be made to look white. I couldn't think of anything I could do about the snow, so I left it just white paper. Then it looked so empty that I painted the road passing the house—scratchy grey lines. Those two paintings—the lighthouse with the cloudy sky and the night with bare trees and snow—must have been important to me because I kept them until a few years ago. They were the only really creative efforts of this period.

The copies that I had made with the teacher and others that I made later at the Convent were framed by my mother and hung on the wall. They were never very satisfactory to me, because I could always see where the teachers had worked on them. I hadn't been able to make them exactly right, so I didn't like them and I didn't like always being reminded of the teachers' work. (The pretentiously framed copies have all been lost as far as I know.)

The year I was finishing the eighth grade, I asked our washwoman's daughter what she was going to do when she grew up. She said she didn't know. I said very definitely—as if I had thought it all out and my mind was made up—"I am going to be an artist."

I don't really know where I got my artist idea. The scraps of what I remember do not explain to me where it came from. I only know that by that time it was definitely settled in my mind. I hadn't seen many pictures and I hadn't a desire to make anything like the pictures I had seen. But in one of my mother's books I had found a drawing of a girl that I thought very beautiful. The title under it was "Maid of Athens." It was a very ordinary pen-and-ink drawing about two inches high. For me, it just happened to be something special—so beautiful. Maybe I could make something beautiful . . . I think my feeling wasn't as articulate as that, but I believe that picture started something moving in me that kept on going and has had to do with the everlasting urge that makes me keep on painting.

Up to that time—aside from the "Maid of Athens"—I can't remember any picture that interested me except a Mother Goose book printed on cloth, a little girl with pink roses in front of her on my tablet cover, and a

painting that hung in my grandmother's parlor—some very fierce-looking Arabs on horseback crossing a stream.

I didn't have a very clear idea of what an artist would be. Later, when people asked what kind of an artist I would be, it always embarrassed me. I didn't know. Then they would ask, "Well, are you going to be an illustrator or a portrait painter or a designer, or what?" The idea of being an illustrator didn't mean much to me. I never associated my idea of being an artist with illustrations in books that we had and I didn't know what they meant by a designer. So I would say, "A portrait painter." I could grasp the idea of a portrait painter. There were two quite handsome portraits of my great-grandmother and great-grandfather at home. There was a crayon portrait of my mother, but I wondered how anyone could possibly imagine that it looked like her. The other two were dark and dignified, and great-grandmother wore a white lace collar and cuffs and a lace cap tied with a light blue ribbon that I thought very pretty. She wore a thin gold ring on her first finger. It looked very nice on her hand. But her face wasn't pretty to me, so the picture meant little to me.

The man was better looking. He was comfortable and rosy, with a queer collar that curved up near his ears. He held in his hands a newspaper attached to a long, dark polished stick. There was also a portrait of my grandmother. She looked old and sad. I didn't care for that one either. I think I had no desire at all to be a portrait painter. The portraits in the house didn't interest me enough to have made me think I would enjoy making them. I remember someone's saying that if I were going to be a portrait painter I would have to paint anyone who wanted to be painted. I emphatically insisted that I only intended to paint people whom I liked or thought beautiful.

The fall I was thirteen, I was taken to boarding school—a Dominican convent beyond Madison. The Sister who had charge of the art classes had beautiful large dark eyes and very white lovely hands, but she always felt a bit hot and stuffy to me. I felt like shrinking away from her.

My first day in the studio she placed a white plaster cast of a baby's hand on a table, gave me some charcoal and told me to draw it. I worked laboriously—all in a cramp—drawing the baby's hand with a very heavy black line. I thought my drawing very nice and I liked doing it. When the Sister saw it she was very impatient. She said I had drawn the hand too small and my lines

were all too black. She particularly emphasized the fact that it was too small.
At the time I thought that she scolded me terribly. I was so embarrassed that it
was difficult not to cry. The Sister sat down and drew a few light lines blocking
in the way she thought the drawing should be started. It looked very strange to
me—not at all beautiful like my own drawing. I wasn't convinced that she was
right, but I said to myself that I would never have that happen again. I would
never, never draw anything too small. So I drew the hand a little bit larger than
she suggested and that whole year never made a heavy black line again.
I worked mostly with a fairly hard lead pencil and always drew everything a
little larger and a little lighter than I really thought it should be.

When my drawings were put up on the wall for exhibition in June, there
was a whole wall of the pale drawings of casts. The Sister wrote G. O'Keeffe
on each of them in her big free hand—writing with a lead pencil much
blacker than the tone of my drawings. I was shocked to see my name so big
and black on my pale drawings. And it didn't seem like my name—it was
someone quite apart from me. I had never thought much about having a last
name.

My second year of high school, my brother and I lived with our
mother's younger sister in Madison. The art teacher was one of those thin,
bright-eyed women that I have always since associated with the idea of an Art
Teacher. She wore her hat in school—a hat made all of artificial violets. She
seemed thin in spirit as well as in body—thin in every way. Her eyes were
brown and very bright. She looked a little too old for her brightness. She is very
vivid to me standing in front of the class—her hat of violets and a fresh spring
feeling about her costume. Holding a Jack-in-the-pulpit high, she pointed out the
strange shapes and variations in color—from the deep, almost black earthy
violet through all the greens, from the pale whitish green in the flower through
the heavy green of the leaves. She held up the purplish hood and showed us the
Jack inside. I had seen many Jacks before, but this was the first time I remember
examining a flower. I was a little annoyed at being interested because I didn't
like the teacher. I didn't like anything about her, not even the interest she
aroused in me. But maybe she started me looking at things—looking very
carefully at details. It was certainly the first time my attention was called to the
outline and color of any growing thing with the idea of drawing or painting it.

When I went to Chatham Episcopal Institute in Virginia the following two years, it was not the fashionable girls' school it has since become. Most of the floors were unpainted. We had kerosene lamps for light and a small wood stove in each room for heat. The principal was the art teacher and the studio was my home about the place. I only remember two things that I painted in those years—a large bunch of purple lilacs and some red and yellow corn—both painted with the wet-paper method on full-sized sheets of rough Whatman paper. I must have painted a great deal with watercolor by that time or I wouldn't have had the freedom I had with that big sheet of white paper and the big brush that I used. I remember wondering how I could paint the big shapes of bunches of lilacs and—at the same time—each little flower. I slapped my paint about quite a bit and didn't care where it spilled. The red and yellow corn was my best painting—or I should say I assume it was—because when I graduated they kept it, saying that it was customary to keep the pupil's best work. That corn painting was burned when the old building burned.

Every day during those two years the students took an afternoon walk in a line headed by a teacher out across the hills and woods. I loved the country and always on the horizon far away was the line of the Blue Ridge mountains—calling—as the distance has always been calling me. Often after walking with the whole school, I would go walking again with another student. We sometimes got permission to go by ourselves and sometimes we just sneaked away for an hour or two—which would have been considered an inexcusable offense if we had been caught. Those walks over the Virginia hills and through the woods were the best things that happened for me in those years—because I never did like school.

The next year when I was at the Art Institute in Chicago I was sent down to one of those big galleries on the first floor to draw casts. I had an easel, drawing board, charcoal and an apron. I was told to draw a great big headless armless man's torso. It didn't particularly interest me but I tried to do what I thought I was expected to do. A boy about my age used to come out of the big cold spaces from somewhere among the casts and look at my drawings. I would go and look at his drawings. His looked much richer and livelier than mine—very black lines and shadows. Mine were pale and neat like those cast drawings I had made at the Convent. It was evident that no good Sister had told him not to use such black lines for a white cast. He would criticize my

drawings very solemnly and I thought he knew about it. He talked as if he did. I noticed later that my drawings got better marks in the monthly concours than his did in spite of the fact that he was able to convince me that he knew more about drawing than I did.

I have never understood why we had such dark olive green rooms for art schools. The Anatomy Class was in one of those dark-colored half-lighted dismal rooms. When I went in, the room was full. Most of the students were much older than I was. I was a little girl with a big black ribbon bow on my braid of hair. The man teaching had a soft light-brown beard and an easy way of moving and speaking. After talking a while he said, "Come out," to a curtain I hadn't noticed. Out walked a very handsome, lean, dark-skinned, well-made man—finely cut face, dark shining hair, dark moustache—naked except for a small loincloth. I was surprised—I was shocked—blushed a hot and uncomfortable blush—didn't look around in my embarrassment and don't remember anything about the anatomy lesson. It was a suffering. The class only came once a week and I had to make up my mind what I was going to do about it before time for the next lesson. I still had the idea that I wanted to be an artist. I thought that meant I had to go to art school. Drawing casts in the upstairs gallery wouldn't go on forever. If I was any good at all I'd be promoted to the Life Class where there would be nude models. It was something I hadn't counted on but had to face if I was going to be an artist. I don't know why it seemed so difficult. In the summer when we went swimming down on the river a boy my age wore the least little piece of a bathing suit and I don't remember thinking anything about it except that he was blond and beautiful and laughing. The bare figure in that dismal dark classroom with everybody else dressed was different—he was definitely there to be looked at. Maybe if I had had a passionate interest in anatomy I wouldn't have been shocked. But I had no interest at all in anatomy and the long names of things —the teacher did not connect it in any way with my drawing upstairs. When the next lesson came and everyone else drifted in the direction of the Anatomy Class, I drifted in, too. I don't remember learning anything except that I finally became accustomed to the idea of the nude model.

Later I went to John Vanderpoel's lectures on drawing the human figure. They were held in the auditorium upstairs—a light fresh-feeling room compared to the classrooms in the basement. Vanderpoel was a hunchback. As he

lectured he made very large drawings on a sheet of tan paper as high as he could reach. He was very clear—drawing with black and white crayon as he talked. I always looked forward to those lectures. They helped me with the drawings of casts and with the Life Class. When the lectures were printed in his book, "The Human Figure," I bought the book and treasured it for many years. He was a very kind, generous little man—one of the few real teachers I have known.

Then there was a year of painting at the Art Students League in New York. Mornings with Luis Mora, a handsome slim young man who drew hands or heads—always the same hands or heads—along the sides of the pupils' drawings. I later found that he was always drawing his wife no matter what model he had.

Two paintings that I made in that class stand out in my mind. One was a man seated, bending forward. I undoubtedly would not have remembered anything about it if I hadn't wondered how it could be good enough to get a Number Four in the monthly concours of all the Life Classes. The other painting was of the back of a man, standing. I had prepared the canvas for this painting with something white. The color on it was so fresh and bright that I took the painting home and placed it in the window to dry. While it was there I visited someone living across the street and was astonished to see my painting in my window. It looked so fresh and clean compared to the dingy things we usually did at the League. The League rooms were in the upper part of the building but they all had the dingy color of the Art Institute in Chicago.

The Chase Still Life Class was much more fun. Every day we all had to paint a new still life. Then once a week William Merritt Chase came in to criticize. As soon as he arrived in the office downstairs everyone in the building knew it and we all got out our five or six canvases to be criticized. He wore a high silk hat, rather tight fine brown suit, light-colored spats and gloves, a carnation in his lapel. He had a beard and moustache and glasses on a cord. There was something fresh and energetic and fierce and exacting about him that made him fun. His love of style—color—paint as paint—was lively. I loved the color in the brass and copper pots and pans, peppers, onions and other things we painted for him. The slick canvases had eight or ten paintings— painted one on top of the other as the weeks went by. To interest him, the paintings had to be alive with paint and a kind of dash and "go" that kept us looking for something lively, kept us pretty well keyed up.

I sat through Kenyon Cox's Anatomy Classes and learned nothing that I remember. I only remember the tall, very thin man in his loose clothes standing talking. The figure had a relaxed kind of grace that fascinated me and is very vivid to me now. To lift his hand seemed an effort, but it was a fine gesture when he did lift it. The face was very sour. The women in his Life Class were terrified of his sharp criticisms.

Eugene Speicher was one of the older students at the League and a very handsome young man. He often stopped me and wanted me to pose for him. Speicher wanted to paint me—but I wanted to work myself. One morning as I climbed to the top floor for the Life Class, there he sat with his fresh linen smock, blocking the whole stairway and threatening that he would not let me pass unless I promised to pose for him. I was annoyed and wanted to go up to work.

"It doesn't matter what you do," he said. "I'm going to be a great painter and you will probably end up teaching painting in some girls' school." I insisted on passing and he remarked, "I'll give you the painting if you pose for me." Finally he let me go, and I went down the dark hall to the Life Class. The model happened to be a very repulsive man who gave me the creeps, so I gave up and went back to Speicher. He worked very quickly and the portrait was soon finished—probably because he had it so clear in his mind when he started.

The next day he wanted to do one for himself so I sat again. Others came in to paint also. I hadn't been sitting very long when a student came in and suggested that we all go to "291" to see the Rodin drawings. Every teacher at the League had insisted that we see them. Speicher gave up his painting and off we went.

It was a day with snow on everything. I remember brushing snow off a little tree by the railing as we walked up the steps of the brownstone at 291 Fifth Avenue, where Alfred Stieglitz had his gallery. The boys had heard that Stieglitz was a great talker and wanted to get him going. We went up in the little elevator and entered a small room. Stieglitz came out carrying some photographic equipment in his right hand and glared at us from behind his pince-nez glasses. Yes, we wanted to see the Rodin drawings.

The drawings were curved lines and scratches with a few watercolor washes and didn't look like anything I had been taught about drawing. The teachers at the League thought that Stieglitz might just be fooling the public with the name Rodin, or that Rodin might be fooling both Stieglitz and the

public with such drawings. I think that some of them were supposed to have been done with his eyes shut. At that time they were of no interest to me— but many years later, when I was settling Stieglitz's estate, they were the drawings I most enjoyed.

The boys began to talk with Stieglitz and soon the conversation was heated and violent. I went to the end of the smallest room. There was nothing to sit on—nothing to do but stand and wait. Finally, after much loud talk the others came for me and we went down to the street.

One day someone took me into the Composition Class at the League. I didn't think much of the compositions put up for criticism and I wasn't interested in what was said about them, but it started me thinking that I would try to make a painting I would really like.

About this time I walked up Riverside Drive one clear moonlight night with two or three other students. Up near the Soldiers and Sailors Monument we sat down on the grass. When I looked about at the night I saw two tall poplar trees breathing—rustling in the light spring air. The foliage was thick and dark and soft—the grass bright in the moonlight. The river, near—with the twinkling lights from the other side, far away. I studied the outlines of the trees carefully. The openings where the sky came through—the unevenness of the edges—the mass of the trees, dark, solid, very alive. Next morning I tried to paint it. I was fairly satisfied with my trees and water but the sky and grass baffled me. However, I covered the canvas as best I could and thought the trees particularly beautiful. I showed the painting to a student whose paintings I liked. He immediately told me that there was no color in my trees—that they should be painted with spots of red and blue and green like the Impressionists. I said I hadn't seen anything like that in my trees the night before. He insisted that it was there and I just hadn't seen it, that I didn't understand. And he took my painting and began painting on it to show me. He painted on the trees— the very part that I thought was so good. He tried to explain to me about the Impressionists. I hadn't heard of anything like that before—I didn't understand it and I thought he had spoiled my painting. I took the painting and worked on it again. I couldn't get it to be like the beautiful night I had seen and when I painted over what he had done, the whole thing was sticky and much worked over and dried very badly—but I kept it for years. It represented an effort toward something that had meaning to me—much more than the work at school.

There was one other painting belonging to this year that was definitely something I had to say. I went to Lake George in June to a summer school for scholarship students. I was eligible because I had won a prize with a painting in the Chase Still Life Class. There were about twenty other students from the League. We had a sailboat with a red sail, the daisies were blooming, the mountains were blue beyond the lake—but it just didn't seem to be anything I wanted to paint. One night a boy and I rowed across the lake. He was furious with me because I wanted to let another boy go with us. He was cross all the way across the lake and crosser still when we found—after we finished shopping—that our boat was gone and we had to walk back around the end of the lake. On the way I stood a moment looking out across the marshes—marshes with tall cattails, a patch of water, more marsh, then the woods with a few birch trees shining white at the edge on beyond. In the darkness it all looked just like I felt—wet and swampy and gloomy, very gloomy. In the morning I painted it. My memory of it is that it was probably my best painting that summer. It was the second thing I had to say after those trees at night on Riverside Drive.

It was in the fall of 1915 that I first had the idea that what I had been taught was of little value to me except for the use of my materials as a language—charcoal, pencil, pen and ink, watercolor, pastel, and oil. I had become fluent with them when I was so young that they were simply another language that I handled easily. But what to say with them? I had been taught to work like others and after careful thinking I decided that I wasn't going to spend my life doing what had already been done.

I hung on the wall the work I had been doing for several months. Then I sat down and looked at it. I could see how each painting or drawing had been done according to one teacher or another, and I said to myself, "I have things in my head that are not like what anyone has taught me—shapes and ideas so near to me—so natural to my way of being and thinking that it hasn't occurred to me to put them down." I decided to start anew—to strip away what I had been taught—to accept as true my own thinking. This was one of the best times of my life. There was no one around to look at what I was doing— no one interested—no one to say anything about it one way or another. I was alone and singularly free, working into my own, unknown—no one to satisfy but myself. I began with charcoal and paper and decided not to use any color until it was impossible to do what I wanted to do in black and white. I believe it was June before I needed blue.

"Blue Lines" was first done with charcoal. Then there were probably five or six paintings of it with black watercolor before I got to this painting with blue watercolor that seemed right.

1 Blue Lines, 1916. Watercolor, 25 x 19.

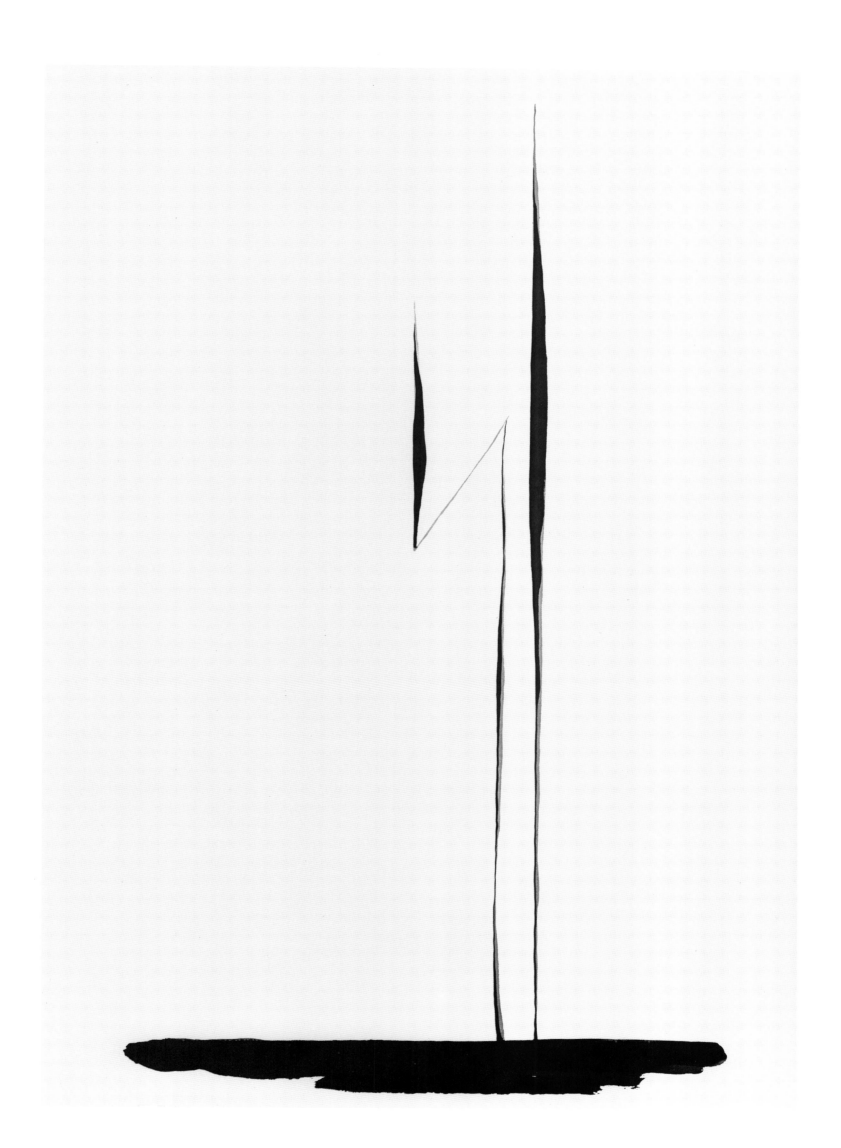

Texas had always been a sort of far-away dream. When we were children my mother read to us every evening and on Sunday afternoons. It was particularly for my older brother, whose eyes were not good. I had listened for many hours to boys' stories—Stanley's adventures in Africa, Hannibal crossing the Alps, Julius Caesar, "Pilgrim's Progress," all the Leatherstocking tales, stories of the Wild West, of Texas, Kit Carson and Billy the Kid. It had always seemed to me that the West must be wonderful—there was no place I knew of that I would rather go—so when I had a chance to teach there— off I went to Texas—not knowing much about teaching.

Amarillo, Texas, was the cattle-shipping center for a large area of the Southwest. Trains ran east and west and north and south. For days we would see large herds of cattle with their clouds of dust being driven slowly across the plains toward the town. When the cattle arrived they were put in pens near

2 From the Plains I, 1919. Oil on canvas, 27 x 23.

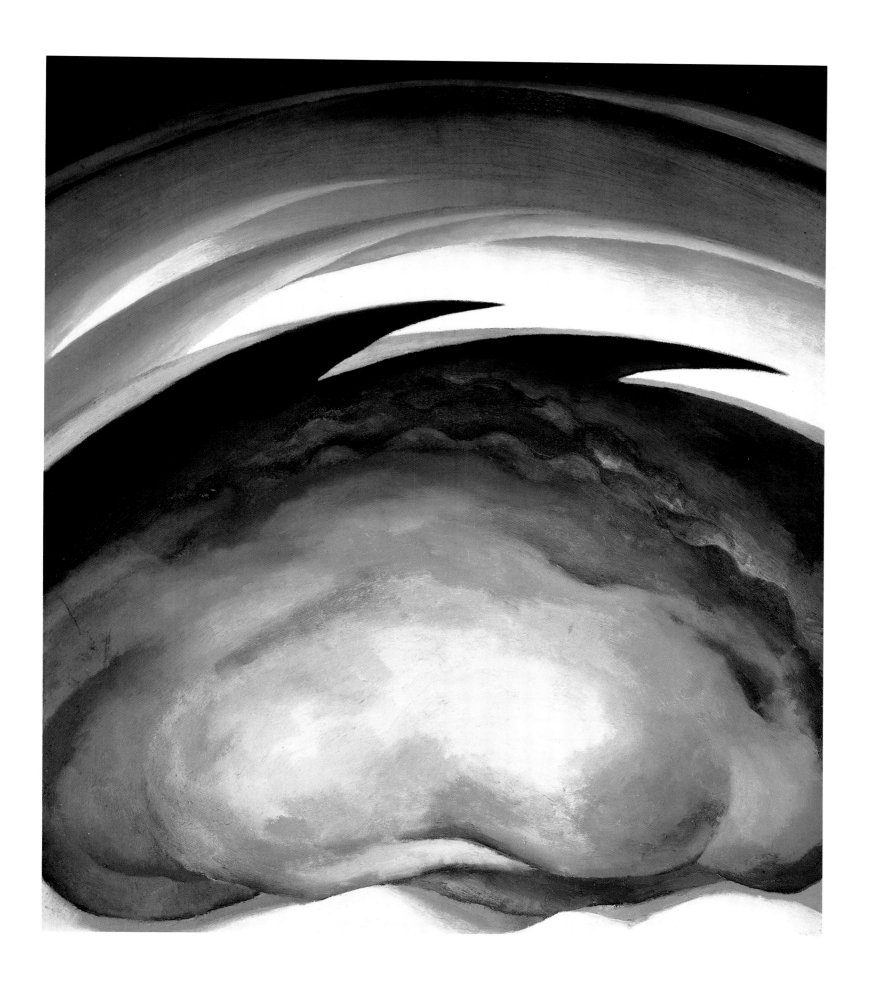

the station, separated from their calves and sometimes kept there for two or three days. The lowing of the cattle was loud and sad—particularly haunting at night.

"From the Plains I" and "Orange and Red Streak" were painted in New York months after I left that wide world. And years after, I painted it twice again. The cattle in the pens lowing for their calves day and night was a sound that has always haunted me. It had a regular rhythmic beat like the old Penitente songs, repeating the same rhythms over and over all through the day and night. It was loud and raw under the stars in that wide empty country.

In 1914 I went back to New York to study with Arthur Dow at Teachers College, Columbia University. On my first Sunday in the city, I noticed that the American Watercolor Society was having its fall show so, remembering some of my old friends and acquaintances, I went down to see what they were doing.

3 *From the Plains II*, 1954. Oil on canvas, 48 x 72.

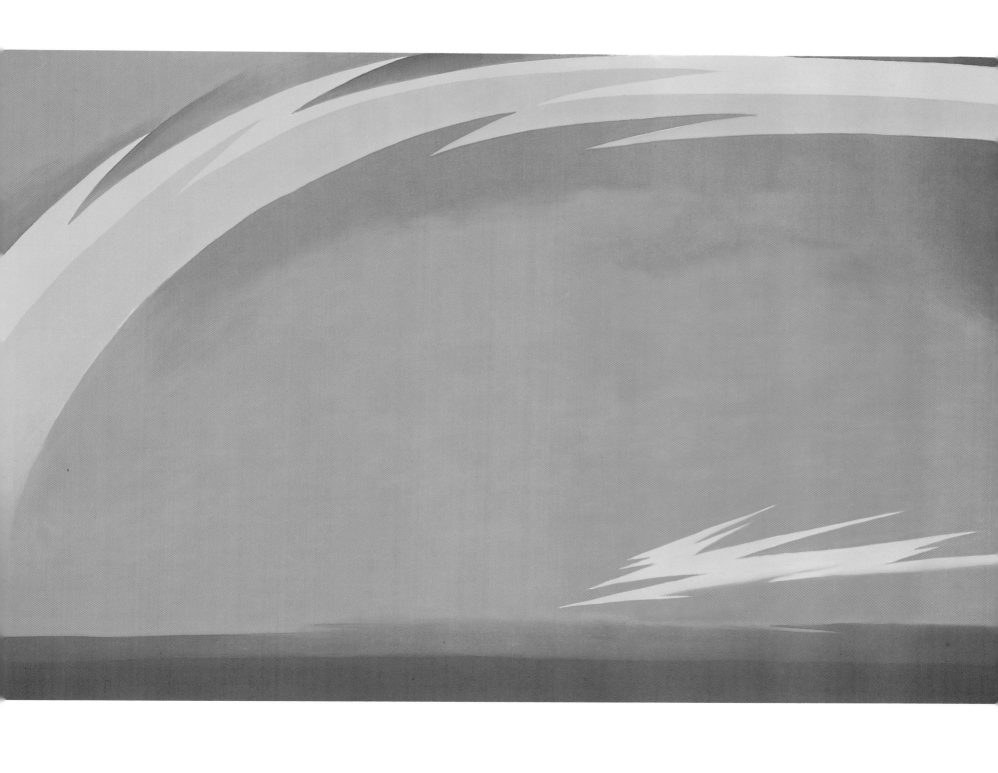

Everyone was just about as they had been six years before. I hadn't been looking at pictures during the time away from New York, but I was really very bored with all of it as I walked around and I thought, "Making a painting as good as these is no problem. I'll go home and make one this afternoon for their next show."

So I made a watercolor of a slim girl in a long black dress against some red salvia. I remembered vividly having seen one of my sisters standing that way at the side of our house and I thought at the time what a fine portrait it would make. My painting was about ten inches wide and twenty-two inches tall. It didn't take me long. I put it aside and the next week I went out and bought a frame. It was the first painting I had framed myself. In the spring I sent it to the show and it was accepted and hung. After the show I tore the painting up—it really wasn't very good.

4 *Orange and Red Streak, 1919. Oil on canvas, 27 x 23.*

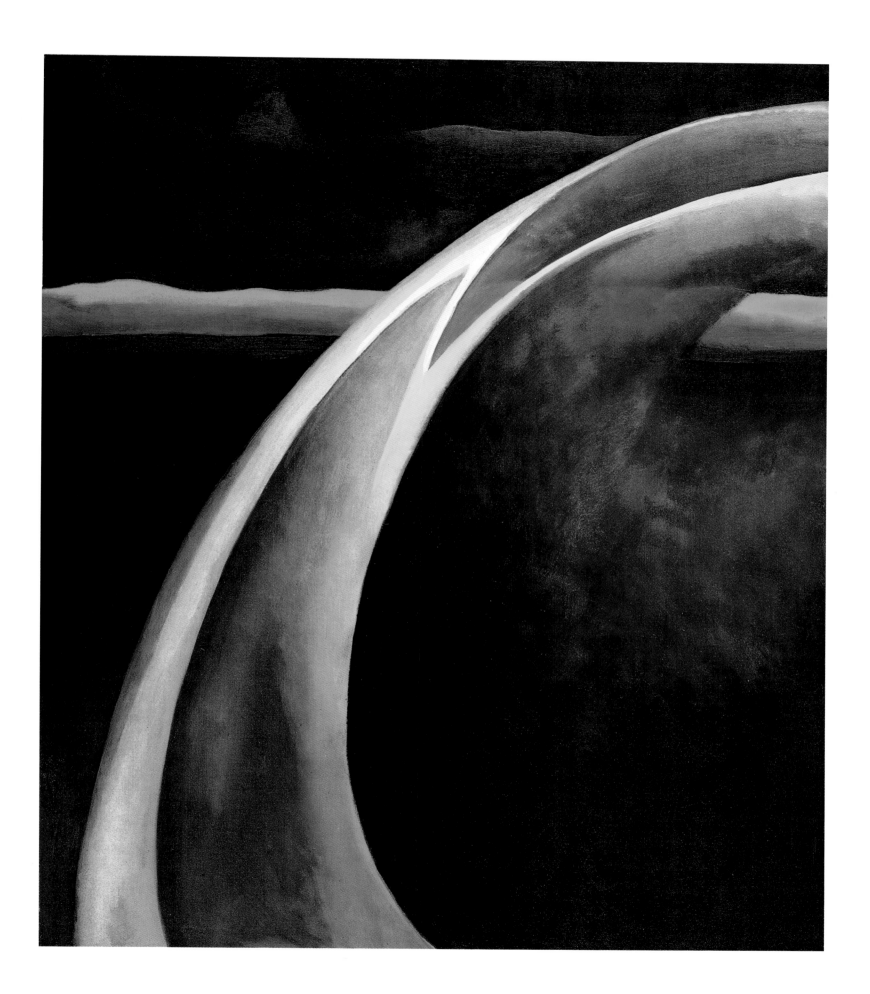

When I taught in Canyon, Texas, my sister Claudia was with me. Saturdays, right after breakfast, we often drove the twenty miles to the Palo Duro Canyon. It was colorful—like a small Grand Canyon, but most of it only a mile wide. It was a place where few people went unless they had cattle they hoped had found shelter there in bad weather. The weather seemed to go over it. It was quiet down in the canyon. We saw the wind and snow blow across the slit in the plains as if the slit didn't exist.

The only paths were narrow, winding cow paths. There were sharp, high edges between long, soft earth banks so steep that you couldn't see the bottom. They made the canyon seem very deep. We took different paths from the edge so that we could climb down in new places. We sometimes had to go down together holding to a horizontal stick to keep one another from falling. It was usually very dry, and it was a lone place. We never met anyone there. Often as we were leaving, we would see a long line of cattle like black lace against the sunset sky.

Those perilous climbs were frightening but it was wonderful to me and not like anything I had known before. The fright of the day was still with me in the night and I would often dream that the foot of my bed rose straight up into the air—then just as it was about to fall I would wake up. Many drawings came from days like that, and later some oil paintings.

5 *Painting No. 21 (Palo Duro Canyon), 1916. Oil on board, 13 x 16.*

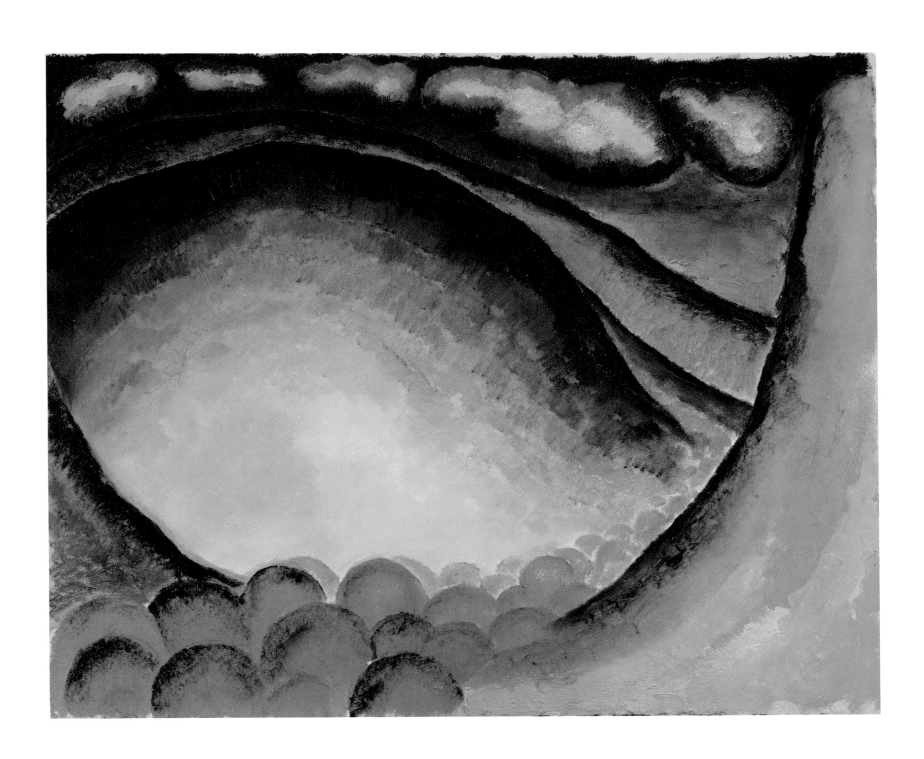

We often walked away from the town in the late afternoon sunset. There were no paved roads and no fences—no trees—it was like the ocean but it was wide, wide land.

The evening star would be high in the sunset sky when it was still broad daylight. That evening star fascinated me. It was in some way very exciting to me. My sister had a gun, and as we walked she would throw bottles into the air and shoot as many as she could before they hit the ground. I had nothing but to walk into nowhere and the wide sunset space with the star. Ten watercolors were made from that star.

6 Evening Star V, 1917. Watercolor, 9 x 12.

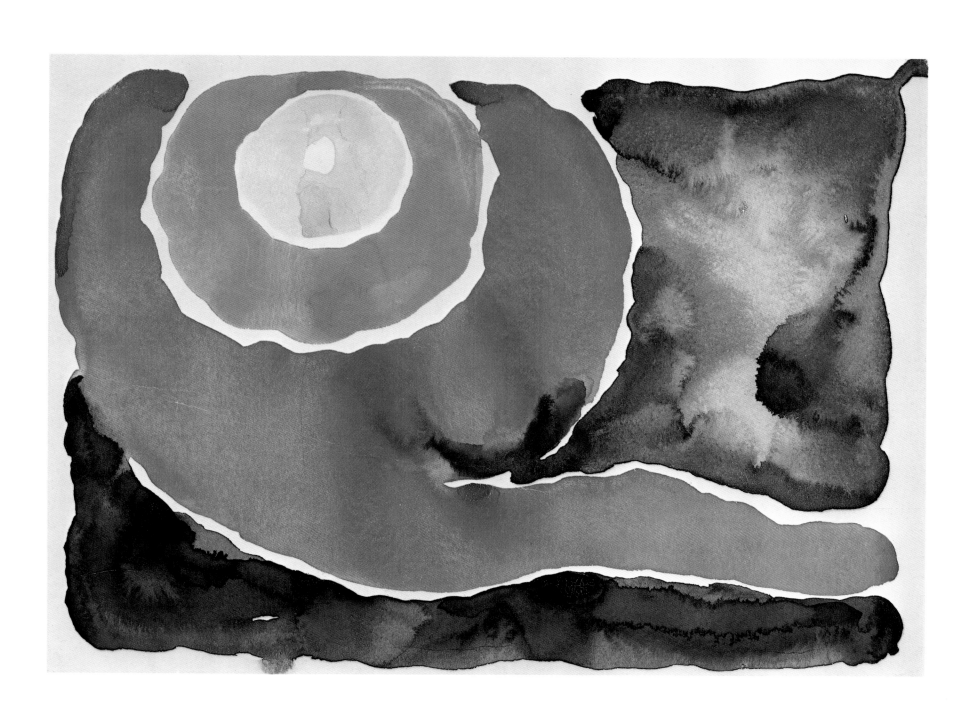

7 *Evening Star III, 1917. Watercolor, 9 x 12.*

8 *Evening Star IV, 1917. Watercolor, 9 x 12.*

9 *Evening Star VI, 1917. Watercolor, 9 x 12.*

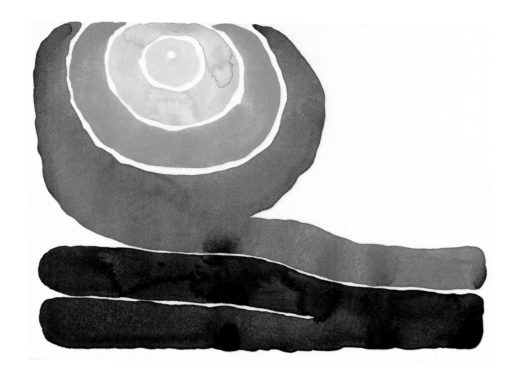

In the spring of 1916 someone at Teachers College asked me if I were Virginia O'Keeffe. I answered, "No, I am Georgia O'Keeffe." "Well, I thought that maybe you were Virginia. Virginia O'Keeffe is having a show of drawings at the Stieglitz Gallery at 291 Fifth Avenue."

I knew this show was mine because Stieglitz had seen my drawings and kept them, telling the person who had taken them to him that he intended to show them. Even though I had heard this, I was startled and shocked. For me the drawings were private and the idea of their being hung on the wall for the public to look at was just too much. I went immediately to "291" and asked Stieglitz to take the drawings down. He said he wanted them on the wall to look at. There were also drawings by Charles Duncan and oils by Rene Lafferty. Stieglitz and I argued and though I didn't like it, I went away leaving the drawings on the wall.

Stieglitz and I corresponded through the next year and in the spring of 1917 he gave me another show of drawings and watercolors that I had rolled up in newspaper and sent him like letters during the year. The first picture I ever sold was sold from that show. It was a black shape with smoke above it, a picture of the early morning train roaring in. I was busy with the last quarter of school work in Texas but when I had time to think about it, I decided to go to New York to see the show. When I began to work on my ticket I found that I would be near Niagara. I had always wanted to see Niagara Falls, so this was my chance. I planned to go there and arrive in New York in the daytime.

10 Blue II, 1916. Watercolor, 16 x 11.

When I arrived at "291," Stieglitz had taken my show down, but he put it back on the wall for me. Though I was only in New York about three days, this was the first time Stieglitz photographed me—my face twice—my hands several times. One day we drove to Coney Island with friends. The only thing I remember about Stieglitz from that trip is his black Loden cape. It was a cold, windy day and it was put around me. In later years a cape was always part of his costume.

Between these two shows I had taught with Alon Bement at the University of Virginia. I taught there for three summers, and the second year going down from New York, Bement said, "Now when I talk to your classes I don't want you to get up right after me and tell the class that what I say isn't so and to pay no attention to me."

Bement was a very good teacher but he was a very poor painter. I guess he wasn't a painter at all. He had no courage and I believe that to create one's own world in any of the arts takes courage.

My sisters had persuaded me to visit Bement's class at the University in the summer of 1912. I hadn't been painting for several years but he had an idea that interested me. An idea that seemed to me to be of use to everyone—whether you think about it consciously or not—the idea of filling a space in a beautiful way. Where you have the windows and door in a house. How you address a letter and put on the stamp. What shoes you choose and how you comb your hair.

11 Light Coming on the Plains II, 1917. Watercolor, 12 x 9.

In later years Bement always felt he didn't get proper credit for having been of great use to me when he first knew me. I think he didn't know the many ways he helped me. He told me things to read. He told me of exhibitions to go and see—sometimes even told me of theater not to miss. The two books that he told me to get were Jerome Eddy, "Cubists and Post-Impressionism," and Kandinsky, "On the Spiritual in Art." He told me to look at the pictures in Eddy's book—that I needn't bother to read it—but that I should read the Kandinsky. I looked at the Eddy very carefully and I read the Kandinsky.

It was some time before I really began to use the ideas. I didn't start at it until I was down in Carolina—alone—thinking things out for myself. Later I described that time in the foreword Stieglitz asked me to write for the catalogue for my show at the Anderson Galleries in New York in 1923. I couldn't think of anything to write except to say what had happened:

"I grew up pretty much as everybody else grows up and one day seven years ago found myself saying to myself—I can't live where I want to—I can't go where I want to—I can't do what I want to—I can't even say what I want to. School and things that painters have taught me even keep me from painting as I want to. I decided I was a very stupid fool not to at least paint as I wanted to

12 Starlight Night, 1917. Watercolor, 9 x 12.

and say what I wanted to when I painted as that seemed to be the only thing I could do that didn't concern anybody but myself—that was nobody's business but my own. So these paintings and drawings happened and many others that are not here. I found that I could say things with color and shapes that I couldn't say in any other way—things that I had no words for. Some of the wise men say it is not painting, some of them say it is. Art or not Art—they disagree. Some of them do not care. Some of the first drawings done to please myself I sent to a girl friend requesting her not to show them to anyone. She took them to '291' and showed them to Alfred Stieglitz and he insisted on showing them to others. He is responsible for the present exhibition.

 "I say that I do not want to have this exhibition because, among other reasons, there are so many exhibitions that it seems ridiculous for me to add to the mess, but I guess I'm lying. I probably want to see my things hang on a wall as other things hang so as to be able to place them in my mind in relation to other things I have seen done. And I presume, if I must be honest, that I am also interested in what anybody else has to say about them and also in what they don't say because that means something to me, too."

 (Exhibition catalogue, Anderson Galleries, 1923.)

 As a matter of fact, because of what I had seen in his gallery, I was more interested in what Stieglitz thought about my work than in what anyone else would think.

13 Canyon with Crows, 1917. Watercolor, 9 x 12.

I never took one of Bement's classes at Columbia University, but one day walking down the hall I heard music from his classroom. Being curious I opened the door and went in. A low-toned record was being played and the students were asked to make a drawing from what they heard. So I sat down and made a drawing, too. Then he played a very different kind of record—a sort of high soprano piece—for another quick drawing. This gave me an idea that I was very interested to follow later—the idea that music could be translated into something for the eye.

14 Music—Pink and Blue I, 1919. Oil on canvas, 35 x 29.

There are three paintings of the "Black Spot." I never knew where the idea came from or what it says. They are shapes that were clearly in my mind — so I put them down.

15 Black Spot III, 1919. Oil on canvas, 24 x 16.

I lived for a while in the New York studio of Stieglitz's niece Elizabeth. It was on the top floor of a brownstone house next to the back of the Anderson Galleries on 59th Street. The studio was bright with a north skylight and two south windows. Elizabeth had painted the walls a pale lemon yellow. The floor was orange—not a very good place for painting but it was exciting. It made me feel good and I liked it. The room back of the studio had a rather narrow window opening into a small court so it was not very light. The painting is what one saw as one looked from the bright room into the darker room.

When I knew I was going to stay in New York, I sent for things I had left in Texas. They came in a barrel and among them were all my old drawings and paintings. I put them in with the wastepaper trash to throw away and that night when Stieglitz and I came home after dark the paintings and drawings were blowing all over the street. We left them there and went in. But I remember a large watercolor of many hollyhocks sticking out of a big wastecan.

16 Fifty-ninth Street Studio, 1919. Oil on canvas, 35 x 29.

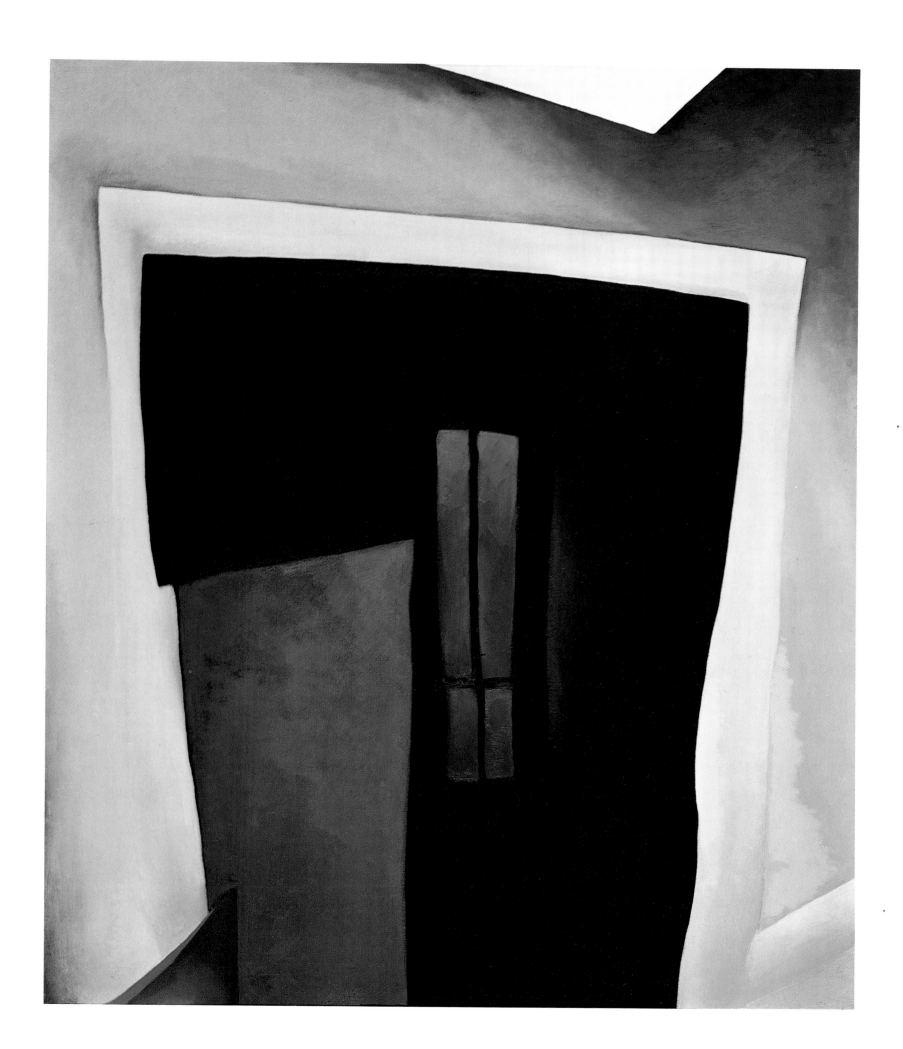

At that time Park Avenue, lined with brownstone houses, seemed to stretch way beyond 59th Street and on to infinity. It was a quiet sunny street—a pleasant place to walk even though the underground trains were visible in some places. There was a large opening between 46th and 47th streets and across this, as I walked down Park Avenue, I saw the Shelton being built on Lexington Avenue.

Later, when I was looking for a place to live, I decided to try the Shelton. I was shown two rooms on the 30th floor. I had never lived up so high before and was so excited that I began talking about trying to paint New York. Of course, I was told that it was an impossible idea—even the men hadn't done too well with it. From my teens on I had been told that I had crazy notions so I was accustomed to disagreement and went on with my idea of painting New York.

My first painting was a night scene of 47th Street, "New York with Moon." There was a street light in the upper foreground at about the Chatham Hotel. The next fall five of us had a group show on the top floor of

17 *New York with Moon, 1925. Oil on canvas, 48 x 30.*

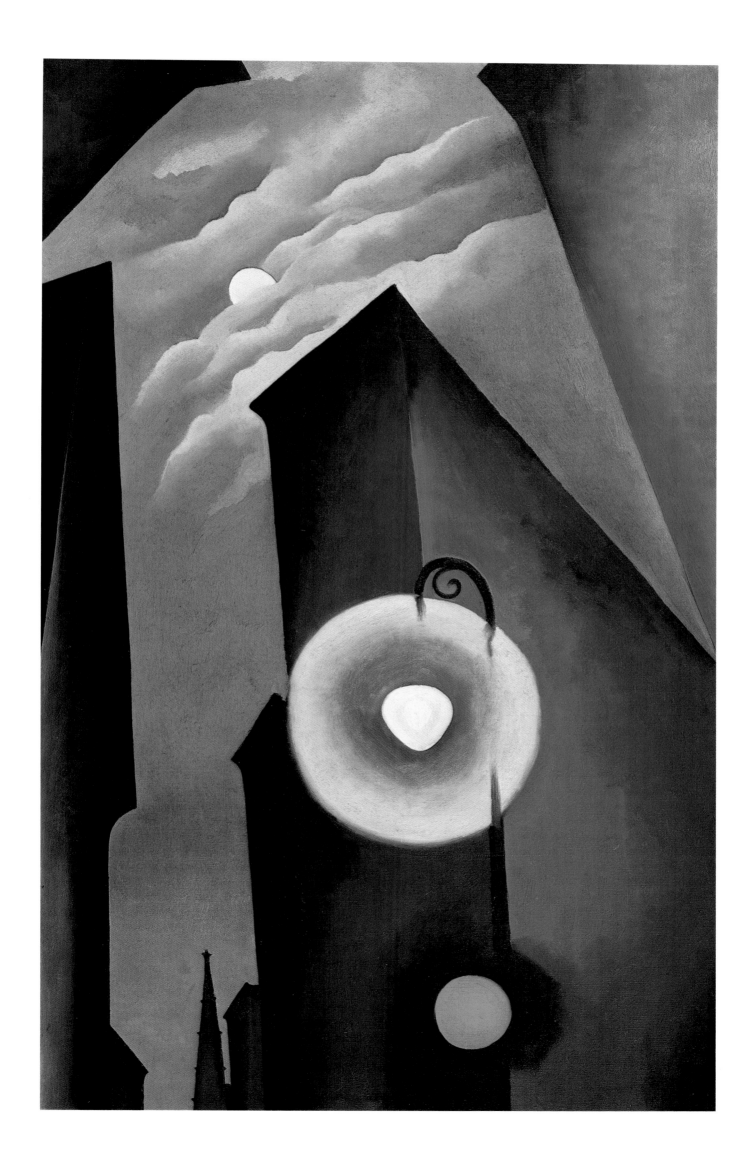

the Anderson Galleries. My large flowers were shown for the first time. At the
end of the hall just outside the door of the show was a perfect place for my
first "New York." It carried well and would have been seen when you
stepped out of the elevator to go toward the show. But the "New York" wasn't
hung—much to my disappointment.

 The next year Stieglitz had a small corner room at the Anderson
Galleries. There were three large windows. As you entered you saw my first
"New York" between two windows. There was a painting of the East River.
My "Black Iris" was there and I don't remember what else. Paintings always
stood on the floor as, with the windows, there were only two good walls. The
room would often be so crowded you could hardly get in. It was of rather
special interest that no one ever put a foot through a canvas in spite of the
crowd. My large "New York" was sold the first afternoon. No one ever objected
to my painting New York after that.

 I painted "The Shelton with Sunspots" in 1926. I went out one morning
to look at it before I started to work and there was the optical illusion of a bite

18 The Shelton with Sunspots, 1926. Oil on canvas, 49 x 31.

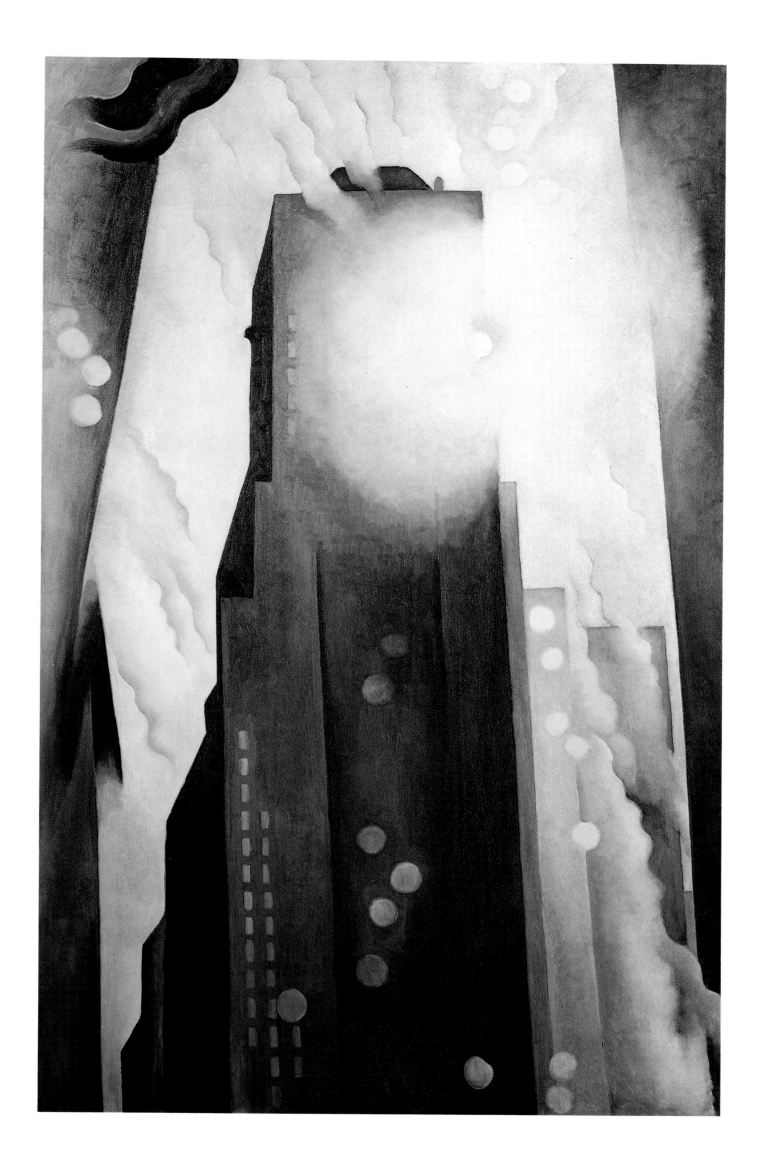

out of one side of the tower made by the sun, with sunspots against the building and against the sky. I made that painting beginning at the upper left and went off at the lower right without going back. There were several other "Sheltons" that I destroyed because they weren't as good as the "Sunspots."

At that time I painted a street that was a narrow V with a small lamppost at the bottom of the V. There were several "East Rivers," some with snow,

19 *East River from the Shelton*, 1927-28. *Oil on canvas, 25 x 22.*

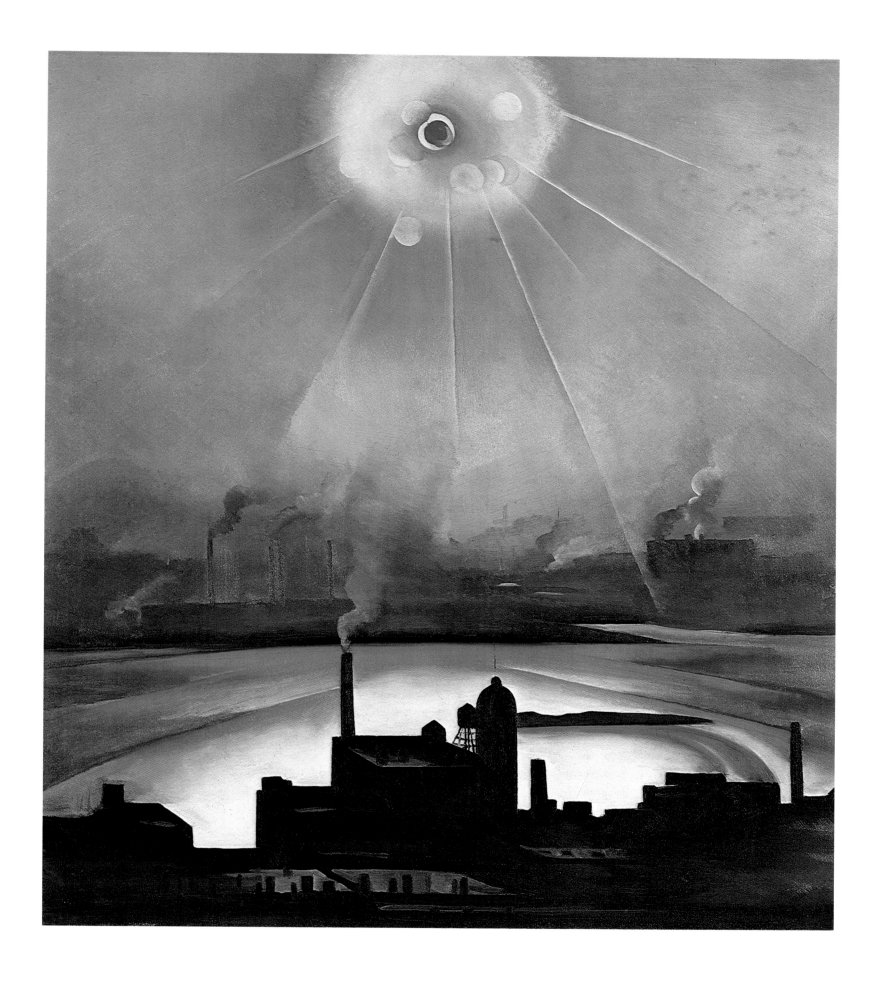

and a large one with low buildings against the river. I walked across 42nd Street many times at night when the black Radiator Building was new—so that had to be painted, too. There was a painting of Lexington Avenue as I saw it out the window at night. Lexington Avenue looked, in the night, like a very tall thin bottle with colored things going up and down inside it.

When you live up high, the snow and rain go down and away from you instead of coming toward you from above. I was never able to do anything with that. There were many other things that I meant to paint. I still see them when I am in the Big City.

20 *Radiator Building—Night, New York, 1927. Oil on canvas, 48 x 30.*

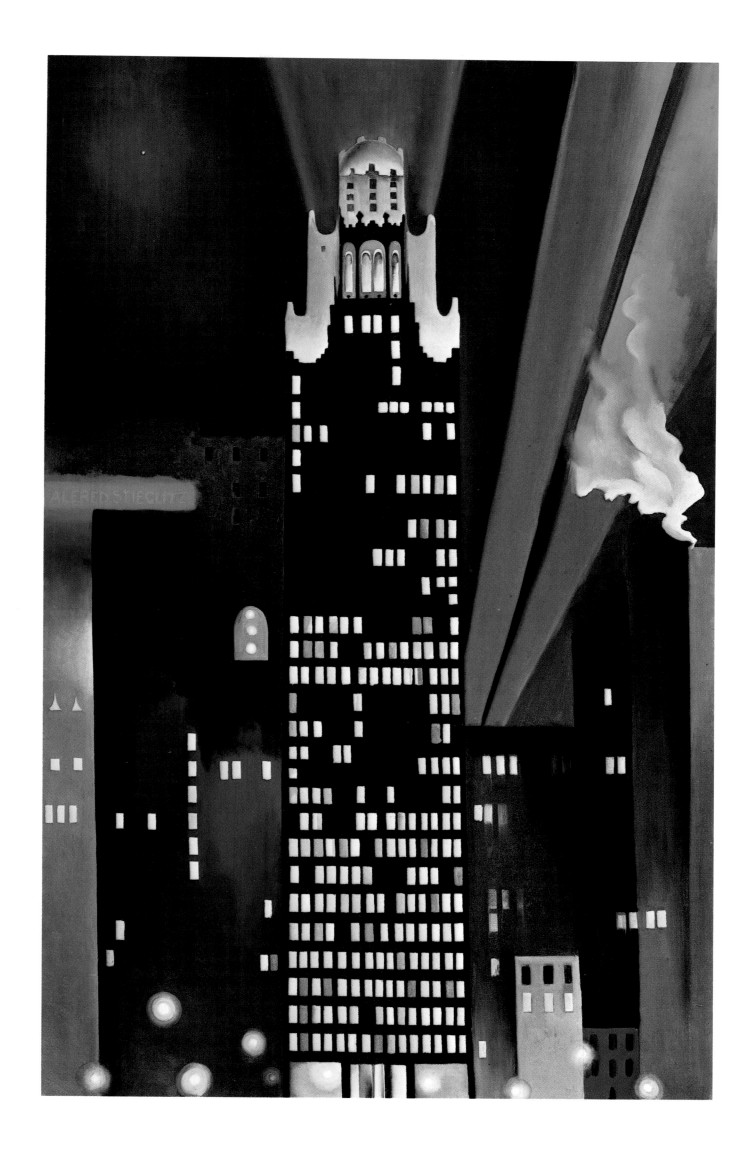

21 New York Night, 1929. Oil on canvas, 40 x 19.

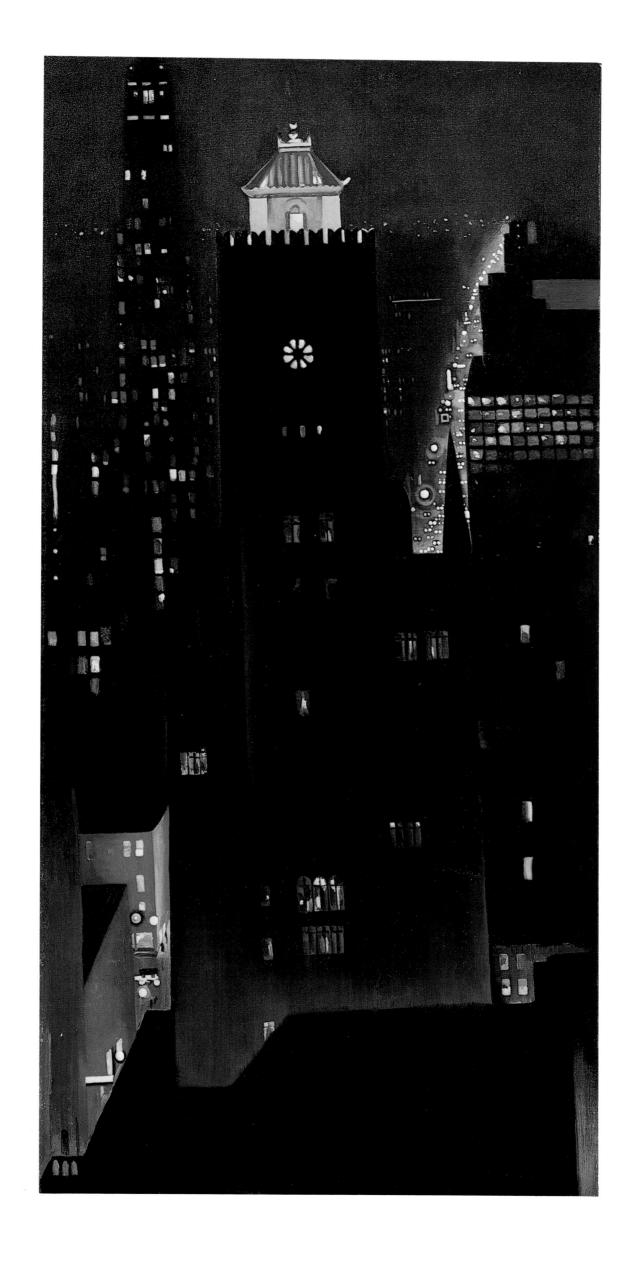

22 City Night, 1926. Oil on canvas, 48 x 30.

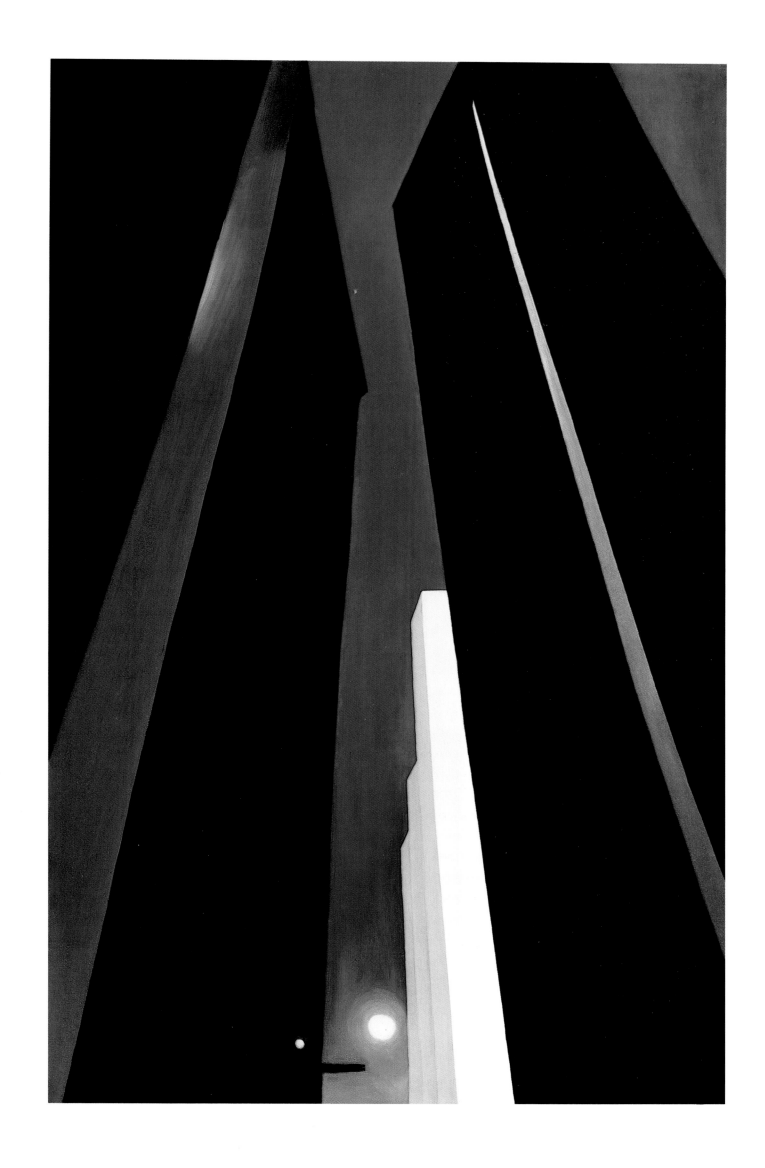

"A flower is relatively small. Everyone has many associations with a flower—the idea of flowers. You put out your hand to touch the flower—lean forward to smell it—maybe touch it with your lips almost without thinking—or give it to someone to please them. Still—in a way—nobody sees a flower—really—it is so small—we haven't time—and to see takes time, like to have a friend takes time. If I could paint the flower exactly as I see it no one would see what I see because I would paint it small like the flower is small.

"So I said to myself—I'll paint what I see—what the flower is to me but I'll paint it big and they will be surprised into taking time to look at it—I will make even busy New Yorkers take time to see what I see of flowers.

23 Abstraction—White Rose III, 1927. Oil on canvas, 36 x 30.

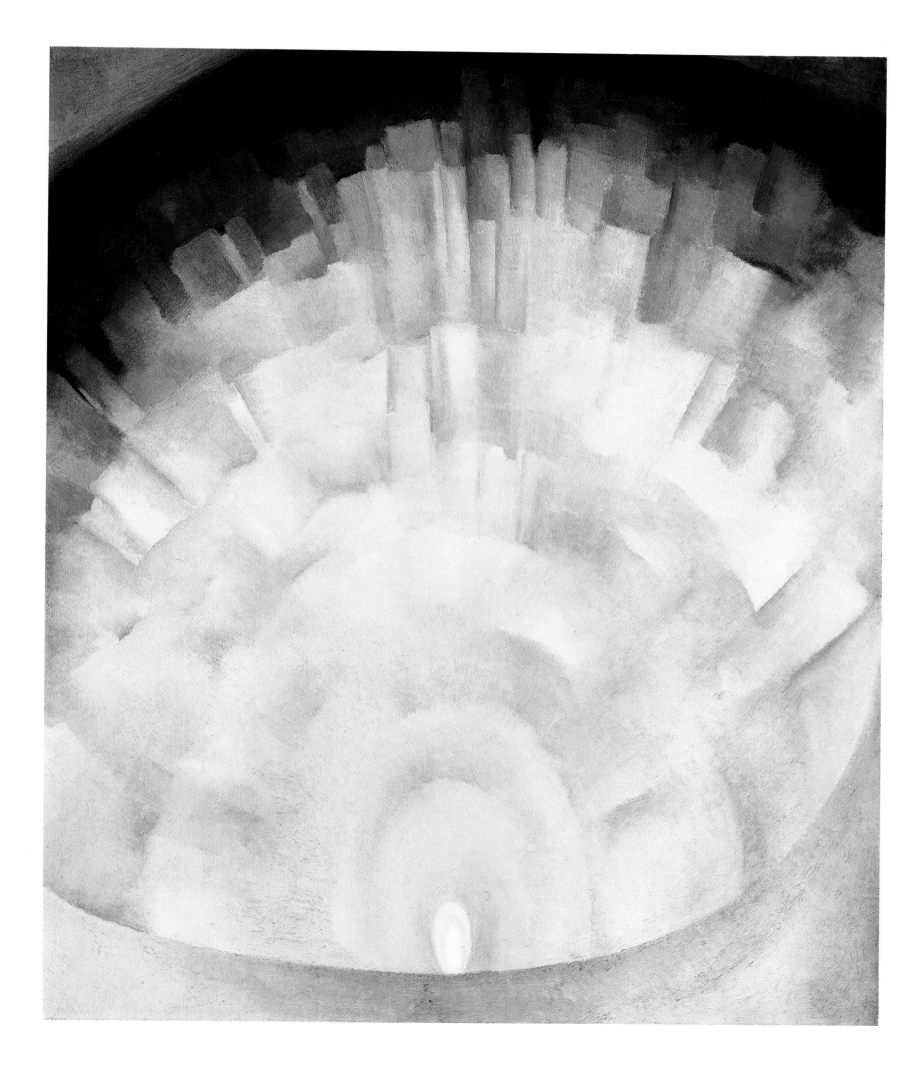

"Well—I made you take time to look at what I saw and when you took time to really notice my flower you hung all your own associations with flowers on my flower and you write about my flower as if I think and see what you think and see of the flower—and I don't.

24 An Orchid, 1941. Pastel, 27 x 21.

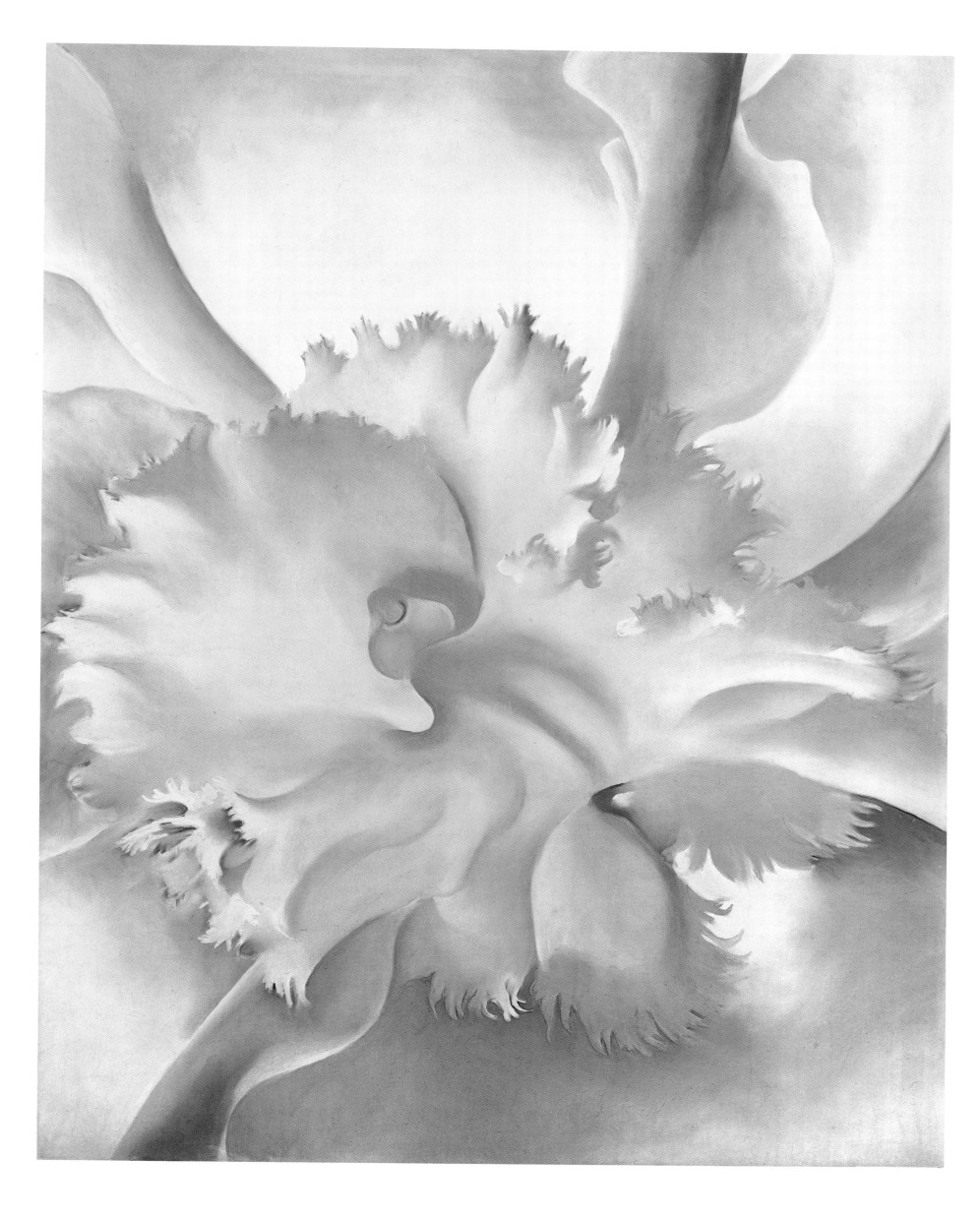

"Then when I paint a red hill, because a red hill has no particular association for you like the flower has, you say it is too bad that I don't always paint flowers. A flower touches almost everyone's heart. A red hill doesn't touch everyone's heart as it touches mine and I suppose there is no reason why it should. The red hill is a piece of the badlands where even the grass is gone. Badlands roll away outside my door—hill after hill—red hills of

25 The White Trumpet Flower, 1932. Oil on canvas, 30 x 40.

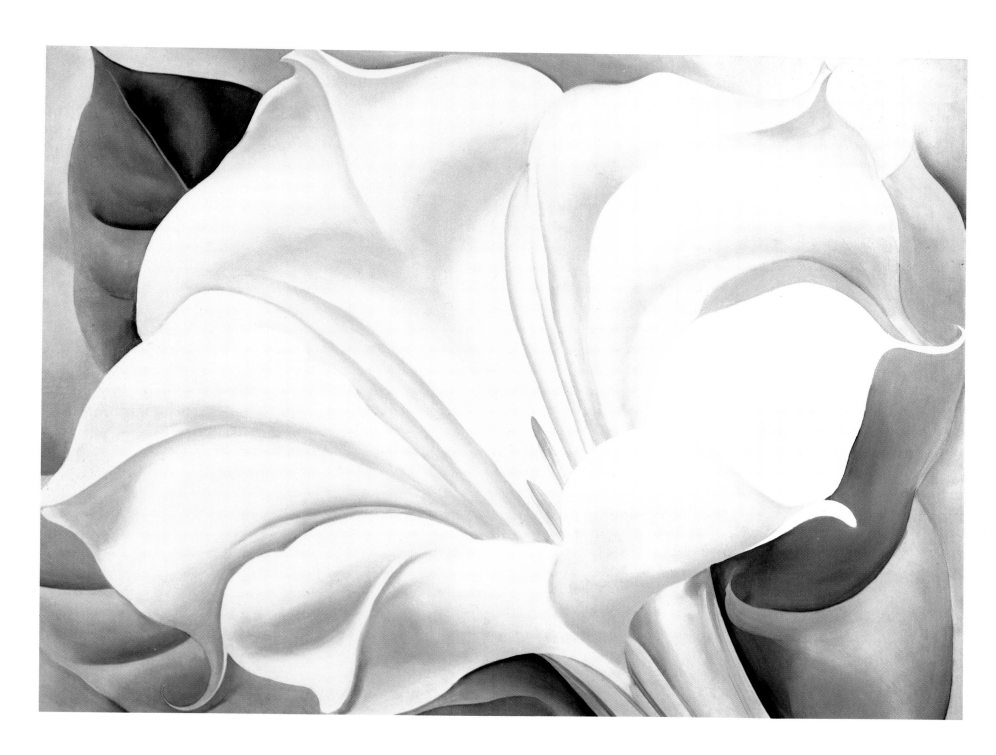

*apparently the same sort of earth that you mix with oil to make paint. All the
earth colors of the painter's palette are out there in the many miles of
badlands. The light Naples yellow through the ochres—orange and red and
purple earth—even the soft earth greens. You have no associations with those
hills—our waste land—I think our most beautiful country. You must not have
seen it, so you want me always to paint flowers...."*

(Exhibition catalogue, An American Place, 1939.)

26 Bleeding Heart, 1932. Pastel, 15 x 10.

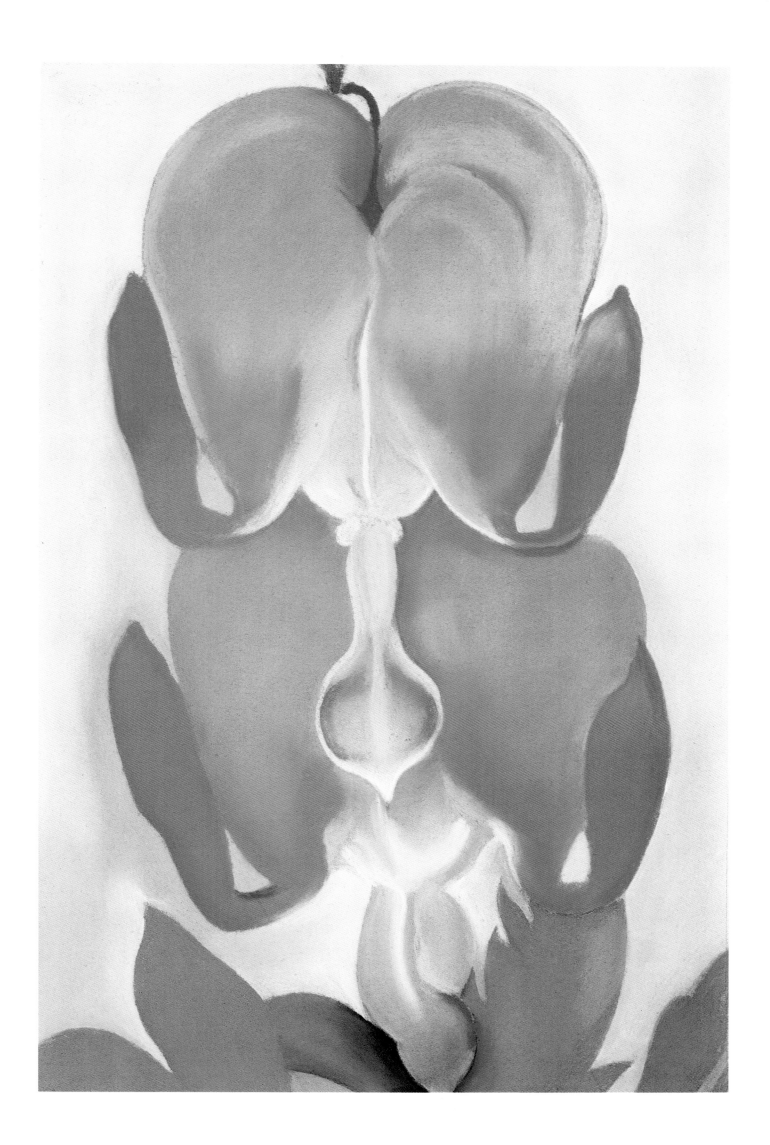

27 Sunflower for Maggie (Sunflower, New Mexico I), 1935. Oil on canvas, 20 x 16.

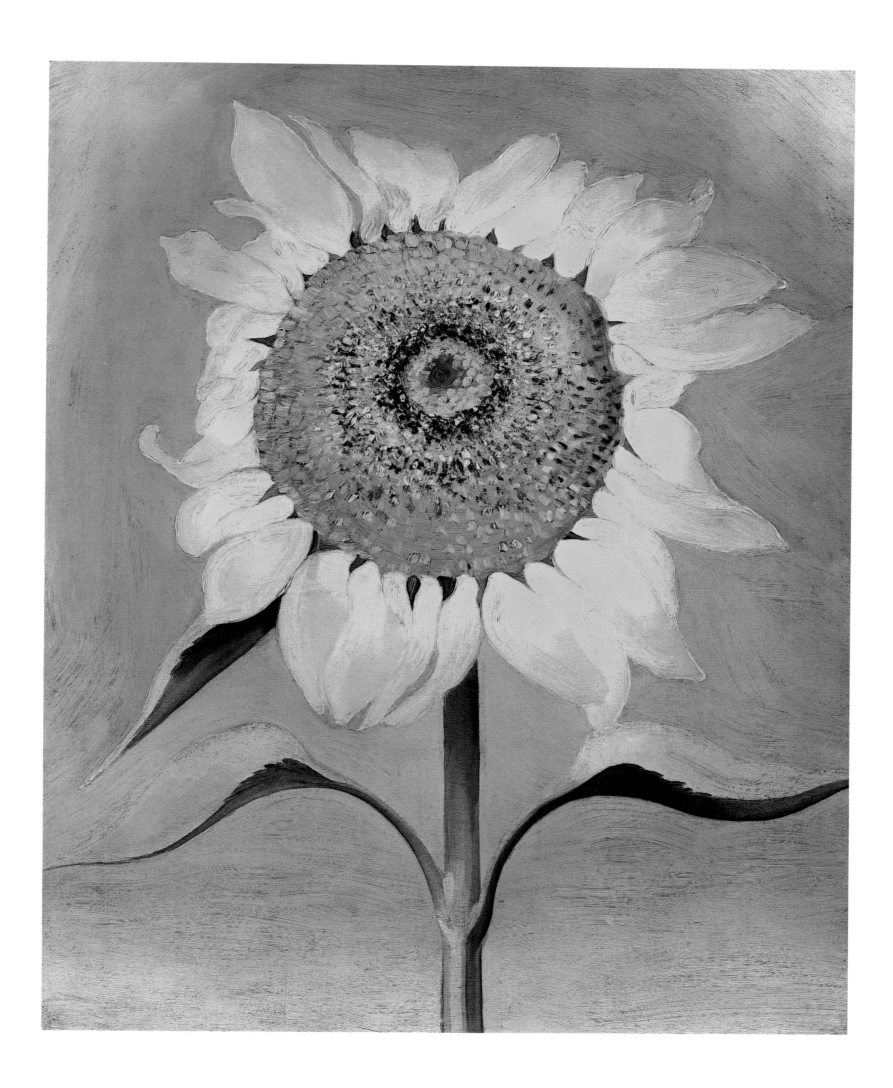

28 *Two Calla Lilies on Pink*, 1928. Oil on canvas, 40 x 30.

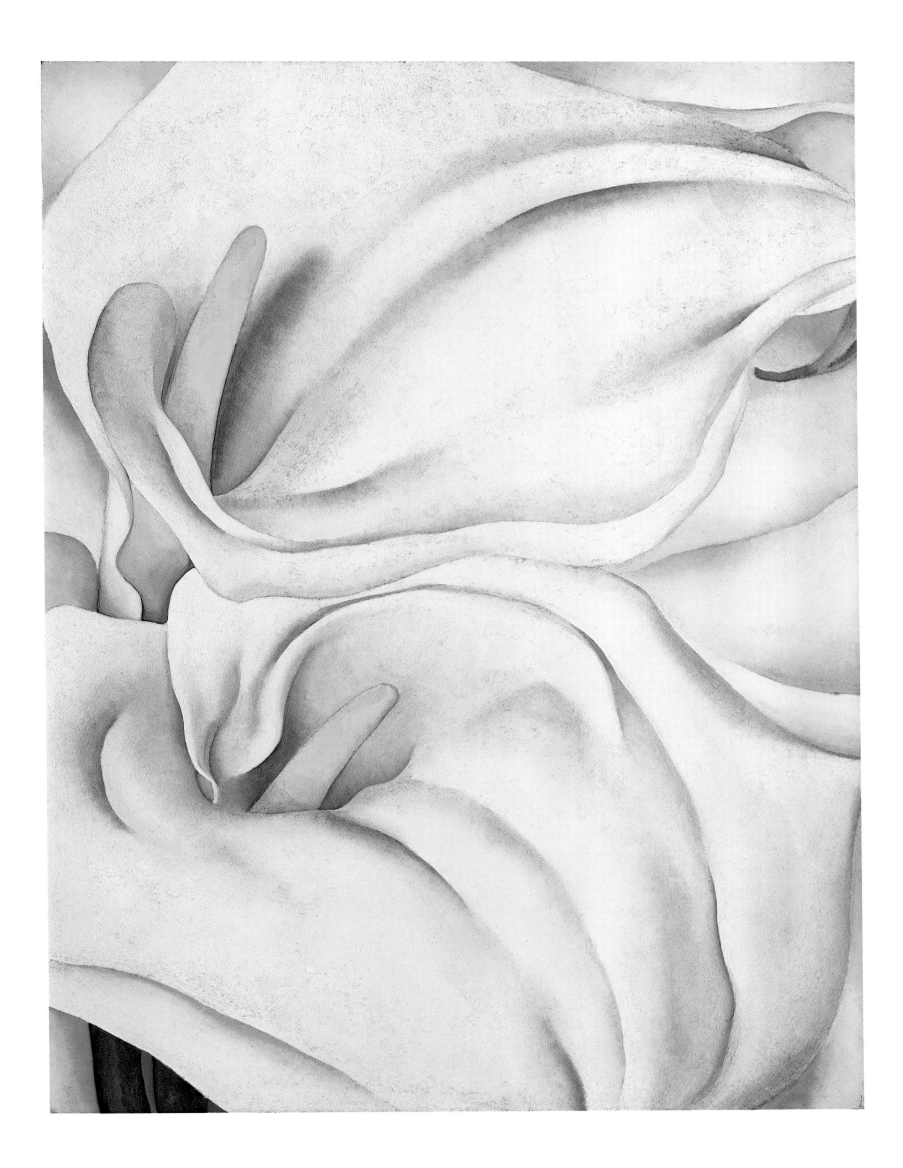

29 Red Poppy, 1927. Oil on canvas, 7 x 9.

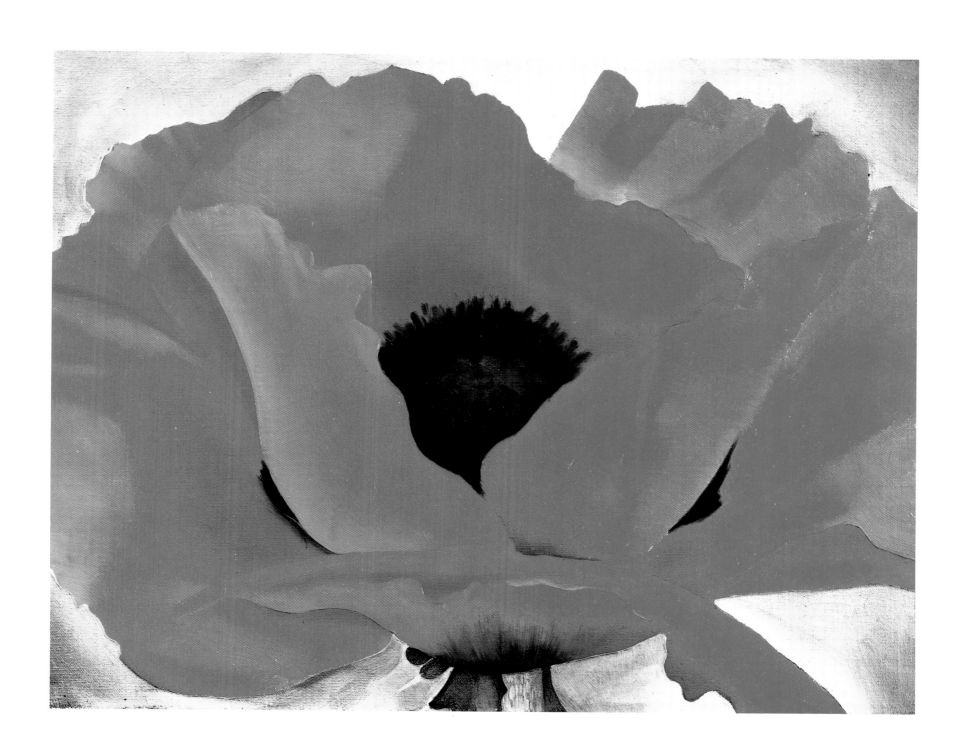

For several years I looked for the black iris at the time it should bloom. I could only find it in New York flower shops for about two weeks in the spring and I painted it many times—year after year. There was a small abstraction of it that sold and resold and traveled quite a bit—it even went to Japan and returned.

I have tried to find the black iris bulb but could not. Once someone gave me an address for it—but I lost the address and forgot who gave it to me so I've never had a plant for the garden.

The first alligator pear I became acquainted with I didn't eat. I kept it so long that it turned a sort of light brown and was so hard that I could shake it and hear the seed rattle. I kept it for years—a dry thing, a wonderful shape.

30 Black Iris, 1926. Oil on canvas, 36 x 30.

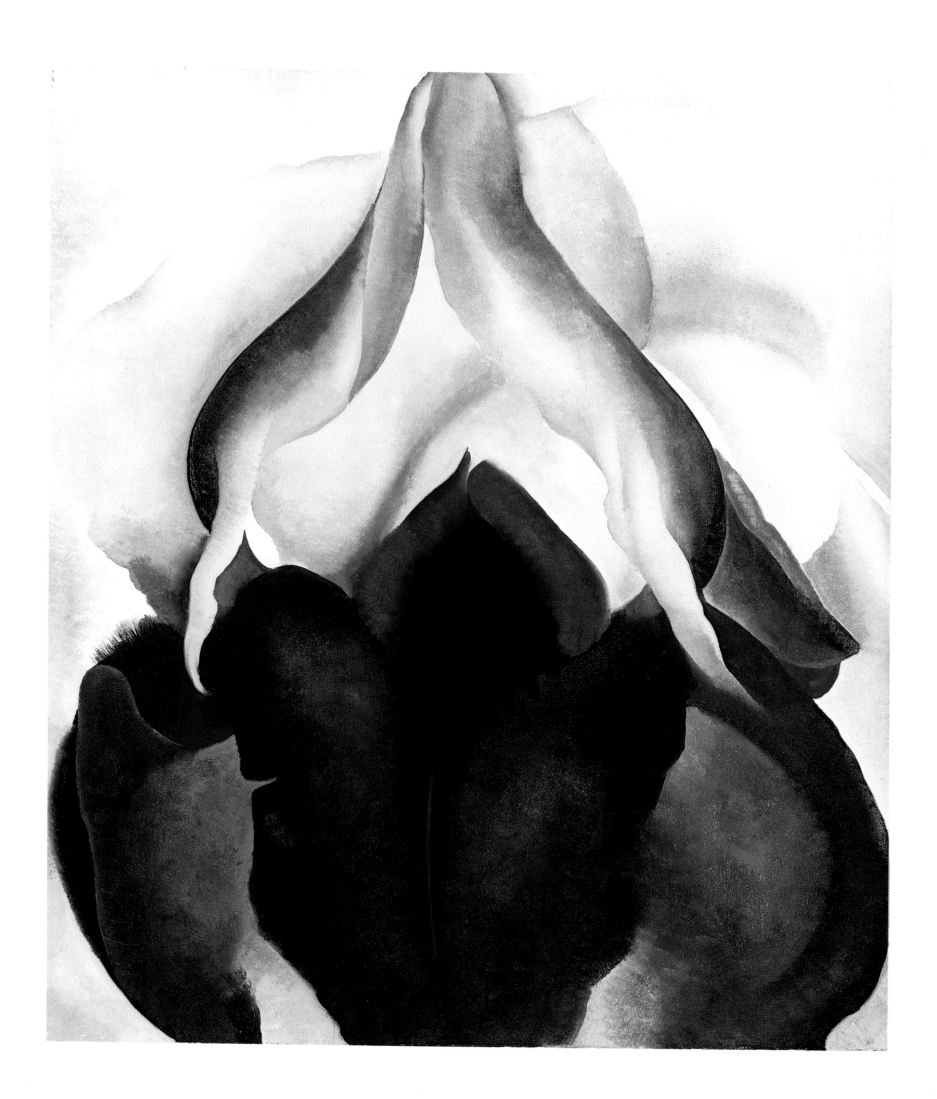

Later I had two green ones—not so perfect. I painted them several times. It was in the time when the men didn't think much of what I was doing. They were all discussing Cézanne with long involved remarks about the "plastic quality" of his form and color. I was an outsider. My color and form were not acceptable. It had nothing to do with Cézanne or anyone else. I didn't understand what they were talking about—why one color was better than another. I never did understand what they meant by "plastic." Years later when I finally got to Cézanne's Mont Sainte-Victoire in the south of France, I remember sitting there thinking, "How could they attach all those analytical remarks to anything he did with that mountain?" All those words piled on top of that poor little mountain seemed too much.

I had an alligator-pears-in-a-large-dark-basket period. One painting is dark with a simplified white scalloped doily under the basket. There was a painting of pears in the basket with a pink line around the outside as a sort of frame.

The best of the alligator pears was a pastel of my first lone dry pear on a white cloth. I was surprised and pleased when it was printed in "The Dial" in 1923. I have always considered that it was one of the times when I did what I really intended to do. One isn't always able to do that....

I get out my work and have a show for myself before I have it publicly. I make up my own mind about it—how good or bad or indifferent it is. After that the critics can write what they please. I have already settled it for myself so flattery and criticism go down the same drain and I am quite free.

31 *Single Alligator Pear,* 1922. Pastel, 12 x 10.

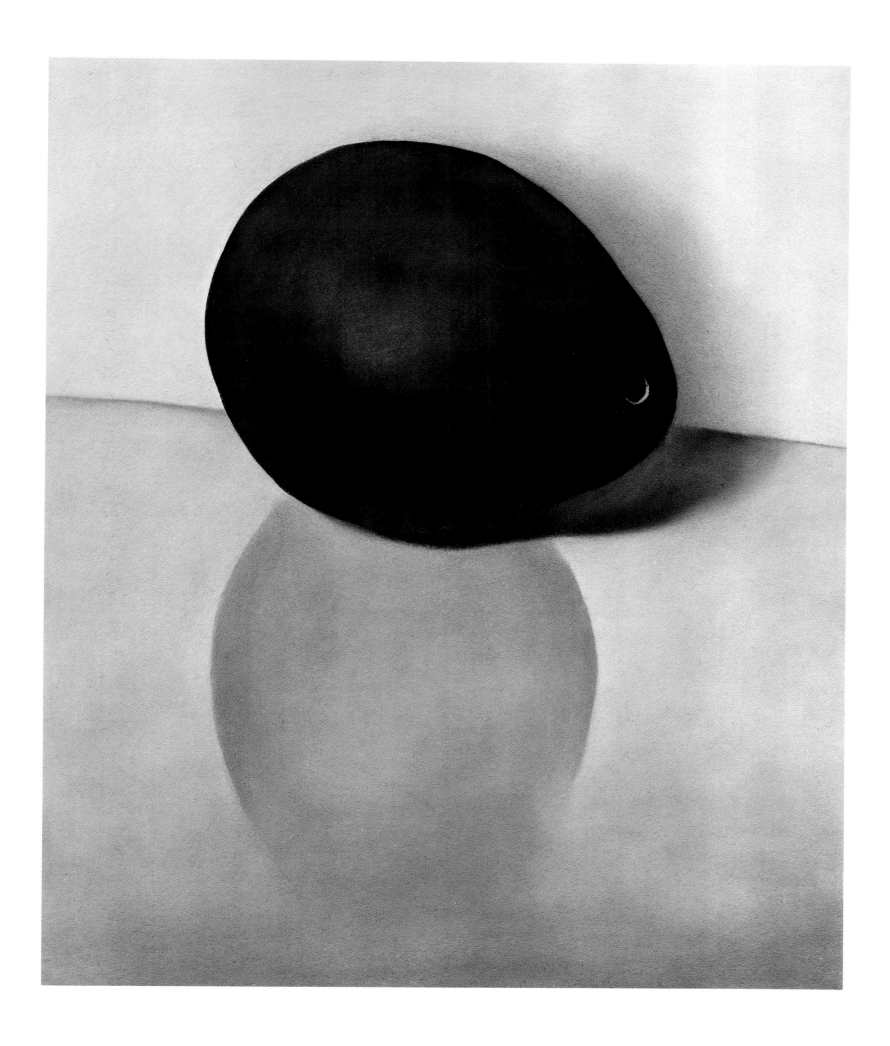

32 *Lake George with Crows, 1921. Oil on canvas, 28 x 25.*

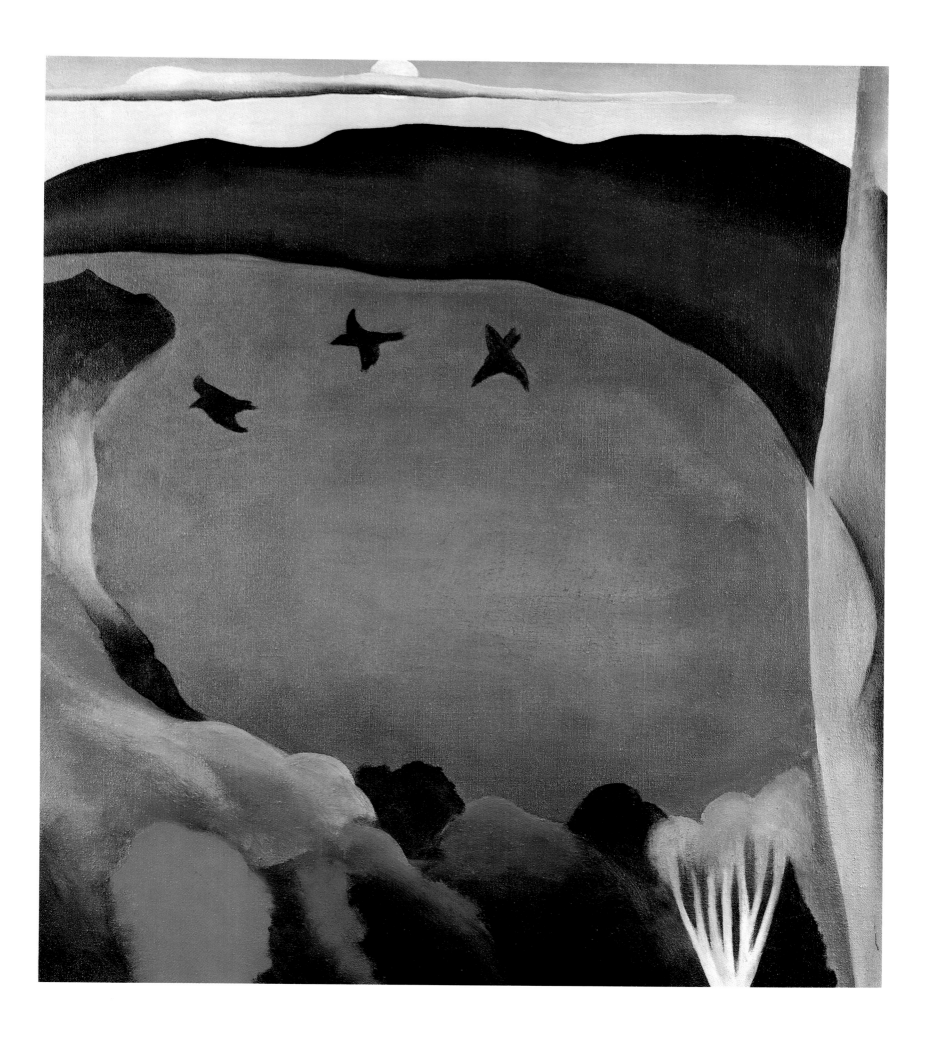

The Shanty was beyond the farmhouse at Lake George where we lived part of the year. It was a one-room building put up years before by young people who worked in the area and wanted a place to dance. It hadn't been danced in for years and I wanted a place to work away from the house so we fixed up the Shanty. I had a long carpenter's bench for a table and that was all. To the north, flat on the ground outside was a platform where I often worked. There was one small raspberry bush by the platform that had one raspberry once in a while. If I sat very still a squirrel would come and pick the berry. Turning it over with his neat little paws, he carefully took off one section at a time, eyeing me brightly as he ate the piece with its small seed. It was a very careful performance.

I often walked through the pasture to the back road and as I walked down past the beautiful juniper bushes the Shanty looked very shabby. It had never been painted and the outside boards were scorched by the sun. The clean, clear colors were in my head, but one day as I looked at the brown burned wood of the Shanty I thought, "I can paint one of those dismal-colored paintings like the men. I think just for fun I will try—all low-toned and dreary with the tree beside the door."

In my next show "The Shanty" went up. The men seemed to approve of it. They seemed to think that maybe I was beginning to paint. I don't remember what the critics said about it, but when Duncan Phillips saw it he bought it for the Phillips Collection. That was my only low-toned dismal-colored painting.

33 *The Shanty,* 1922. Oil on canvas, 20 x 27.

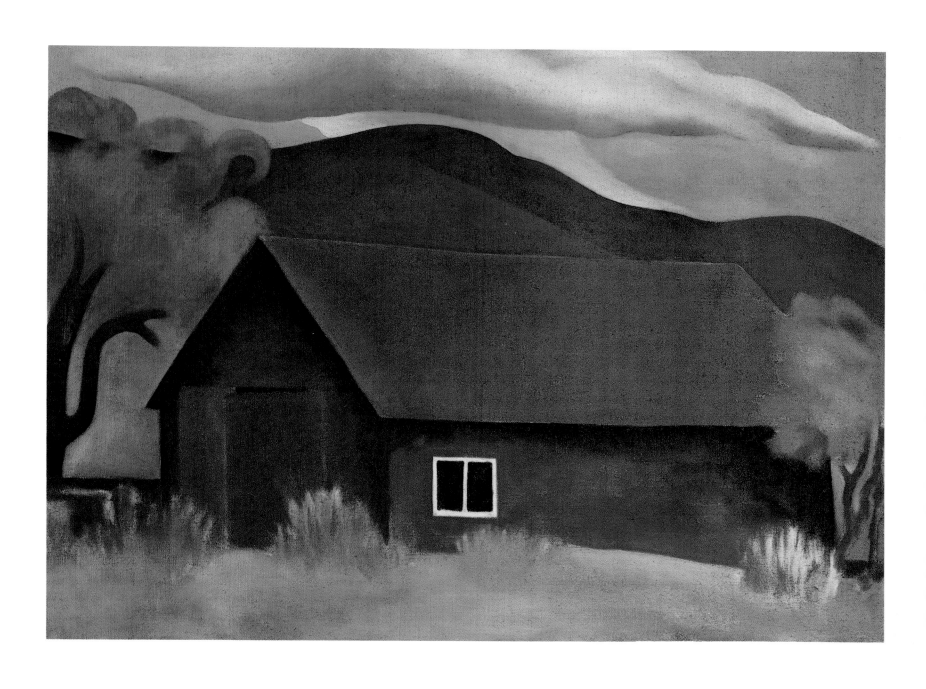

I had a garden at Lake George for some years. The growing corn was one of my special interests—the light-colored veins of the dark green leaves reaching out in opposite directions. And every morning a little drop of dew would have run down the veins into the center of this plant like a little lake— all fine and fresh.

34 *Corn, Dark, 1924. Oil on board, 32 x 12.*

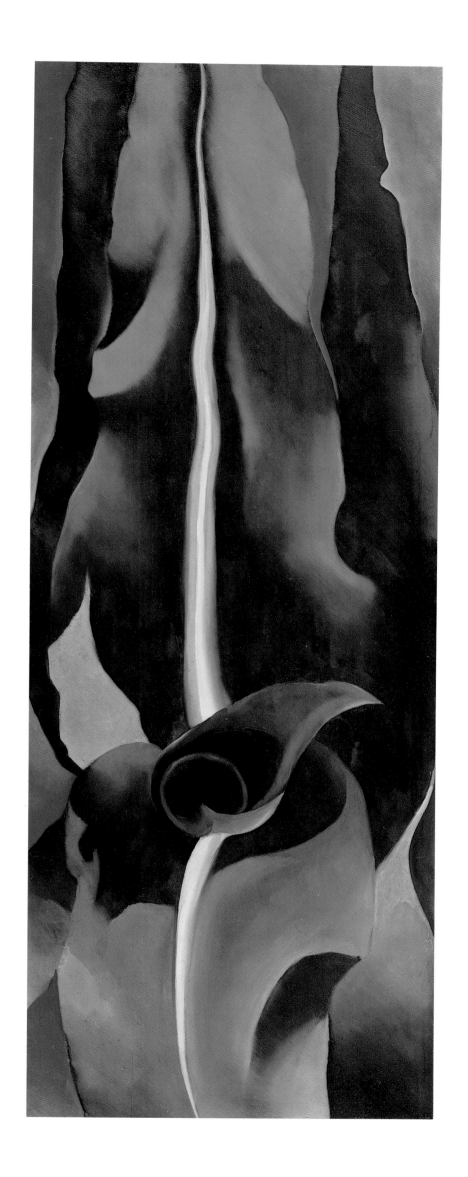

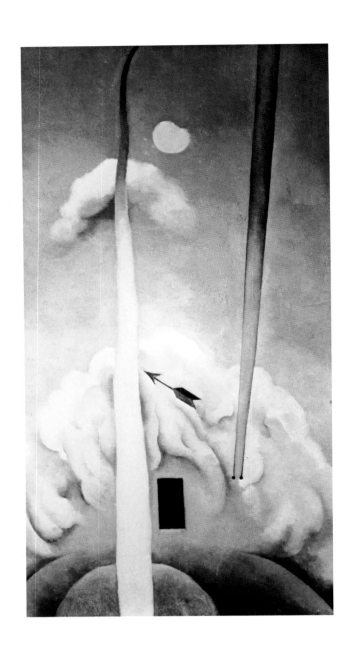

35 *The Flagpole, 1923. Oil on canvas, 35 x 18.*

At Lake George there was a small square house that had been the wooden part of the large greenhouse. Two electric wires ran to it from the farmhouse and there was a fine weathervane on top of it. In front of the little house was a tall white flagpole and there were rows of lavender and white lilacs that ran way beyond it. Stieglitz used the little house as a dark room for his photographic work so the door, when open, was always black.

36 *Flagpole with White House, 1959. Oil on canvas, 48 x 30.*

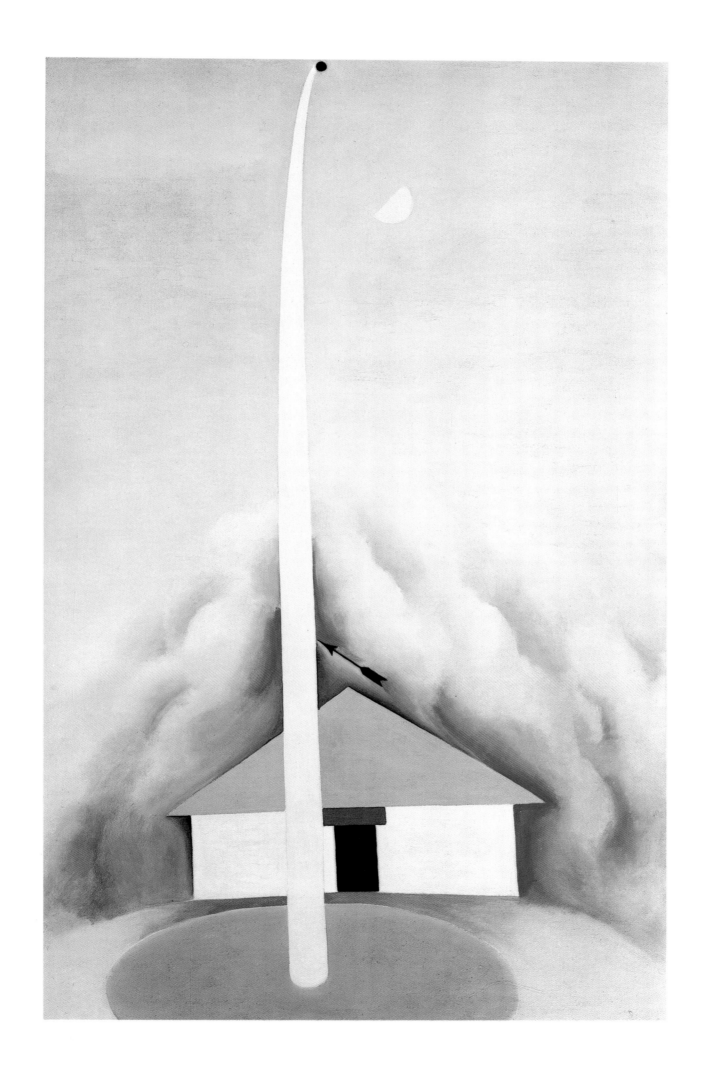

One painting of the flagpole was done in 1923. It was one of my best paintings and was in my first large showing at the Anderson Galleries. Steven Bourgeois brought Joe Duveen to my show and he bought this painting saying he intended to give it to his daughter. When I met her years later she said she had never seen it. I have heard that it might have gone to Poland with a group of other paintings but I do not know. If anyone has seen it anywhere I would be interested to hear.

37 Lake George Window, 1929. Oil on canvas, 40 x 30.

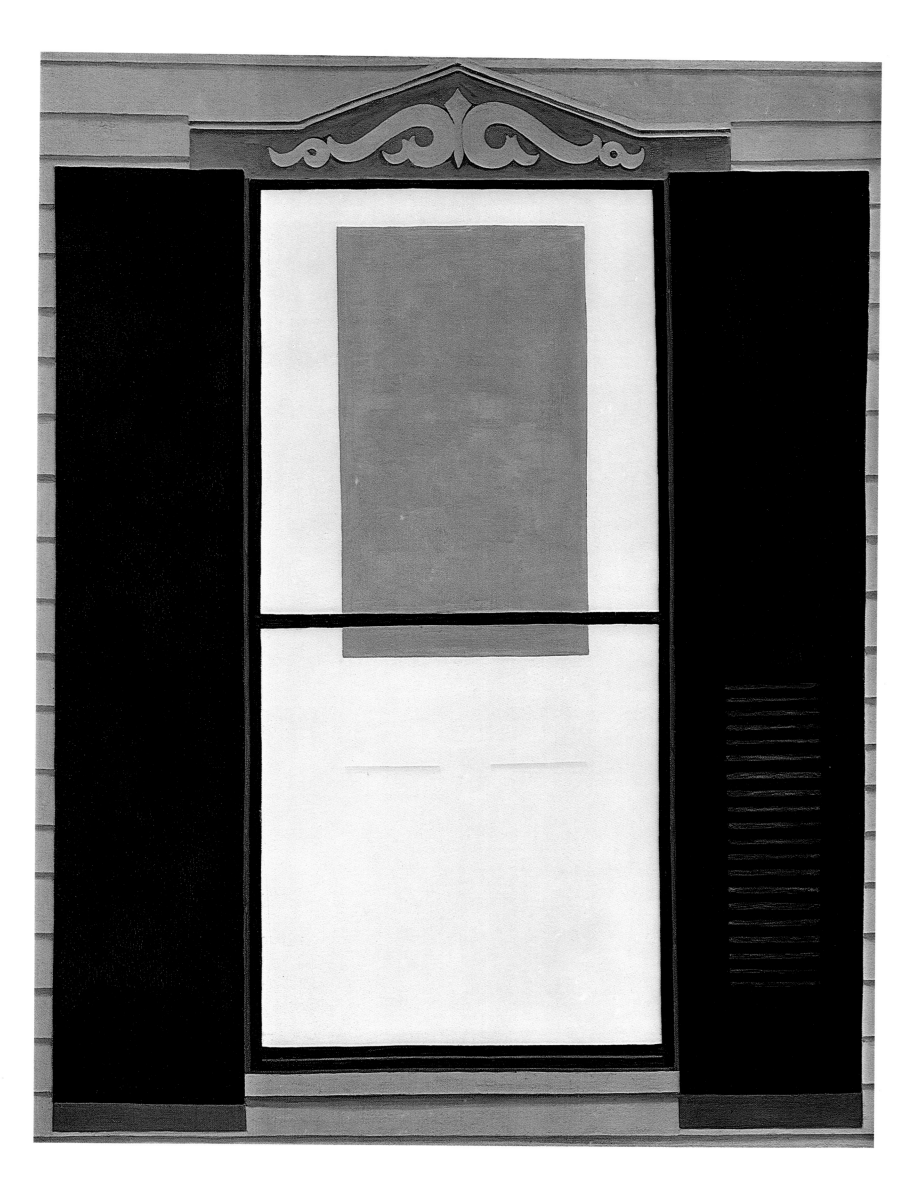

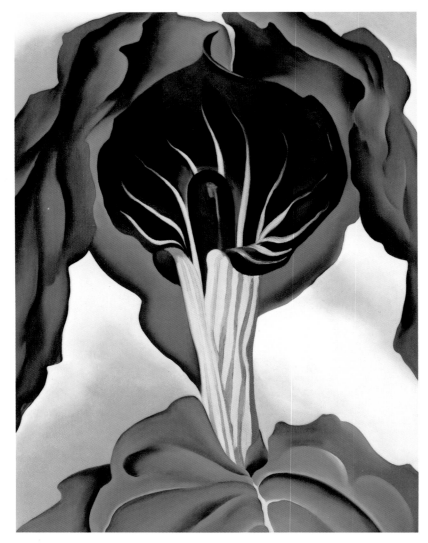

38 *Jack-in-the-Pulpit III, 1930. Oil on canvas, 40 x 30.*

39 *Jack-in-the-Pulpit II, 1930. Oil on canvas, 40 x 30.*

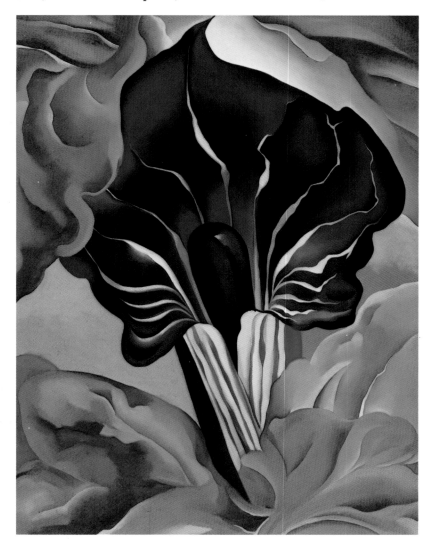

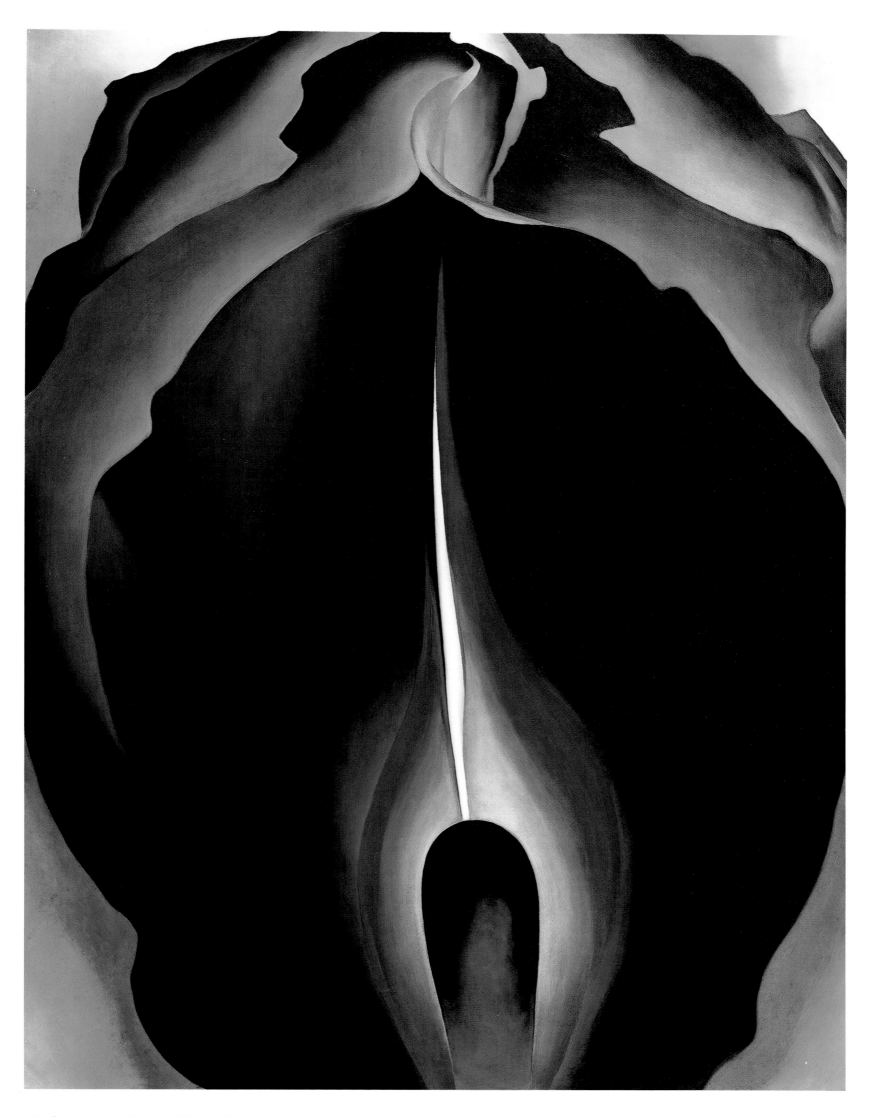

40 *Jack-in-the-Pulpit IV, 1930. Oil on canvas, 40 x 30.*

In the woods near two large spring houses, wild Jack-in-the-pulpits grew —both the large dark ones and the small green ones. The year I painted them I had gone to the lake early in March. Remembering the art lessons of my high school days, I looked at the Jacks with great interest. I did a set of six paintings of them. The first painting was very realistic. The last one had only the Jack from the flower.

41 Jack-in-the-Pulpit V, 1930. Oil on canvas, 48 x 30.

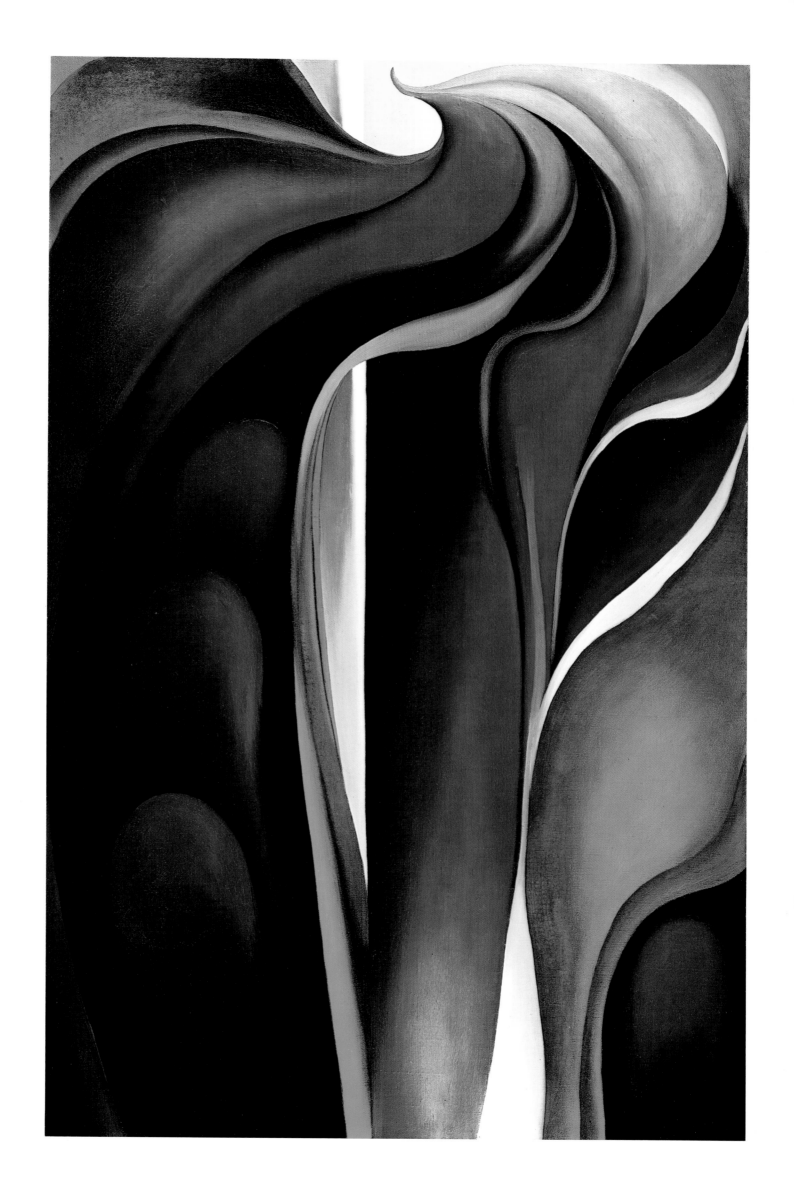

42 *Jack-in-the-Pulpit VI, 1930. Oil on canvas, 36 x 18.*

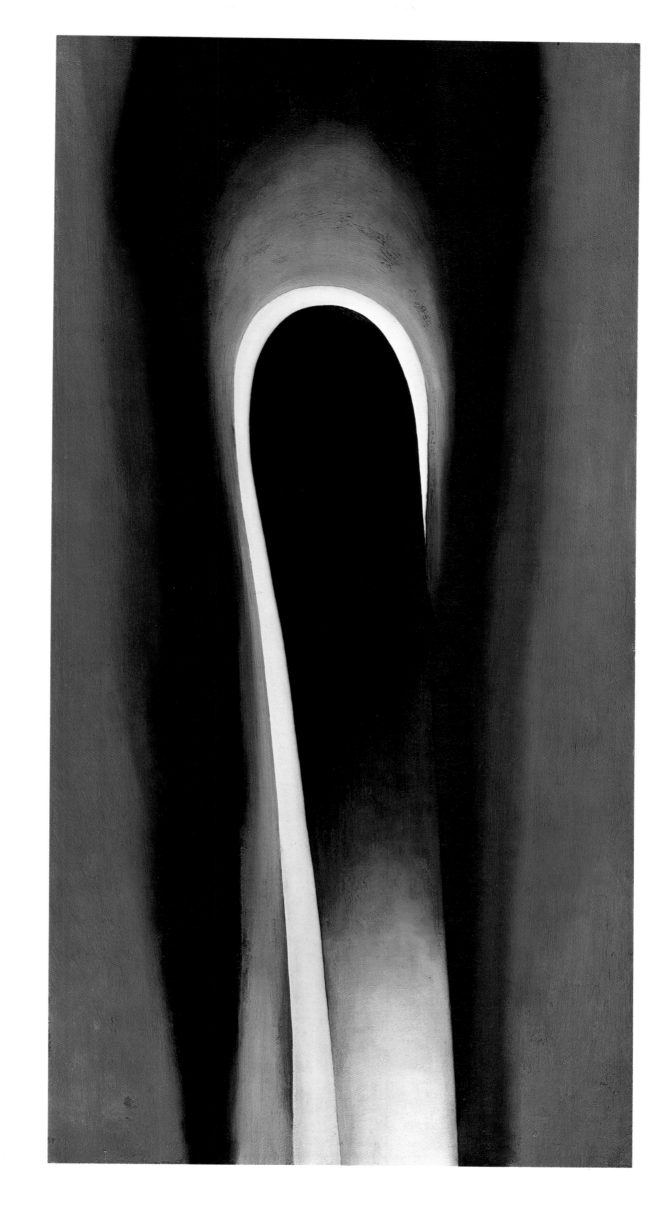

A little way from the dock there was a big old birch tree with many trunks. I have painted the foliage green and have painted it yellow many times. To see the tree at its best I was up early and out in the rowboat under the trees as the sun came up over the mountains across the lake. The trunks were whitest in the early sunrise — the foliage a golden yellow with a few leaves standing out sharply here and there.

43 White Birch, 1925. Oil on canvas, 36 x 30.

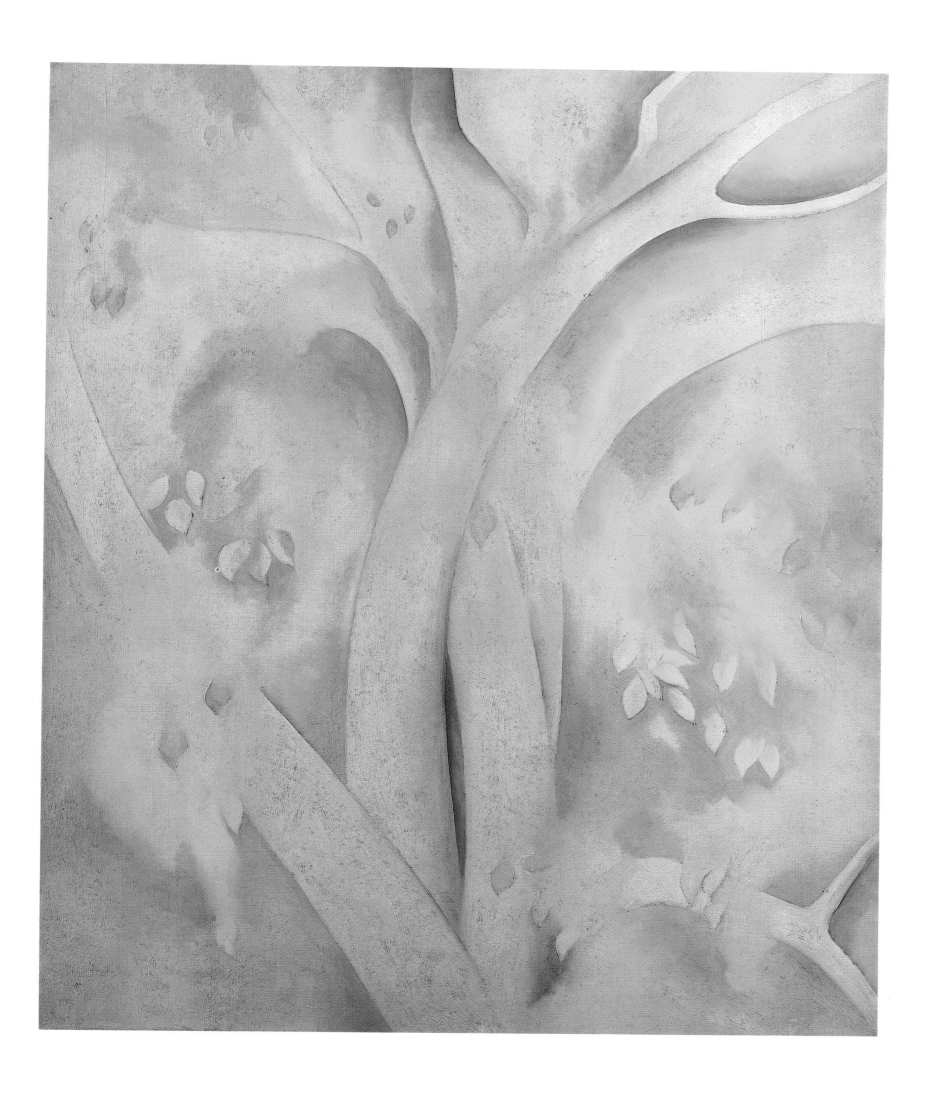

There was a fine old barn at the Lake George farmhouse. You could see it from the kitchen window or from the window of Stieglitz's little sitting room. With much effort I painted a picture of the front part of the barn. I had never painted anything like that before. After that I painted the side where all the paint was gone with the south wind. It was weathered grey—with one broken pane in the small window. A little of the stone foundation was visible above the grass. I have looked at the barn in summer and have looked at it in winter when the snow was deep. Lake George had many grey days. When I painted the back of the barn there was a grey cloud over it toward the lake.

There was one small painting of the front of the barn—only seven inches square and maybe the best. It was sold soon after it was painted. Another picture of the front of the barn brought four hundred dollars—the highest price at the 1923 auction of paintings by American artists of the period.

44 *Barn with Snow*, 1934. Oil on canvas, 16 x 28.

45 *Lake George Barns*, 1926. Oil on canvas, 21 x 32.

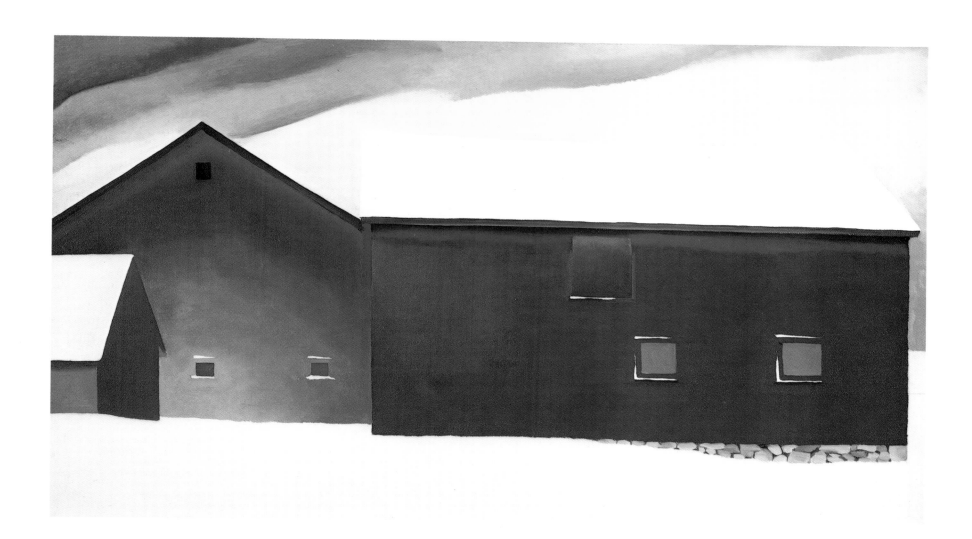

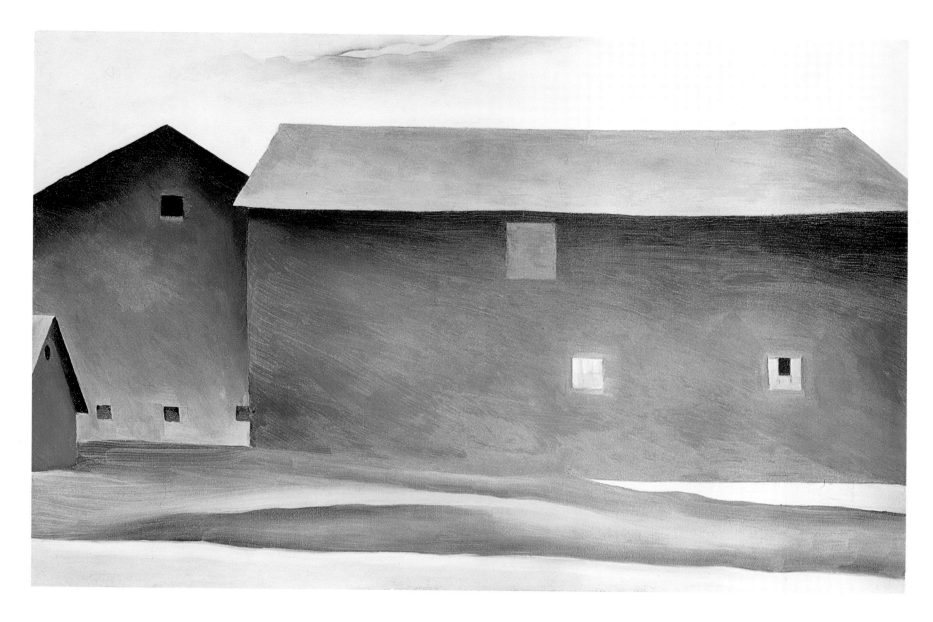

In the spring of 1920 I went to York Beach, Maine, with an old friend of Stieglitz. The house had a board walk across a cranberry bog out to the long, clean beach of the ocean. The house was a large, very plain, almost empty place with a few very good old Indian rugs kicked about in rather disorderly fashion over the otherwise bare floors. My room was large—faced out on the ocean and the rising sun. The first thing you noticed was a large double bed and in the fireplace, birch wood logs for the fire.

In the morning when I went down looking for a kitchen, I came first to the pantry—a long room with two tall windows on each side, long red cotton curtains covering shelves between the windows. Two live lobsters were walking about over the floor eyeing me in their odd fashion. In the kitchen there was a Chinese or Japanese boy doing something with coffee. Later the family collected for breakfast in a very small room upstairs next to my room looking out over the ocean. The sons of the family, when they came home for a few days, always laughingly remarked, "Back to the home of food." Specially when they were home there would be a good-sized brown pot of Boston baked beans for breakfast.

I spent much time walking on the long, clean sandy beach—often picking up extraordinary things that I kept in large platters of water to paint. When walking I seldom met anyone as it was very early springtime and cold. I loved running down the board walk to the ocean—watching the waves come in, spreading over the hard wet beach—the lighthouse steadily bright far over the waves in the evening when it was almost dark. This was one of the great events of the day.

46 Wave, Night, 1928. Oil on canvas, 30 x 36.

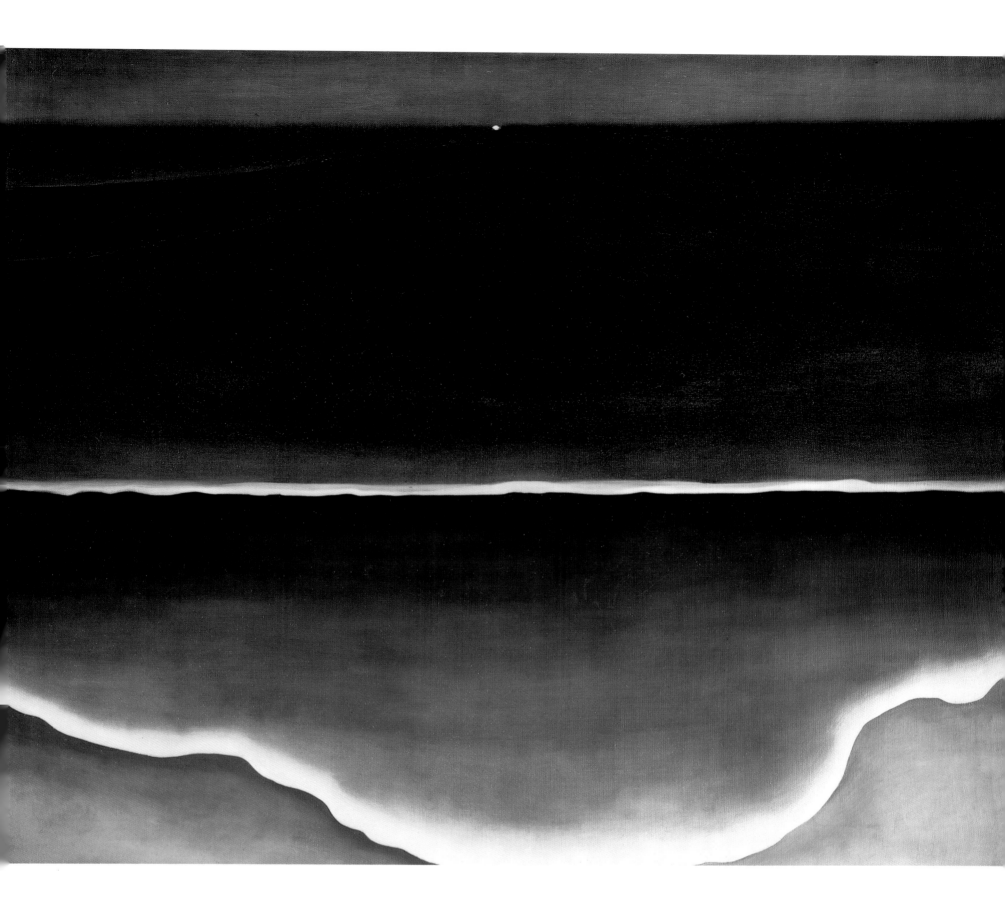

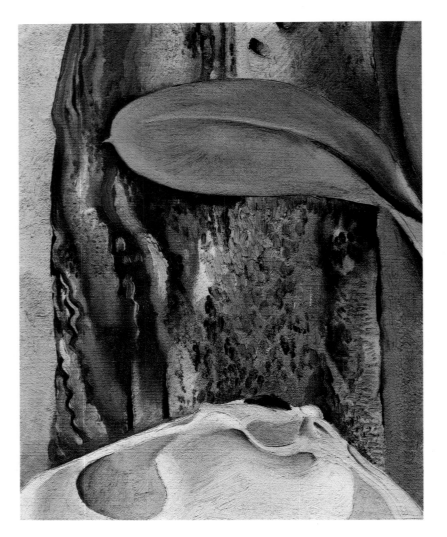

47 Shell and Old Shingle I, 1926. Oil on canvas, 9 x 7.

48 Shell and Old Shingle III, 1926. Oil on board, 11 x 6.

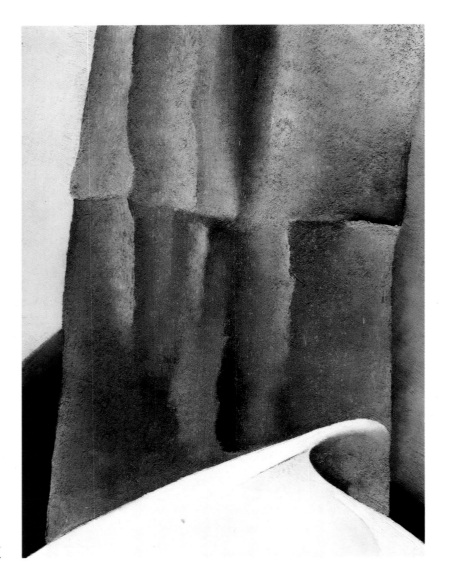

49 Shell and Old Shingle IV, 1926. Oil on canvas, 10 x 7.

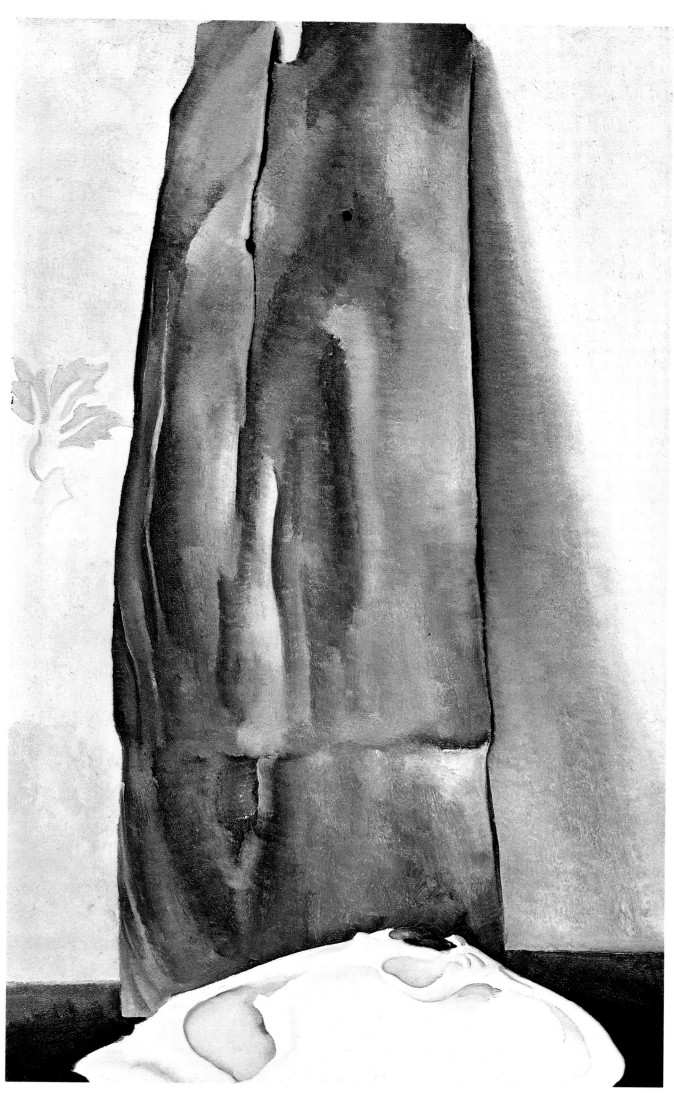

50 *Shell and Old Shingle II, 1926. Oil on canvas, 30 x 18.*

We were shingling the barn and the old shingles, taken off, were free to fly around. Absentmindedly I picked up a loose one and carried it into the house and up to the table in my room. On the table was a white clam shell brought from Maine in the spring. I had been painting it and it still lay there. The white shape of the shell and the grey shape of the weathered shingle were beautiful against the pale grey leaf on the faintly pink-lined pattern of the wallpaper. Adding the shingle got me painting again.

After the first realistic paintings I painted just a piece of the shingle and a piece of the shell. To a couple were added two quite large green leaves that were in a glass on the table. Finally I went back to the shingle and shell — large again — the shingle just a dark space that floated off the top of the painting, the shell just a simple white shape under it. They fascinated me so that I forgot what they were except that they were shapes together — singing shapes.

51 Shell and Old Shingle VI, 1926. Oil on canvas, 30 x 18.

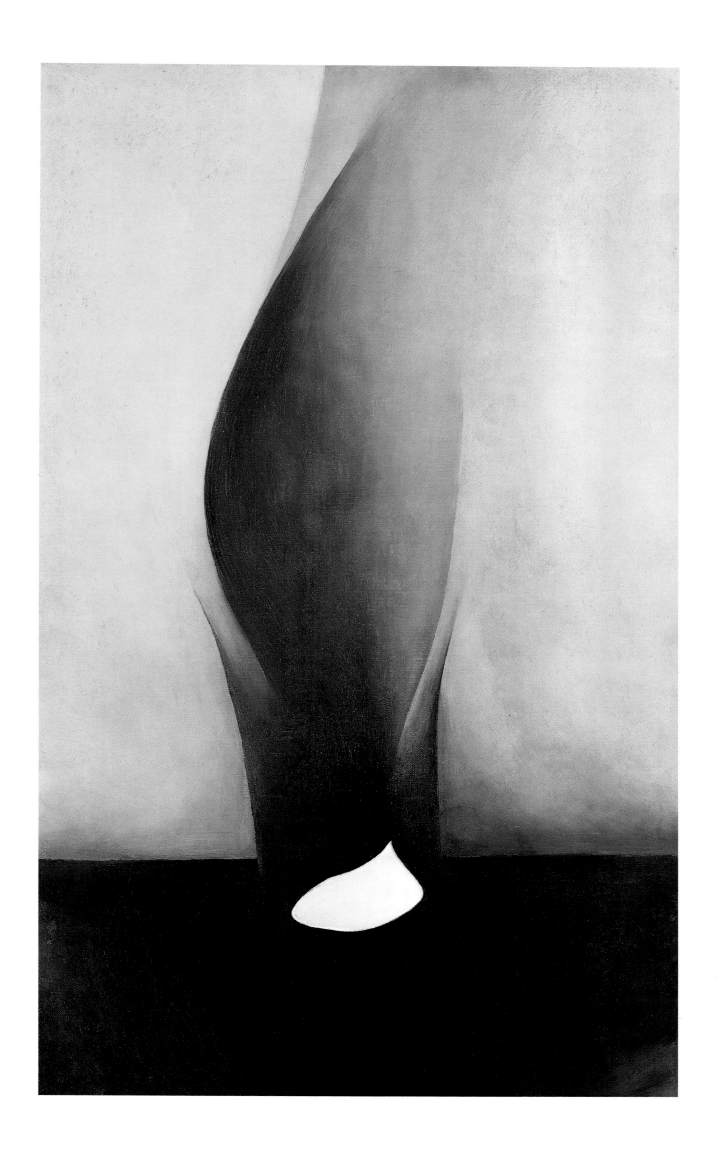

I find that I have painted my life—things happening in my life—without knowing. After painting the shell and shingle many times, I did a misty landscape of the mountain across the lake, and the mountain became the shape of the shingle—the mountain I saw out my window, the shingle on the table in my room. I did not notice that they were alike for a long time after they were painted.

52 Shell and Old Shingle VII (Last of Shell and Old Shingle Series), 1926. Oil on canvas, 21 x 32.

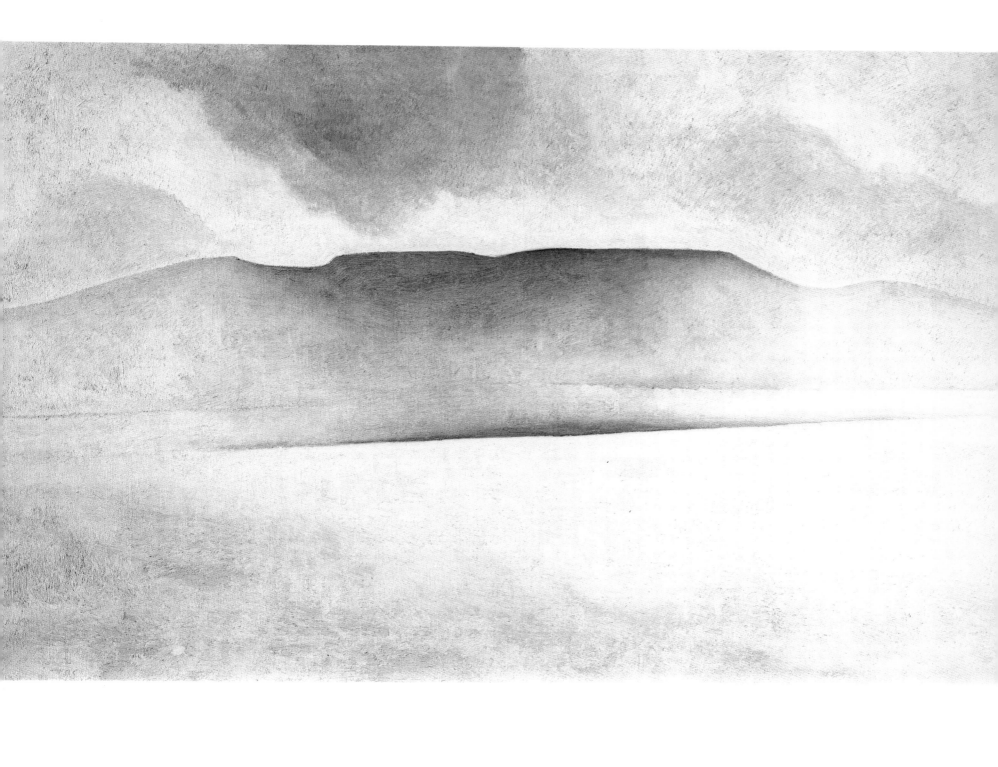

This was a message to a friend—if he saw it he didn't know it was to him and wouldn't have known what it said. And neither did I.

53 Black and White, 1930. Oil on canvas, 36 x 24.

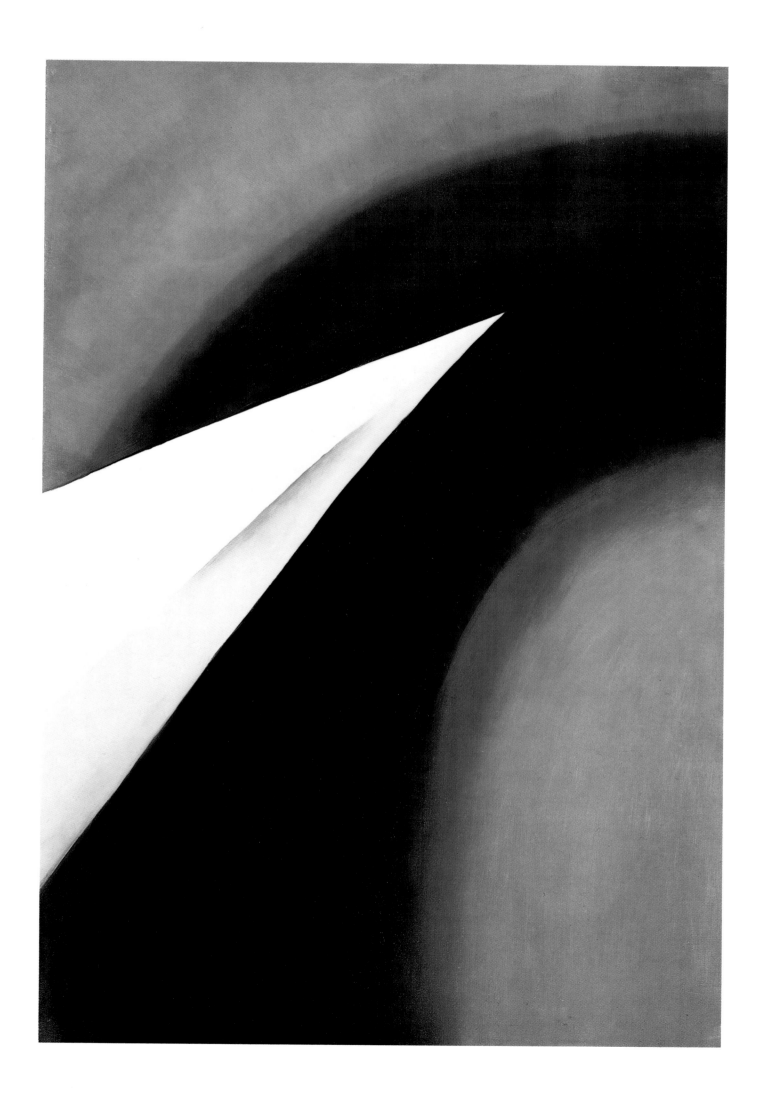

I was on a stretcher in a large room, two nurses hovering over me, a very large bright skylight above me. I had decided to be conscious as long as possible. I heard the doctor washing his hands. The skylight began to whirl and slowly become smaller and smaller in a black space. I lifted my right arm overhead and dropped it. As the skylight became a small white dot in a black room, I lifted my left arm over my head. As it started to drop and the white dot became very small, I was gone. A few weeks later all this became the "Black Abstraction."

54 Black Abstraction, 1927. Oil on canvas, 30 x 40.

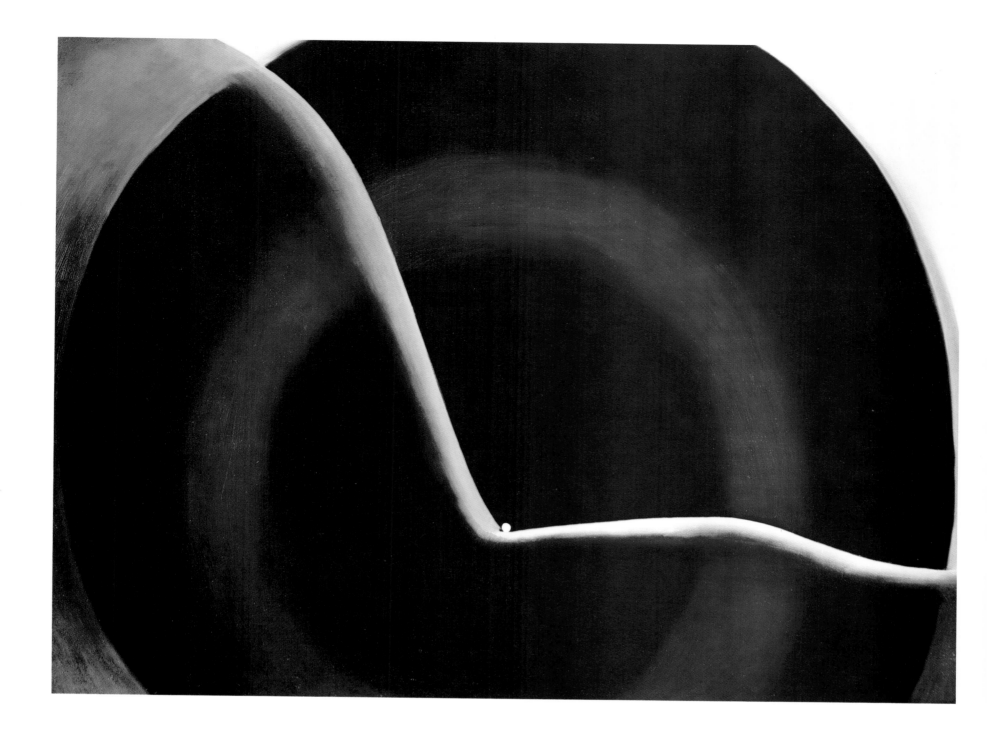

There are people who have made me see shapes—and others I thought of a great deal, even people I have loved, who make me see nothing. I have painted portraits that to me are almost photographic. I remember hesitating to show the paintings, they looked so real to me. But they have passed into the world as abstractions—no one seeing what they are.

55 *Green-Grey Abstraction, 1931. Oil on canvas, 36 x 24.*

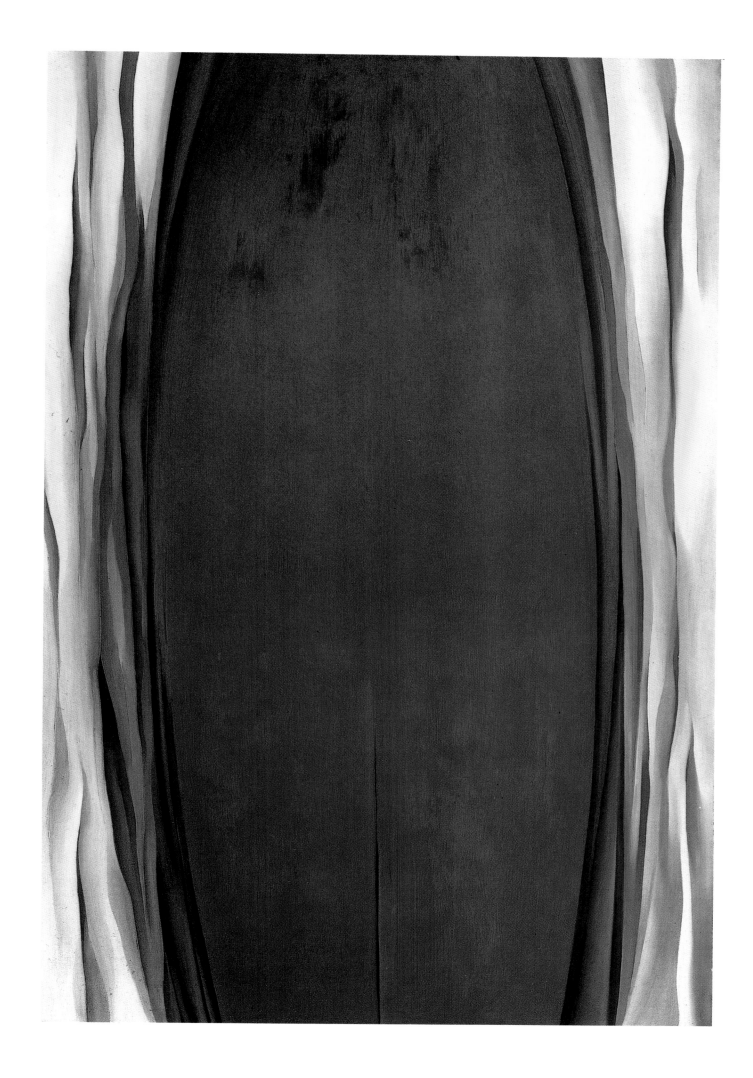

The summer of 1929 when I was at Mabel's at Taos, I had the house that D. H. Lawrence had the summer before he went to Italy. Mabel's house was much larger and a little higher and between the two was an alfalfa field like a large green saucer. On one side of the field was a path lined with flowers. I was usually in a hurry and I ran across the field, not thinking or knowing about snakes, but one day walking the path I picked a large blackish red hollyhock and some bright dark blue larkspur that immediately went into a painting—and then another painting.

56 Black Hollyhock, Blue Larkspur, 1930. Oil on canvas, 30 x 40.

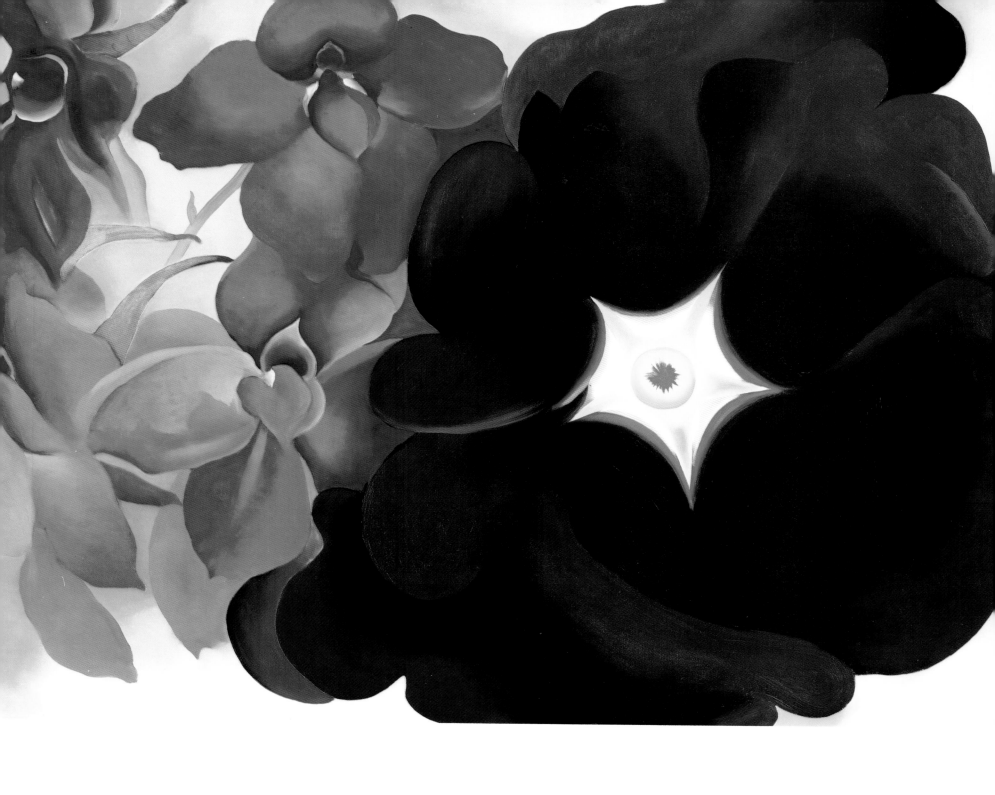

I spent several weeks up at the Lawrence ranch that summer. There was a long weathered carpenter's bench under the tall tree in front of the little old house that Lawrence had lived in there. I often lay on that bench looking up into the tree—past the trunk and up into the branches. It was particularly fine at night with the stars above the tree.

57 The Lawrence Tree, 1929. Oil on canvas, 30 x 40.

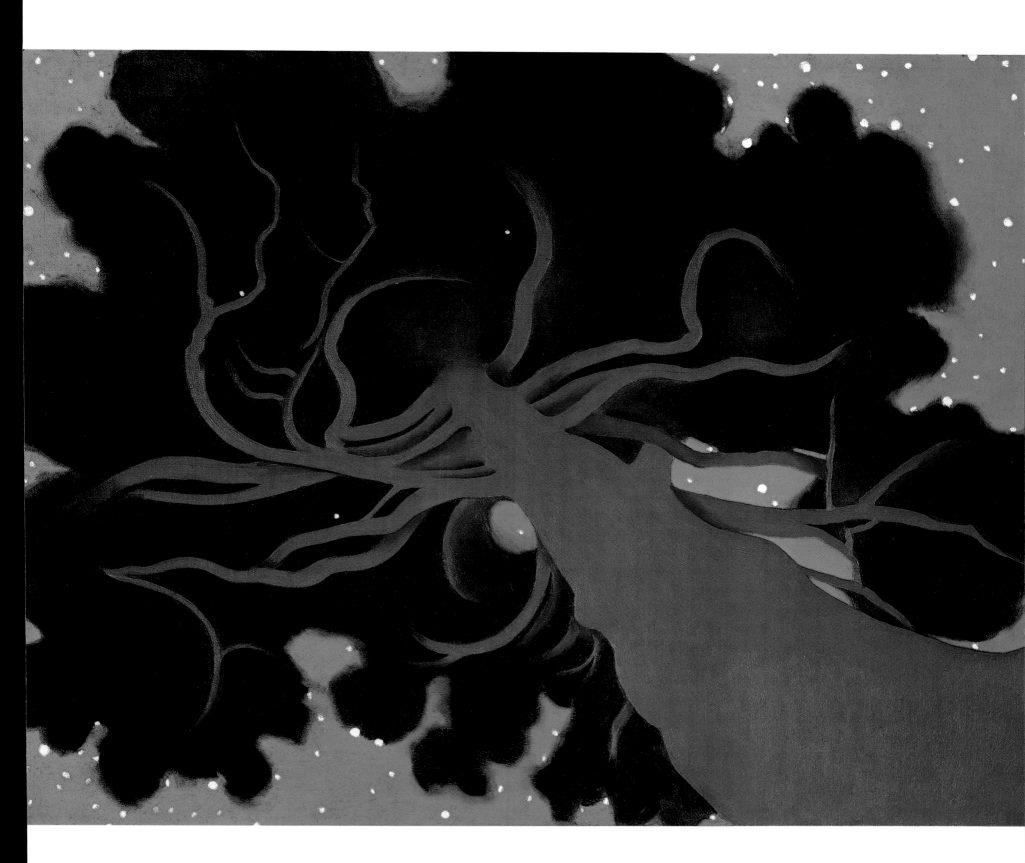

That first summer I spent in New Mexico I was a little surprised that there were so few flowers. There was no rain so the flowers didn't come. Bones were easy to find so I began collecting bones. When I was returning East I was bothered about my work—the country had been so wonderful that by comparison what I had done with it looked very poor to me—although I knew it had been one of my best painting years. I had to go home—what could I take with me of the country to keep me working on it? I had collected many bones and finally decided that the best thing I could do was to take with me a barrel of bones—so I took a barrel of bones.

When I arrived at Lake George I painted a horse's skull—then another horse's skull and then another horse's skull. After that came a cow's skull on blue. In my Amarillo days cows had been so much a part of the country I couldn't think of it without them. As I was working I thought of the city men I had been seeing in the East. They talked so often of writing the Great American Novel—the Great American Play—the Great American Poetry. I am not sure that they aspired to the Great American Painting. Cézanne was so much in the air that I think the Great American Painting didn't even seem a possible dream. I knew the middle of the country—knew quite a bit of the South—I knew the cattle country—and I knew that our country was lush and rich. I had driven across the country many times. I was quite excited over our country and I knew that at that time almost any one of those great minds would have been living in Europe if it had been possible for them. They didn't even want to live in New York—how was the Great American Thing going to happen? So as I painted along on my cow's skull on blue I thought to myself, "I'll make it an American painting. They will not think it great with the red stripes down the sides—Red, White and Blue—but they will notice it."

58 Cow's Skull—Red, White and Blue, 1931. Oil on canvas, 40 x 36.

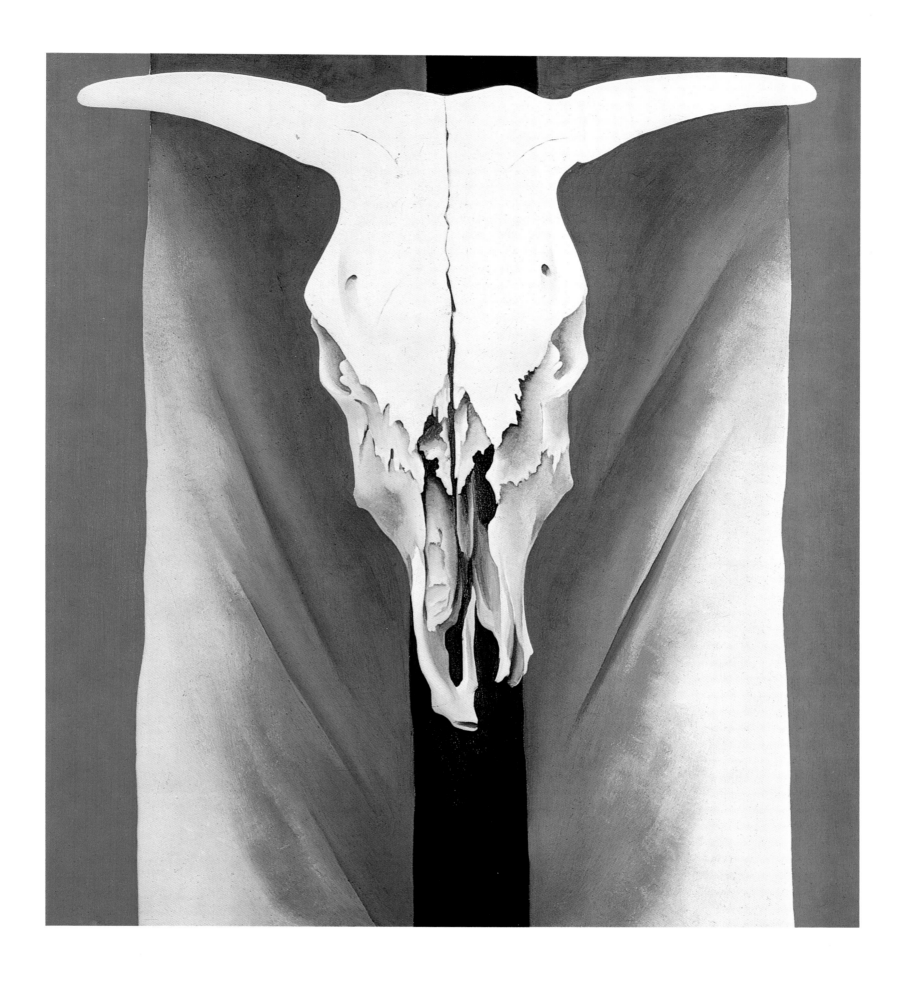

I must have seen the Black Place first driving past on a trip into the Navajo country and, having seen it, I had to go back to paint—even in the heat of mid-summer. It became one of my favorite places to work.

I had a Model A Ford. It was the easiest car I ever had to work in. The windows were high so there was plenty of light. I could take out the right-hand front seat, unbolt the driver's seat, turn it around and sit there to paint with a canvas on the back seats. I could work on a canvas as large as 30" x 40". It was very good until about four in the afternoon when the bees were going home and thought it a good place to settle. Then the windows had to be closed and it was really hot.

The Black Place is about one hundred and fifty miles from Ghost Ranch and as you come to it over a hill, it looks like a mile of elephants—grey hills all about the same size with almost white sand at their feet. When you get into the hills you find that all the surfaces are evenly crackled so walking and climbing are easy.

I don't remember what I painted on my first trip over there. I have gone so many times. I always went prepared to camp. There was a fine little spot quite far off the road with thick old cedar trees with handsome trunks—not very tall but making good spots of shade.

Once a friend and I started in the open car at eleven o'clock on a cold clear night. As we drove we saw a bear by the side of the road in the

59 Grey Hills II, 1936. Oil on canvas, 16 x 30.

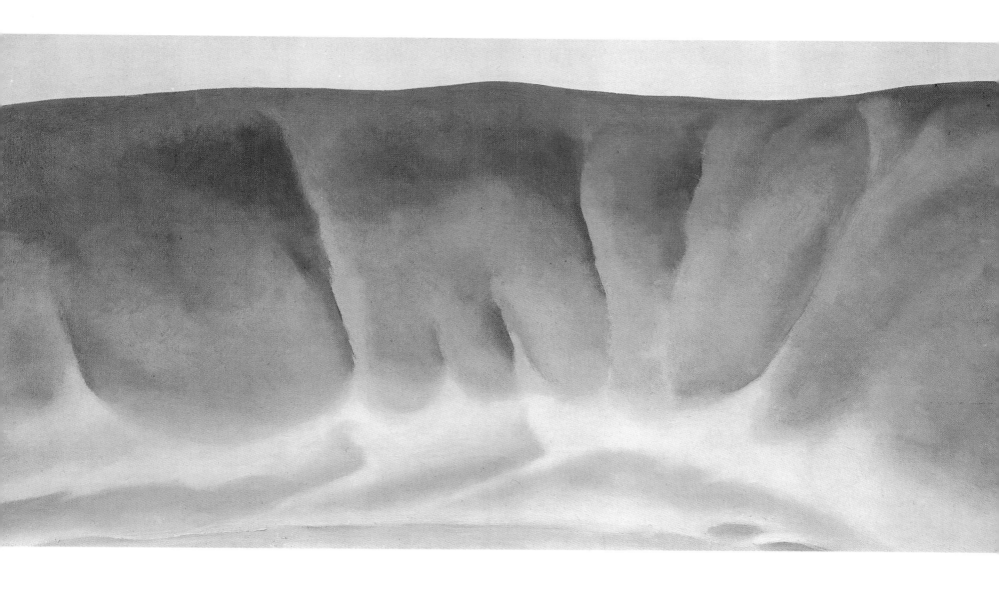

moonlight. We had to sweep the snow off the frozen ground to put down our sleeping bags and we had a very uncomfortable night. You can be much colder from the ground than the air so Maria kept a fire burning all the next day to warm the earth where we intended to sleep. That was the only time I stood on a rug and wore gloves to paint.

We had twenty pounds of very good tender venison. At night we kept the venison on top of the car for fear animals might get it. In the daytime we put it under the car to keep it frozen. We ate our supper at sunset—it was too cold later—venison with a piece of bacon around it, each cooking her own piece on a long-handled toaster over a cedar fire. We were in bed by the time it was dark.

Another time we went on a warm still night. We were very comfortable in a new tent. I was up before the sun and out early to work. Such a beautiful, untouched lonely-feeling place—part of what I call the Far Away. It was a fine morning, sunny and clear, but soon the wind began to blow and it blew hard all day. I went on working. When I was ready to stop, there were clouds everywhere. I had intended to pick up our camp and drive up a riverbed farther into the hills to a place where I wanted to work the next day, but it was the sort of place you do not go into unless the weather is clear.

60 *The Grey Hills, 1942. Oil on canvas, 24 x 36.*

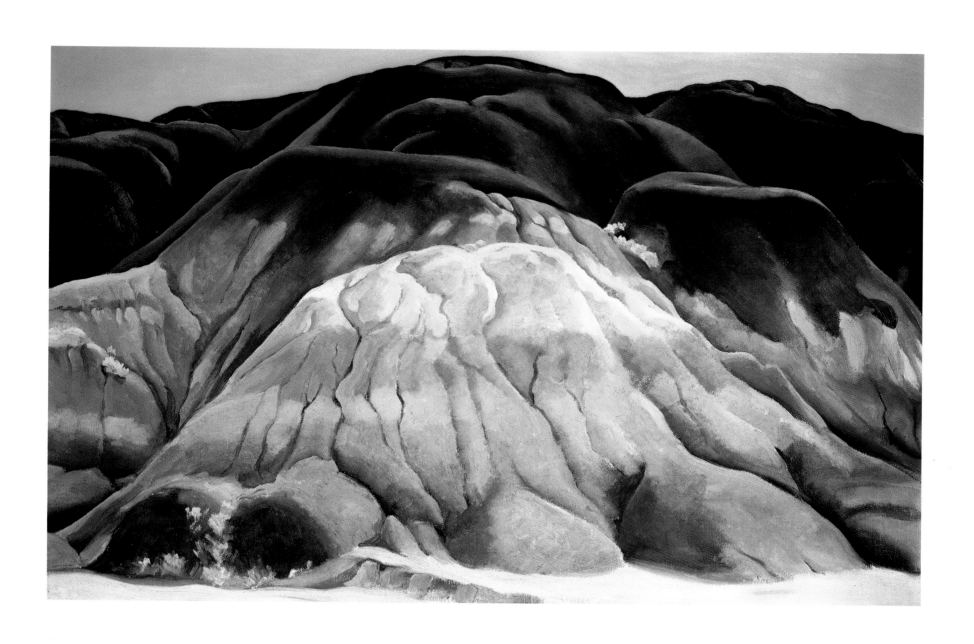

We finally decided to pack up and camp at a spot where we had camped before. Then, weather permitting, I would walk into the place I wanted to paint next day. I wanted so much to stay. Banks of clouds all 'round made me know I was foolish not to go home, but it would mean driving late into the night and seeing very little. So we pitched the new camp behind an odd little hill right by the road. We ate oatmeal for supper and went to bed. Maria read awhile aloud. "Taras Bulba" was fine in the country out there.

In the night I was waked by a mad wind flapping the tent and shaking my bed. Down went one corner of the tent so we got up and tied it to the car. We put all our clothes in the car to be sure they would be dry—the cat was already in the car as we had heard coyotes and were afraid they might get her. We went to sleep again and were waked by rain on the roof of the tent— a little at first, then hard. It poured and it blew—all night the tent rattled and flapped. I was expecting the tent to fall in a heap on us but only one corner went down over my head. I propped it up with a chair and went out to look around. It was a pale dawn, as dismal as anything I've ever seen— everything grey; grey sage, grey wet sand underfoot, grey hills, big gloomy-looking clouds, a very pale moon—and still the wind....

Breakfast was very funny. The wind blew so hard we could only fill our cups half full of coffee. It would just blow away right out of the cups. So we packed up and went home—most of the hundred miles sliding all over the road in the mud.

There were probably twelve or fifteen paintings of the Black Place and I finally painted it from memory—red and later green.

61 Black Place III, 1944. Oil on canvas, 36 x 40.

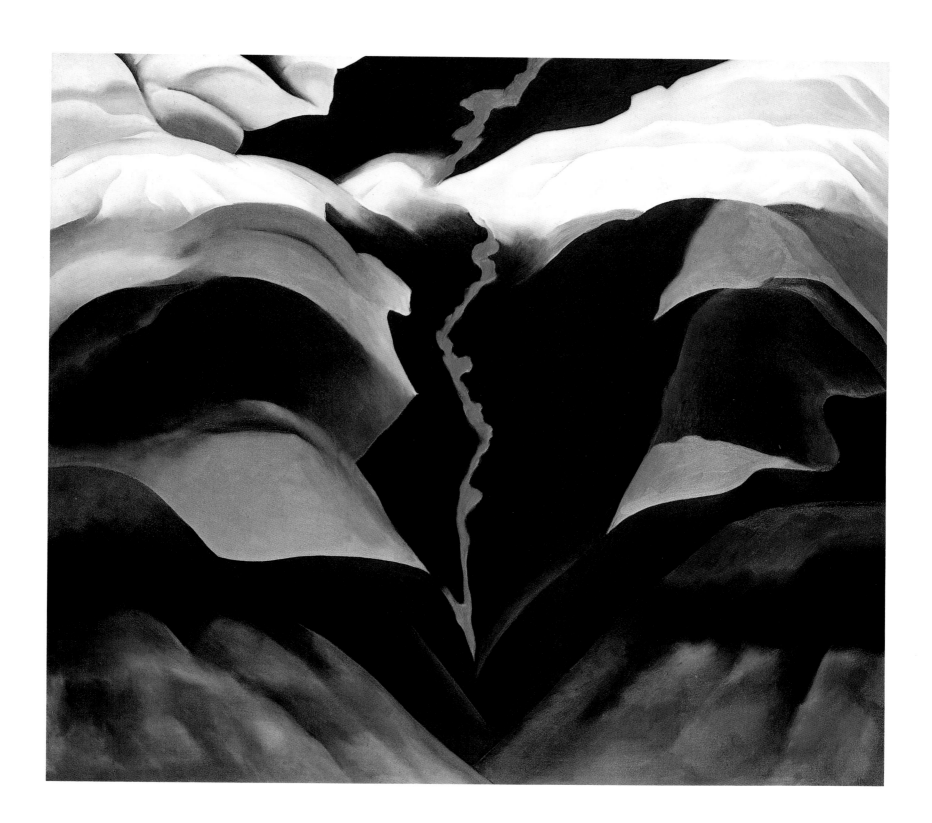

62 *A Fragment of the Ranchos de Taos Church, 1929. Oil on canvas-covered board, 15 x 11.*

The Ranchos de Taos Church is one of the most beautiful buildings left in the United States by the early Spaniards. Most artists who spend any time in Taos have to paint it, I suppose, just as they have to paint a self-portrait. I had to paint it—the back of it several times, the front once. I finally painted a part of the back thinking that with that piece of the back I said all I needed to say about the church. I often painted fragments of things because it seemed to make my statement as well as or better than the whole could. And I long ago came to the conclusion that even if I could put down accurately the thing that I saw and enjoyed, it would not give the observer the kind of feeling it gave me. I had to create an equivalent for what I felt about what I was looking at—not copy it. I was quite pleased with the painted fragment of the Ranchos Church.

63 *Ranchos Church, 1930. Oil on canvas, 24 x 36.*

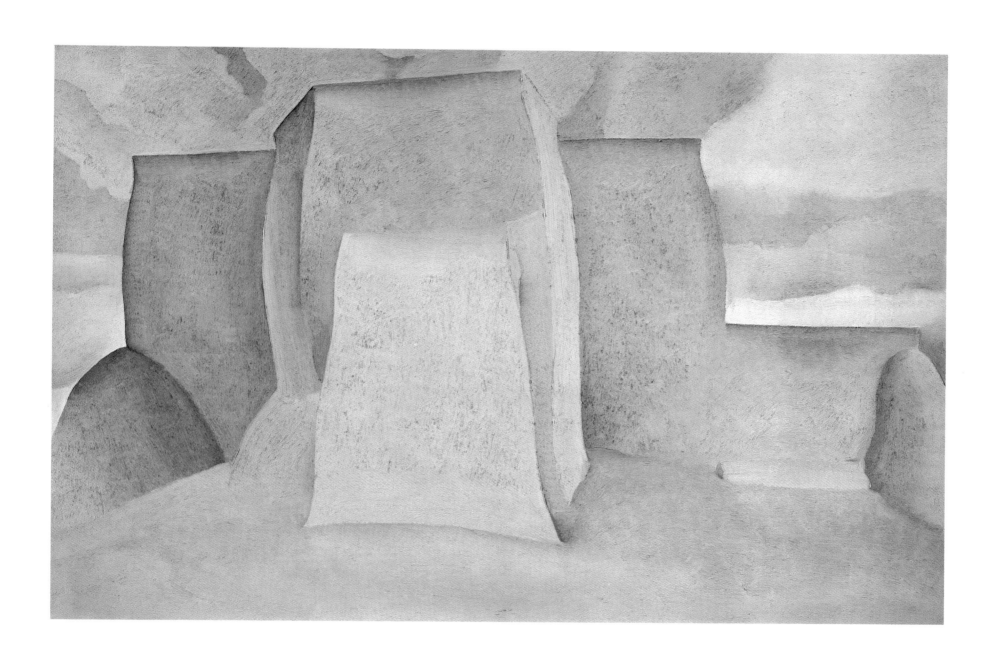

I saw the crosses so often—and often in unexpected places—like a thin dark veil of the Catholic Church spread over the New Mexico landscape.

One evening when I was living in Taos we walked back of the morada toward a cross in the hills. I was told that it was a Penitente cross but that meant little to me at the time. The cross was large enough to crucify a man, with two small crosses—one on either side. It was in the late light and the cross stood out—dark against the evening sky. If I turned a little to the left, away from the cross, I saw the Taos mountain—a beautiful shape. I painted the cross against the mountain although I never saw it that way. I painted it with a red sky and I painted it with a blue sky and stars.

I painted a light cross that I often saw on the road near Alcalde. I looked for it recently but it is not there. I also painted a cross I saw at sunset against the hills near Cameron—hills that look small until you see telephone poles like toothpicks going up and down and you know they are high. The hills are grey—all the same size and shape with once in a while a hot-colored brown hill. That cross was big and strong, put together with wooden pegs. For me, painting the crosses was a way of painting the country.

Once a friend and I drove up the Saint Lawrence River to the Gaspé. After we left Quebec the country became very interesting—farming land with well-to-do Victorian houses usually a miserable dingy color but with beautifully simple long, low barns painted white. The roofs of the barns were sometimes shingled but most of them had black tar paper that often reflected the blue of the sky. Sometimes the roofs were dark red. Almost every house had the skin of a bear killed the year before tacked up on the wall. The people thought walking very dangerous because of the bears but we took a walk almost every day. Quite often a deer would jump down and cross the road but we never saw a bear.

64 Black Cross, New Mexico, 1929. Oil on canvas, 39 x 30.

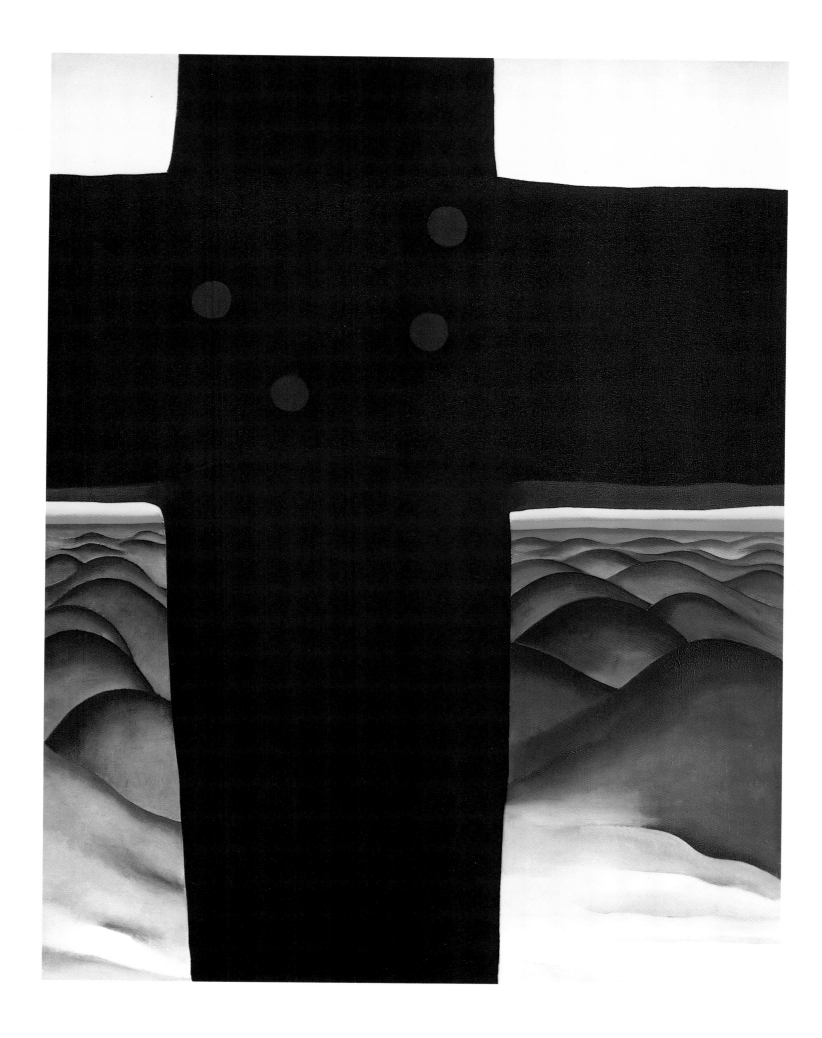

It was hard to find places to sleep and eat. I only remember one motel and it was poor. The sheets on the beds were new unbleached muslin—not ironed and very scratchy.

Once we stopped for a time at a house that had a motel sign at the gate. Everywhere the women and girls in this French area put on hats when they got up in the morning and wore them all day, but at this house the mother was quite unusual and did not wear a hat. The kitchen was the principal room of the house. On one side it had a fine stove with very fancy trimmings. On the other side was a long line of rocking chairs with a spittoon between each two. At one end—over a cupboard—was a long high board for cutting bread and there was usually a loaf with a woodchuck tied and snuggled up beside it. One wondered—but ate the good homemade bread when it came to the table.

The men of the house were fishermen and were usually gone for several days at a time. When they returned we would have a very fine meal— vegetables and lettuce from the garden along with the fish—and always pie. Food left from this meal was put on shelves under the steps that went upstairs and given to us for the next meal—everything from fish to pie. The meal after that was again what was left until all was gone. Then we had spaghetti or beans out of a can or home-canned moose meat that was very good—so good that we brought several cans home. It was the only place where we had enough to eat.

I had painted a cross and a barn before we got to this place. We painted barns there and barns further along. I can remember five paintings of barns that rather pleased me and a great many others that didn't. We went home soon after we left there because we couldn't paint when we were hungry and tired all the time.

65 Stables, 1932. Oil on canvas, 12 x 32.

66 White Canadian Barn II, 1932. Oil on canvas, 12 x 30.

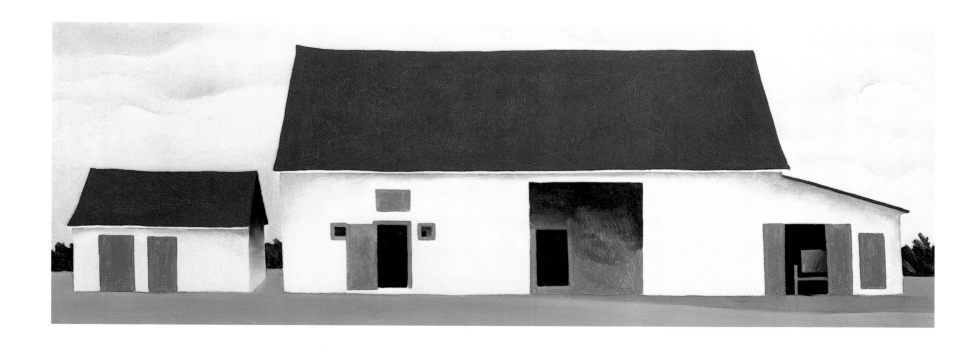

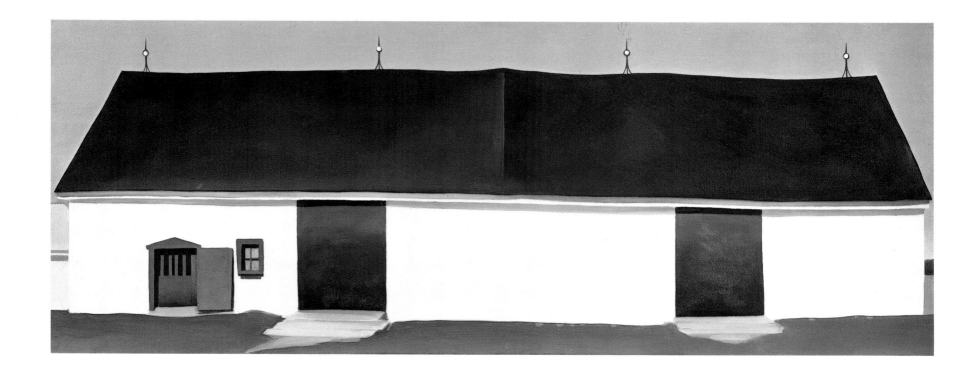

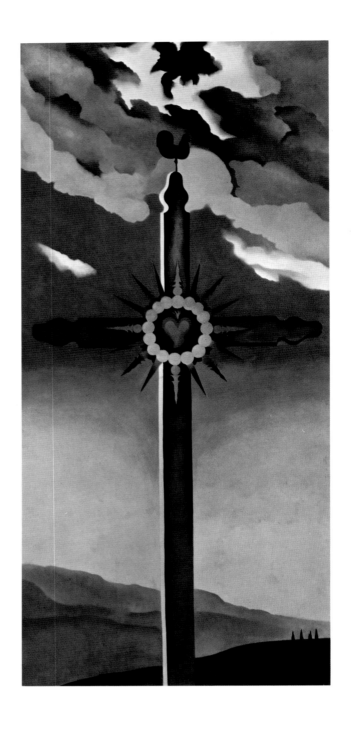

After my summers in New Mexico where I had heard the Penitente songs and painted the dark crosses as I felt them there, the Canadian crosses seemed very different. The Canadian crosses were singing in the sunlight. Sometimes there were pottery figures around them—always they had a feeling of gaiety.

There was one pure stark cross in the center of a profusely blooming potato field overlooking the water where the river was very wide. Each end of the cross was carved and there was a plaque in memory of a father who had drowned trying to save someone else who was drowning at sea.

67 *Cross with Red Heart, 1932. Oil on canvas, 84 x 40.*

68 *Cross by the Sea, Canada, 1932. Oil on canvas, 36 x 24.*

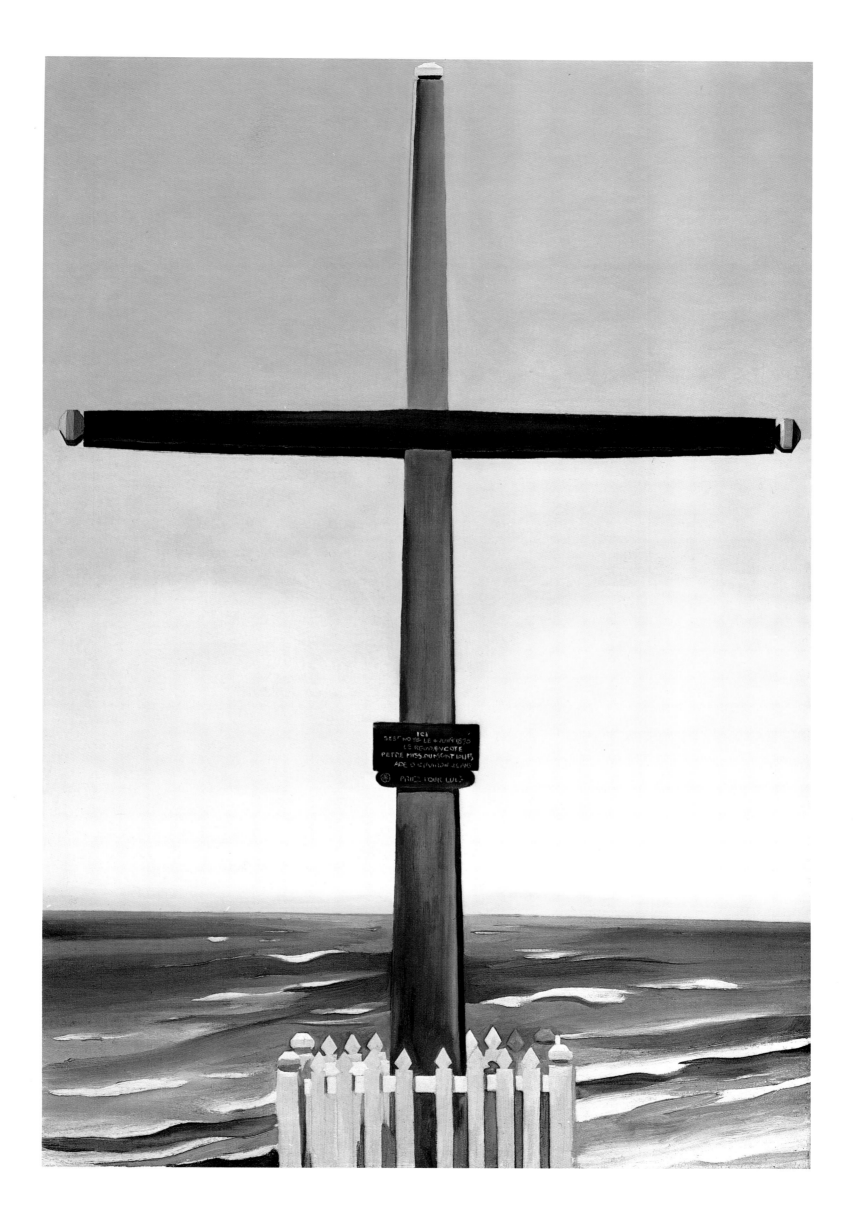

As we drove around a high hedge near the Laurentian hills we saw a tall cross with a red heart carved and painted in the center of it surrounded by twelve sharp carved pieces of wood about a foot long. Each end of the cross had a three-lobed club shape carved on it—a copper rooster weathervane on top of it—gay spring flowers at the foot of it—wild clouds racing over it—a white picket fence around it.

About thirty miles north of where I live in New Mexico is a small village called Cebolla, with sharply pitched, rusted tin roofs. The village has more snow in winter than the lower areas and does not have the usual flat-roofed adobes. The county is one of the poorest areas in the United States and the life of the people is difficult.

After I had been in Canada painting the wide white barns along the Saint Lawrence river, I thought how different the life of the Canadian farmer was from life in Cebolla. So I painted the Cebolla church which is so typical of that difficult life. I have always thought it one of my very good paintings, though its message is not as pleasant as many of the others.

69 Cebolla Church, 1945. Oil on canvas, 20 x 36.

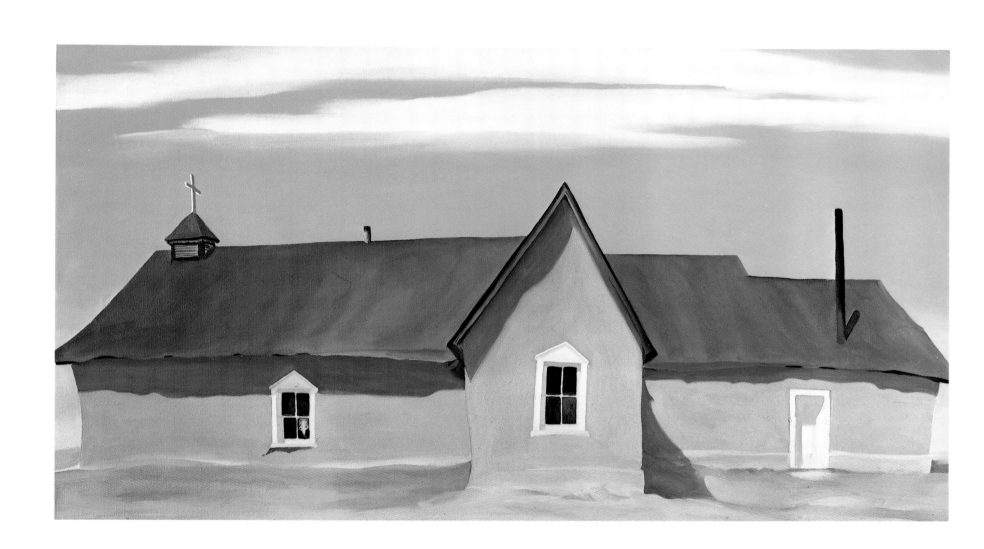

The rows of little hills under the Ram's Head at Ghost Ranch must have been formed by thousands of years of erosion by wind and rain. The hills look soft and gentle but they are so steep and stubborn that there are only a few places where you can climb up or down, usually on the old cattle trails. They seem small because the cliff that they washed from is so high and the distance they are washing away to is so wide. The trees on those hills are very old. They are really small trees — very dry and stiff and prickly.

I had looked out on the hills for weeks and painted them again and again — had climbed and ridden over them — so beautifully soft, so difficult. (Sometimes I pulled the horse, sometimes the horse pulled me.) I had painted those hills from the car in bright sunlight and had failed dismally but I could see them — farther away — from my window in the rain. So I tried again. They seemed right with the Ram's Head.

I don't remember where I picked up the head — or the hollyhock. Flowers were planted among the vegetables in the garden between the house and the hills and I probably picked the hollyhock one day as I walked past. My paintings sometimes grow by pieces from what is around.

70 Ram's Head with Hollyhock, 1935. Oil on canvas, 30 x 36.

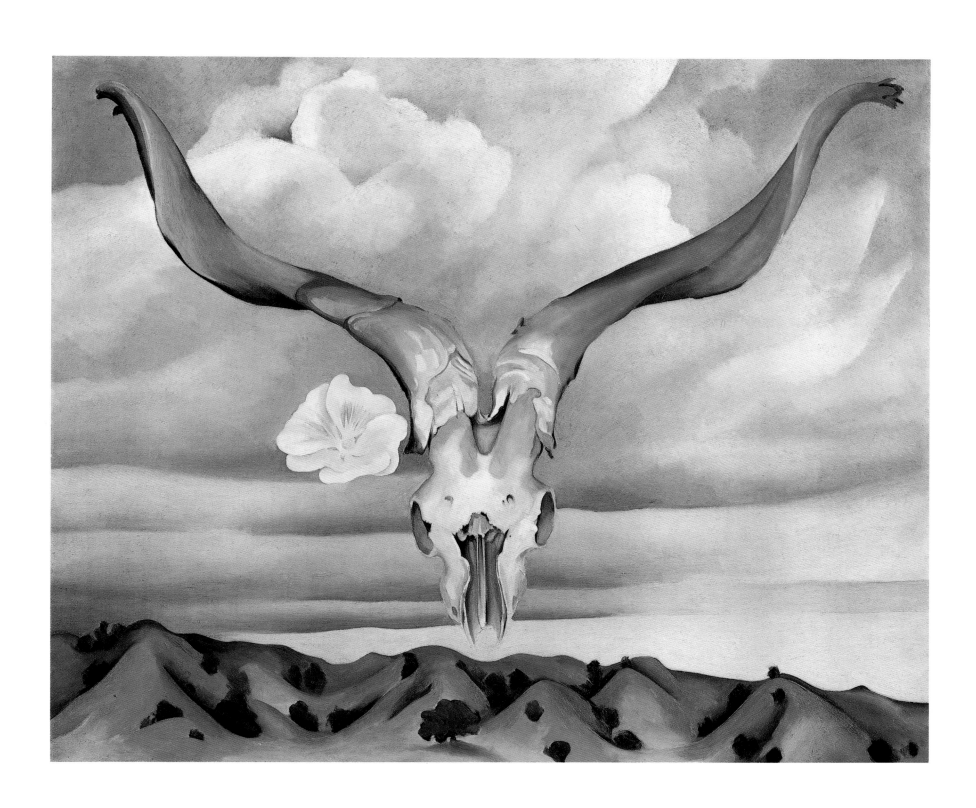

"I have picked flowers where I found them—have picked up sea shells and rocks and pieces of wood where there were sea shells and rocks and pieces of wood that I liked.... When I found the beautiful white bones on the desert I picked them up and took them home too.... I have used these things to say what is to me the wideness and wonder of the world as I live in it.

71 *Summer Days, 1936. Oil on canvas, 36 x 30.*

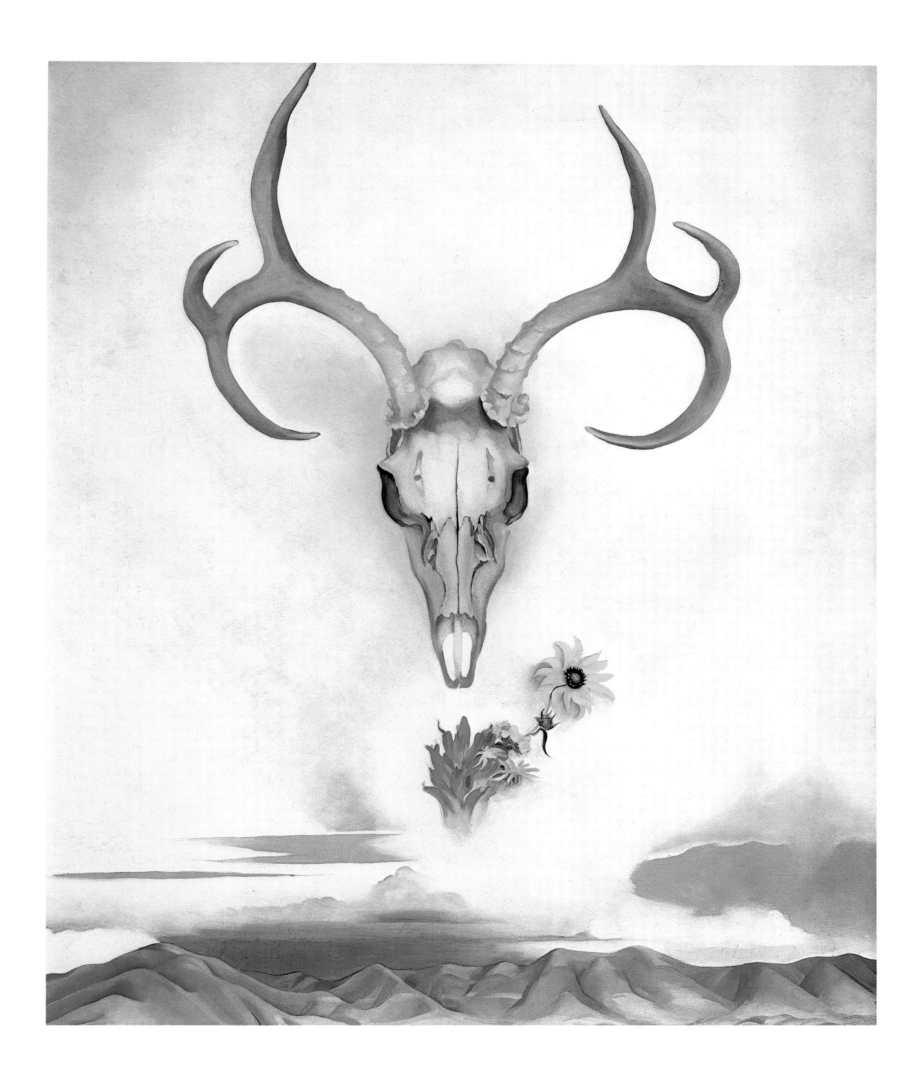

72 From the Faraway Nearby, 1937. Oil on canvas, 36 x 40.

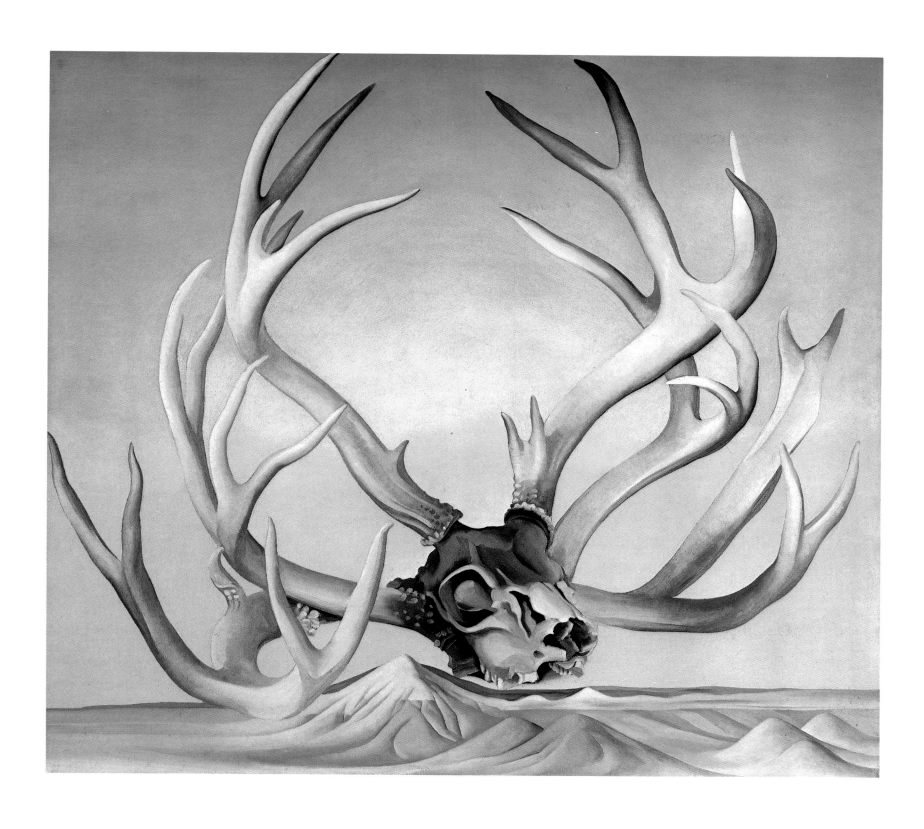

*"A pelvis bone has always been useful to any animal that has it—
quite as useful as a head, I suppose. For years in the country the pelvis
bones lay about the house indoors and out seen and not seen as such things
can be—seen in many different ways. I do not remember picking up the
first one but I remember from when I first noticed them always knowing I
would one day be painting them.*

73 Pelvis with Moon, 1943. Oil on canvas, 30 x 24.

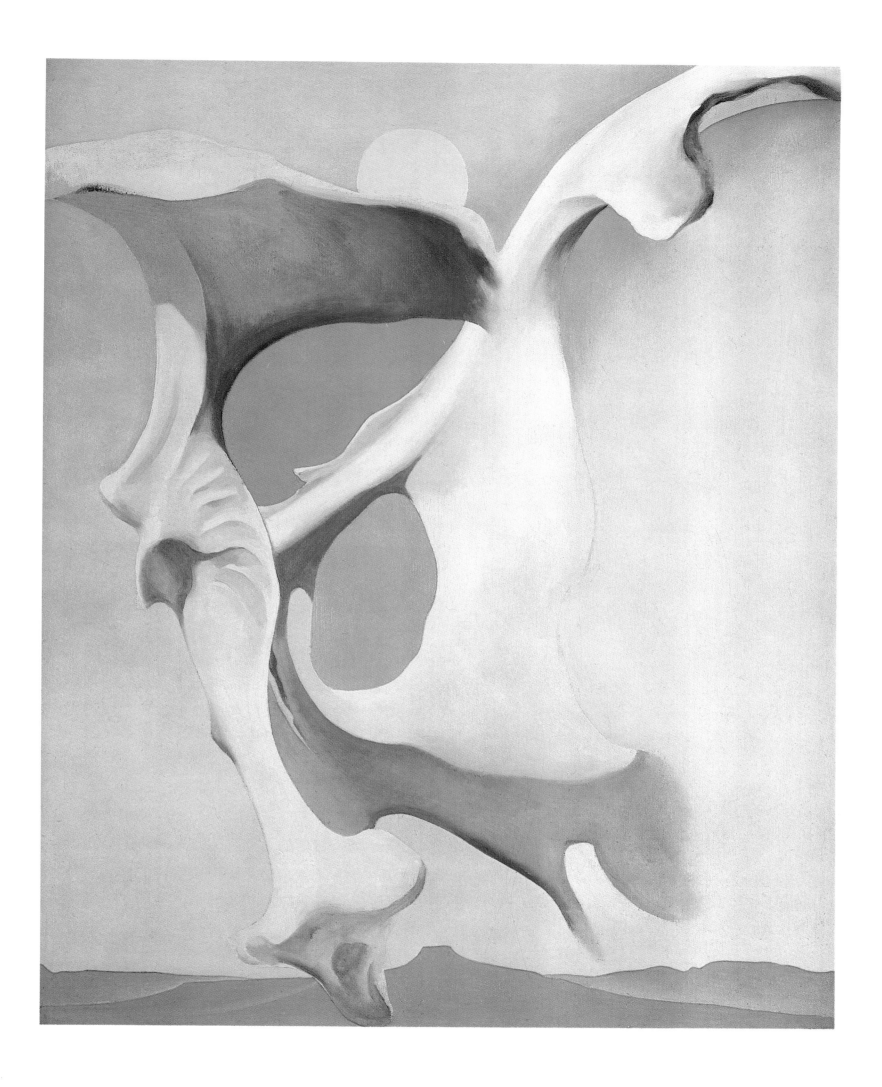

"I was the sort of child that ate around the raisin on the cookie and ate around the hole in the doughnut saving either the raisin or the hole for the last and best.

"So probably—not having changed much—when I started painting the pelvis bones I was most interested in the holes in the bones—what I saw through them—particularly the blue from holding them up in the sun against the sky as one is apt to do when one seems to have more sky than earth in one's world.... They were most wonderful against the Blue—that Blue that will always be there as it is now after all man's destruction is finished."

(Exhibition catalogue, An American Place, 1944.)

74 Pelvis III, 1944. Oil on canvas, 48 x 40.

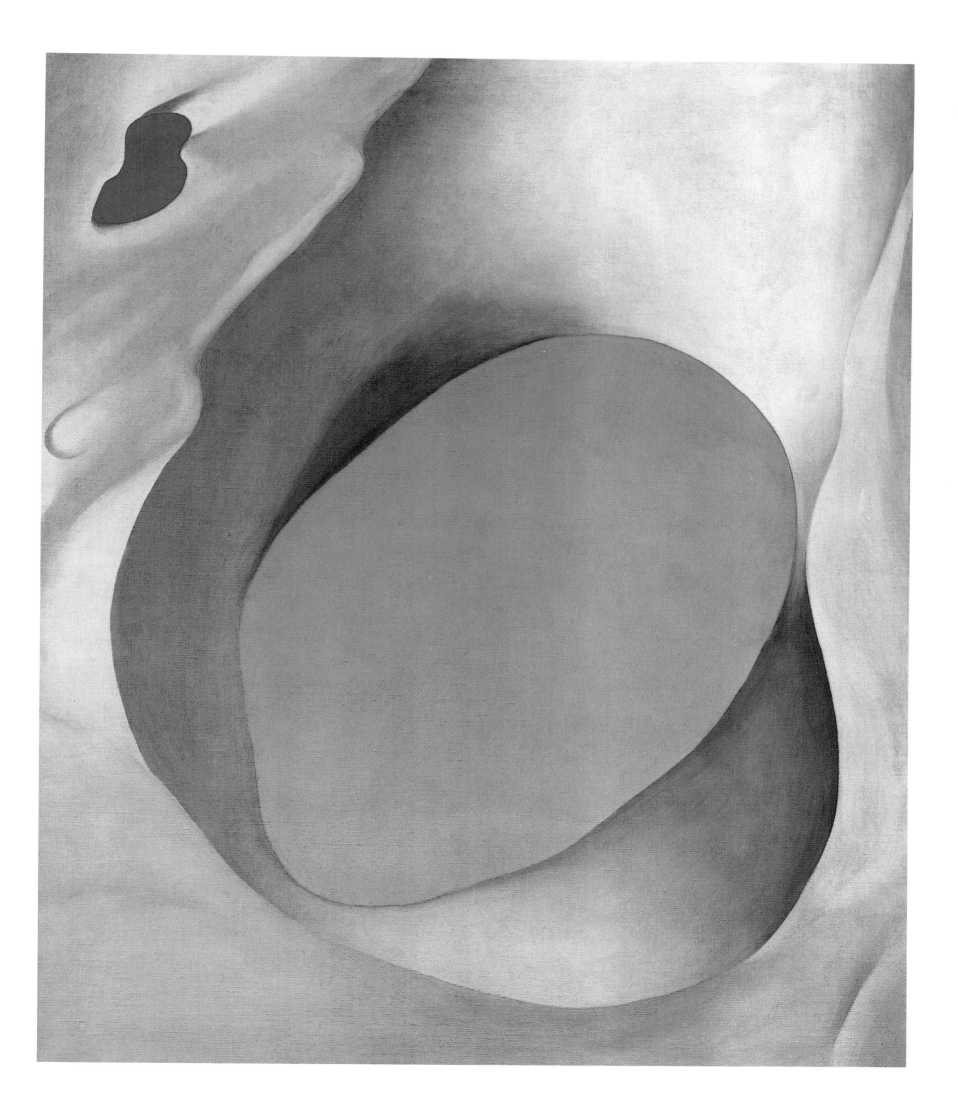

75 Pelvis Series, Red with Yellow, 1945. Oil on canvas, 36 x 48.

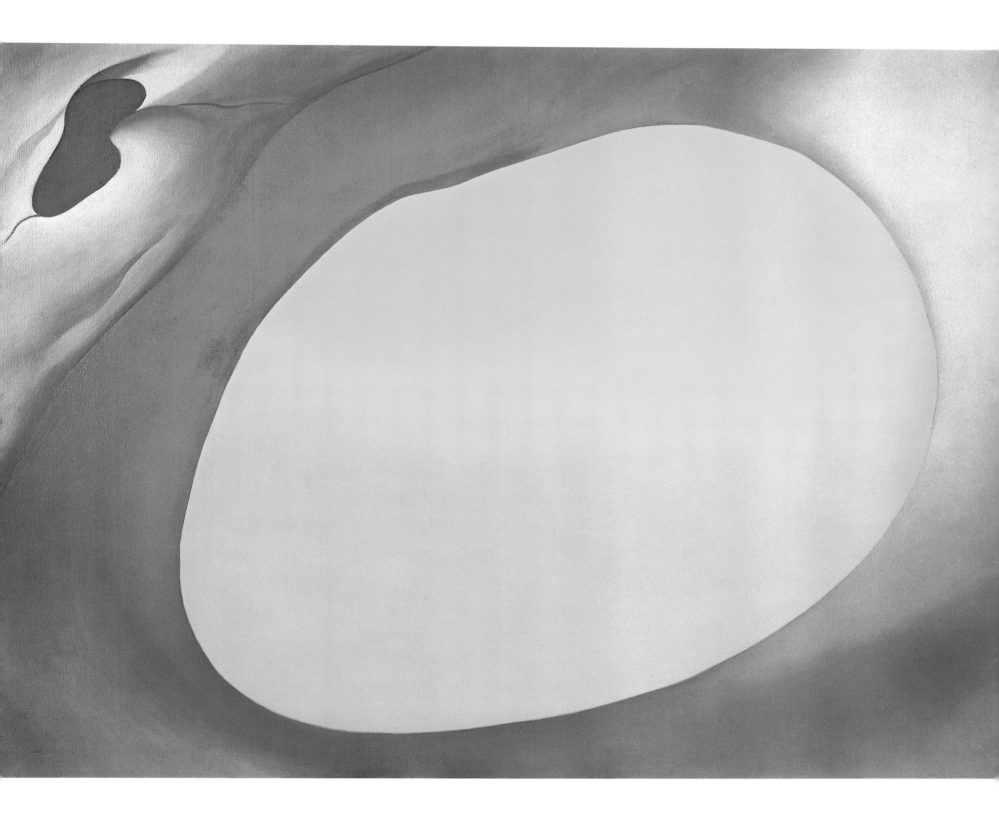

When I was small and went to visit my O'Keeffe grandmother, I sometimes got into the parlor by myself and would take a shell from the "whatnot," a set of fancy shelves between two windows. The shelves held many things I was not to touch but when I got in there alone I would take a shell from the whatnot and hold it close to my ear. I had been told that the sound I heard was the sound of the sea—I had not heard the sea at that time but it was wonderful to me to listen to it in the shell. So when I grew up and went where there were shells I was always looking for them.

The summer I spent in Taos I sometimes rode out to the eastern hills late in the afternoon with the sun at my back. No one else seemed to go there. When the sun went down and was not shining in my eyes I would ride back to the Pueblo. The plain was covered with the grey sage that in a few places crept up a bit against the base of the mountains, looking like waves lapping against the shore. It was a wide wide quiet area. But out in those hills I picked up mussel shells in groups all turned to stone—probably millions of years old. They sometimes even had a little bit of the original blue color. I carried them back and left them somewhere in the unknown. I haven't seen any more shells like them and haven't seen a sea of sage like that either.

76 *Shell on Red, 1931. Oil on canvas, 40 x 30.*

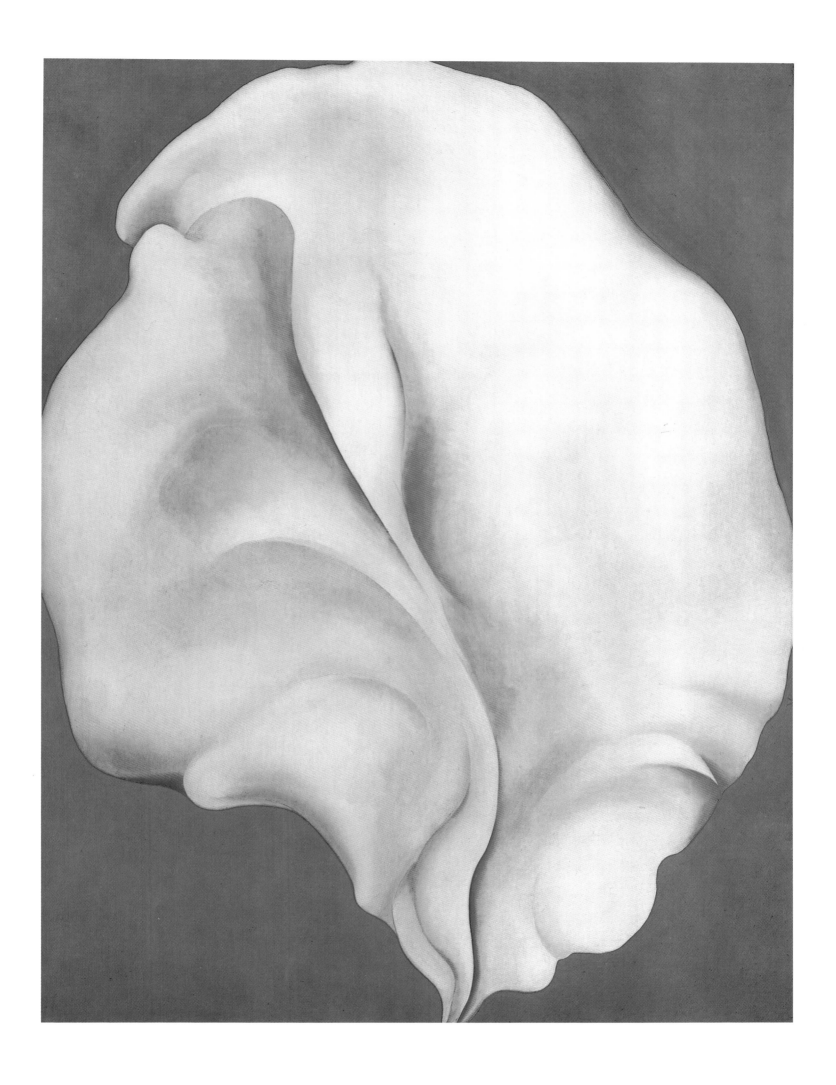

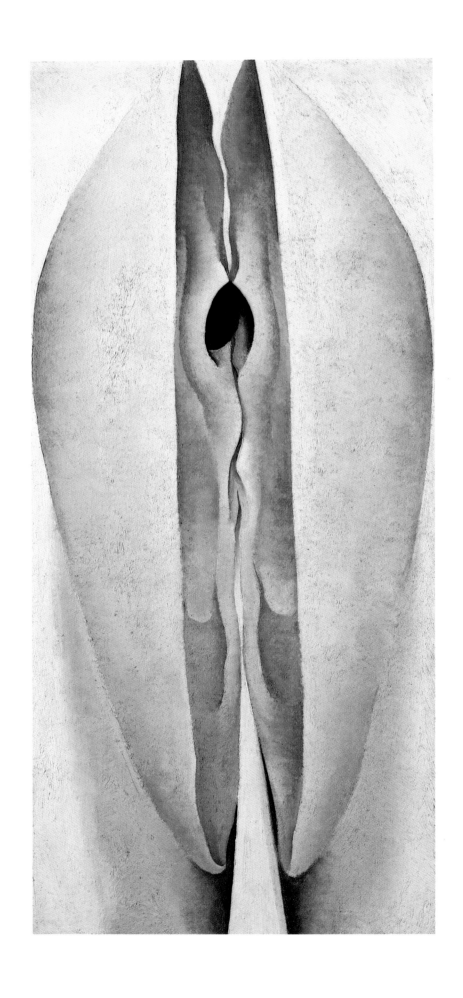

77 Open Clam Shell, 1926. Oil on canvas, 20 x 9.

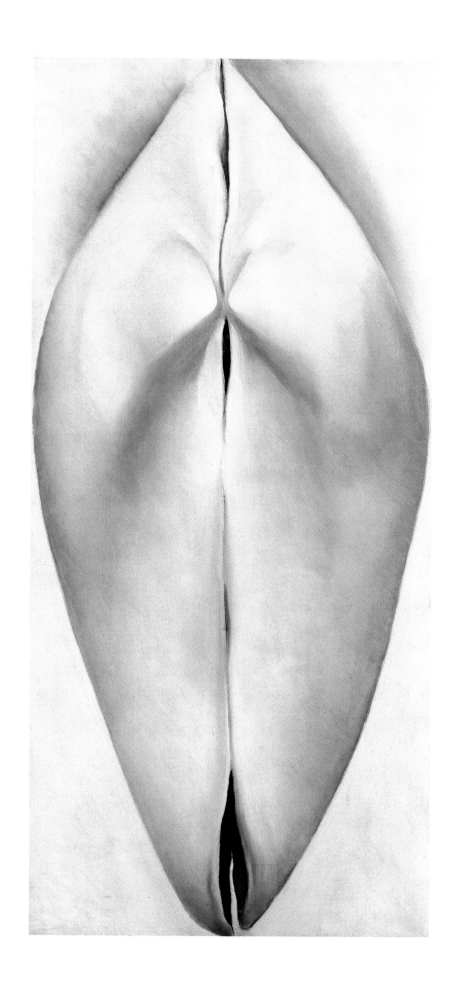

78 Closed Clam Shell, 1926. Oil on canvas, 20 x 9.

I have picked up shells along the coast of Maine—farther south, in the Bermudas and Bahamas I found conch shells along the pure sandy beaches. Then when I was in Yucatán out on the beach from Mérida there were very fine bleached white shells in the undergrowth where the water must have washed them up. I remember leaving a piece of red coral on a beach that I went to by boat in Hawaii. I have always regretted that I forgot to go back and pick up that piece of red coral.

Years later when I was living in Abiquiu I built a large table top covered with glass for my shells—I got them out of the boxes into the daylight under the piece of glass. Each shell was a beautiful world in itself, but I was surprised to find that the shells did not fit in with the adobe house. I gave most of them away as time went by, but among the many different things sent to me by people I don't know are again some wonderful shells. I have always enjoyed painting them—and even now, living in the desert, the sea comes back to me when I hold one to my ear.

79 Shell I, 1928. Oil on canvas, 7 x 7.

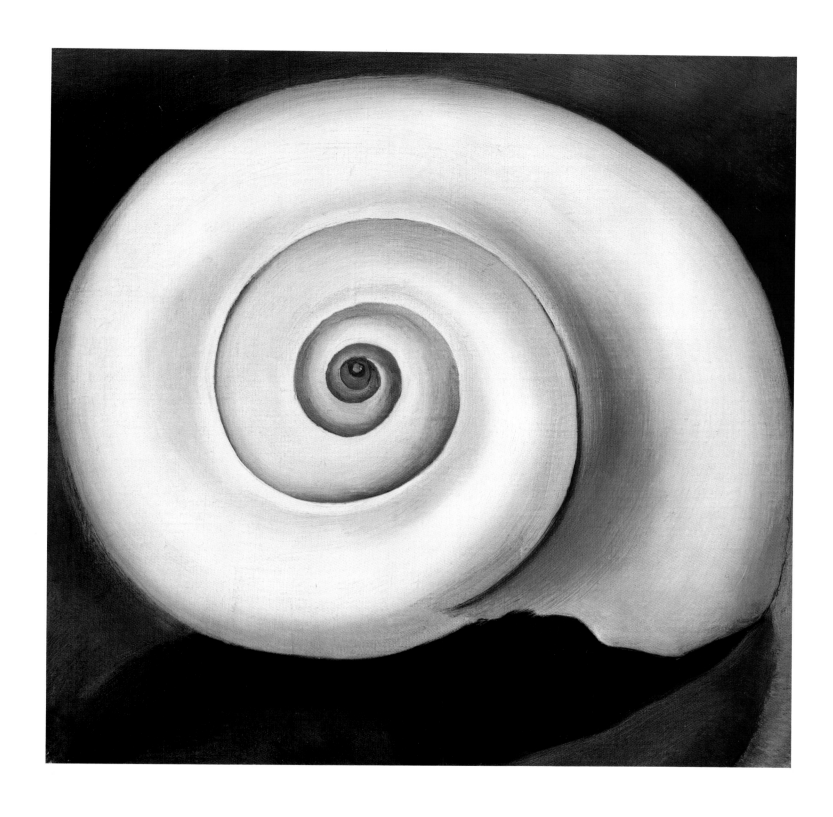

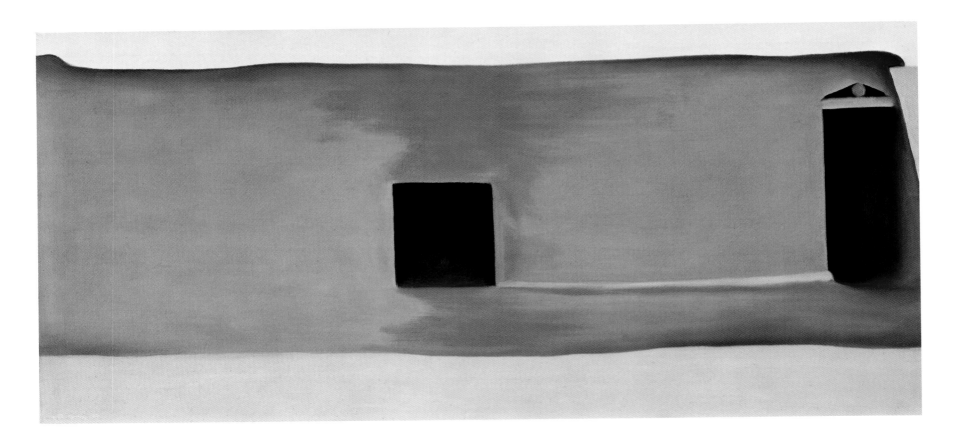

80 *In the Patio IV, 1948. Oil on canvas, 14 x 30.*

81 *In the Patio I, 1946. Oil on paper, 30 x 24.*

When I first saw the Abiquiu house it was a ruin with an adobe wall around the garden broken in a couple of places by falling trees. As I climbed and walked about in the ruin I found a patio with a very pretty well house and bucket to draw up water. It was a good-sized patio with a long wall with a door on one side.

That wall with a door in it was something I had to have. It took me ten years to get it—three more years to fix the house so I could live in it—and after that the wall with a door was painted many times.

82 Patio with Black Door, 1955. Oil on canvas, 40 x 30.

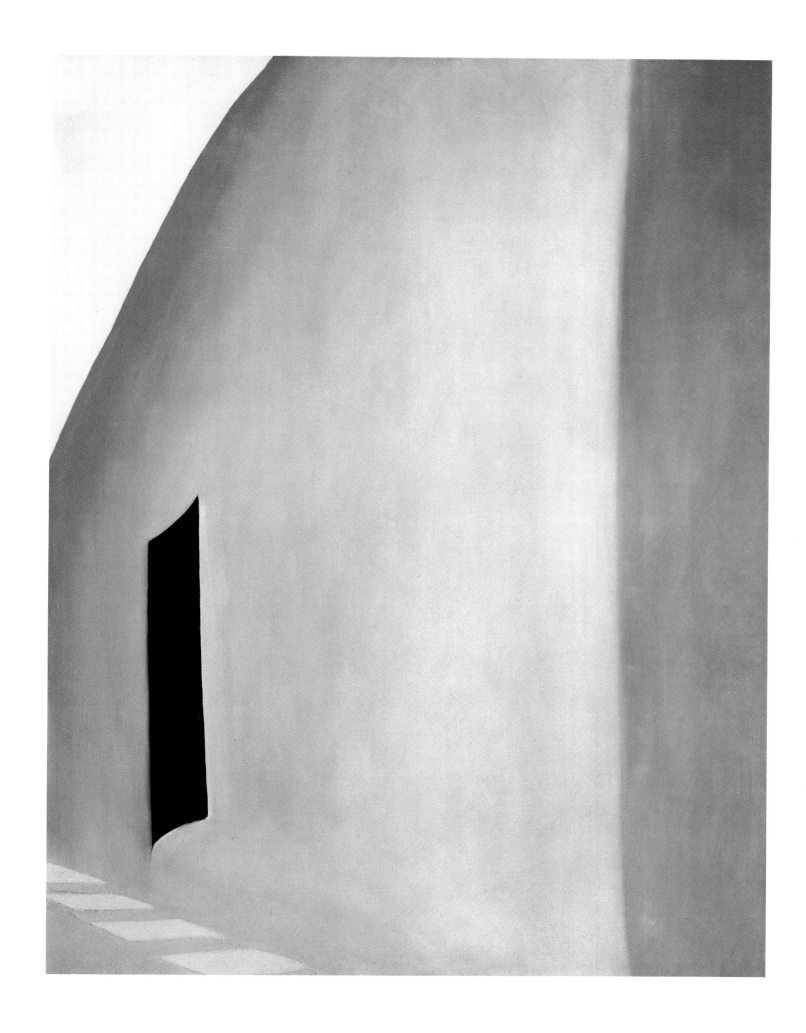

83 White Patio with Red Door, 1960. Oil on canvas, 48 x 84.

The first Jimson weed I saw was blooming between the first two steps of a ladder at Puye Pueblo. I have had it growing near my house in Abiquiu for many years and I have painted it many times.

It is a beautiful white trumpet flower with strong veins that hold the flower open and grow longer than the round part of the flower — twisting as they grow off beyond it. In the tropics where the plant grows almost to the size of a small tree these ribs sometimes curl an inch and a half beyond the flowers and the blossoms droop instead of looking out at you. Some of them are a pale green in the center — some a pale Mars violet. The Jimson weed blooms in the cool of the evening — one moonlight night at the Ranch I counted one hundred and twenty-five flowers. The flowers die in the heat of the day. Don Juan speaks of uses the Yaqui Indians make of the Jimson weed that almost make one afraid. When I found that they are poisonous, I dug them up but in Abiquiu a few keep on growing persistently. Now when I think of the delicate fragrance of the flowers, I almost feel the coolness and sweetness of the evening.

84 Two Jimson Weeds, 1938. Oil on canvas, 36 x 30.

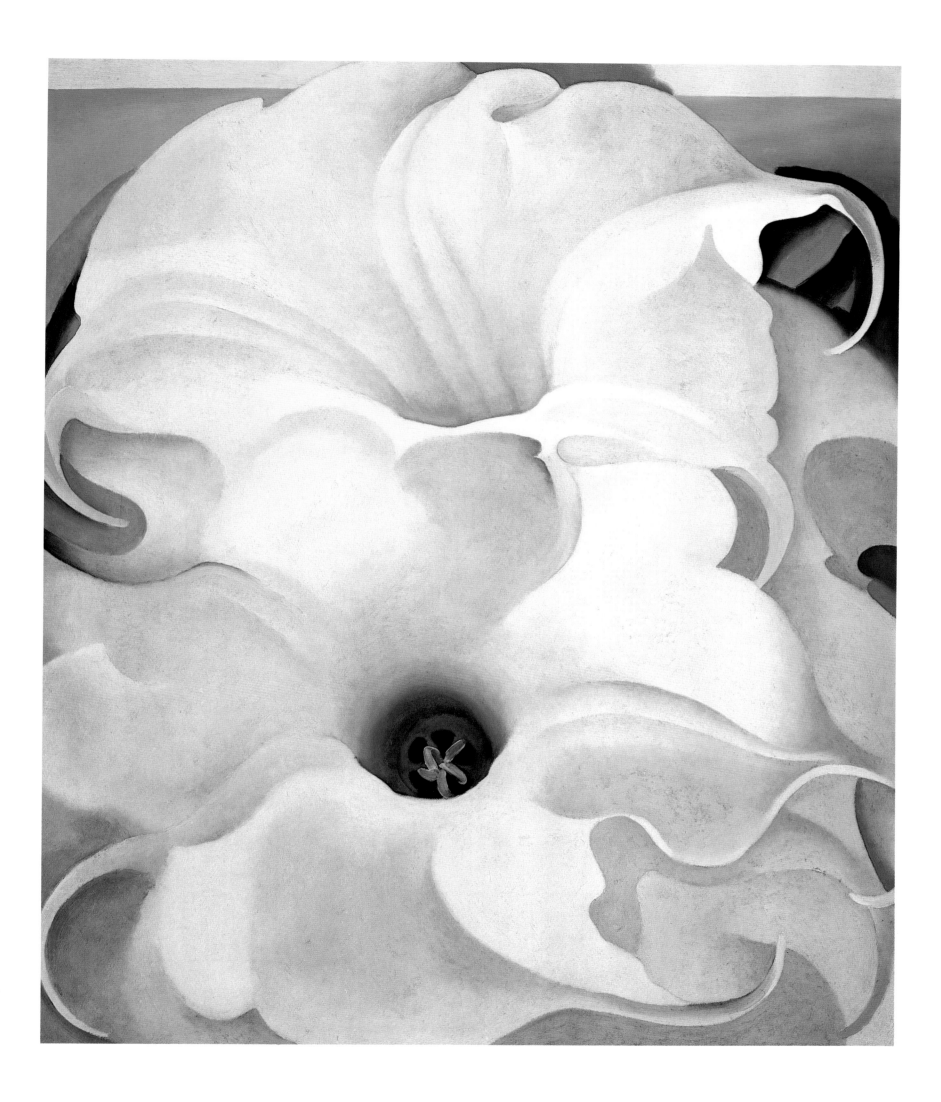

A little way out beyond my kitchen window at the Ranch is a V shape in the red hills. I passed the V many times—sometimes stopping to look as it spoke to me quietly. I one day carried my canvas out and made a drawing of it. The shapes of the drawing were so simple that it scarcely seemed worth while to bother with it any further. But I did a painting—just the arms of two red hills reaching out to the sky and holding it.

85 Red Hills and Sky, 1945. Oil on canvas, 30 x 40.

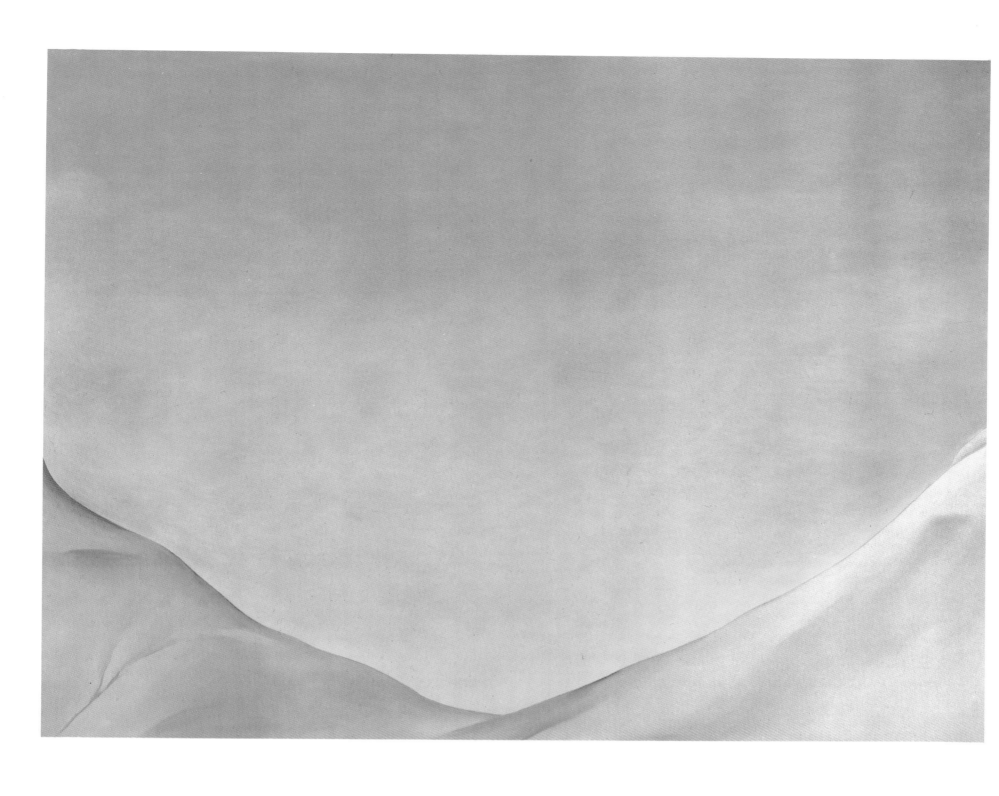

One morning the world was covered with snow. As I walked past the V of the red hills, I was startled to see them white. It was a beautiful early morning—black crows flying over the white. It became another painting— the snow-covered hills holding up the sky, a black bird flying, always there, always going away.

86 A Black Bird with Snow-Covered Red Hills, 1946. Oil on canvas, 36 x 48.

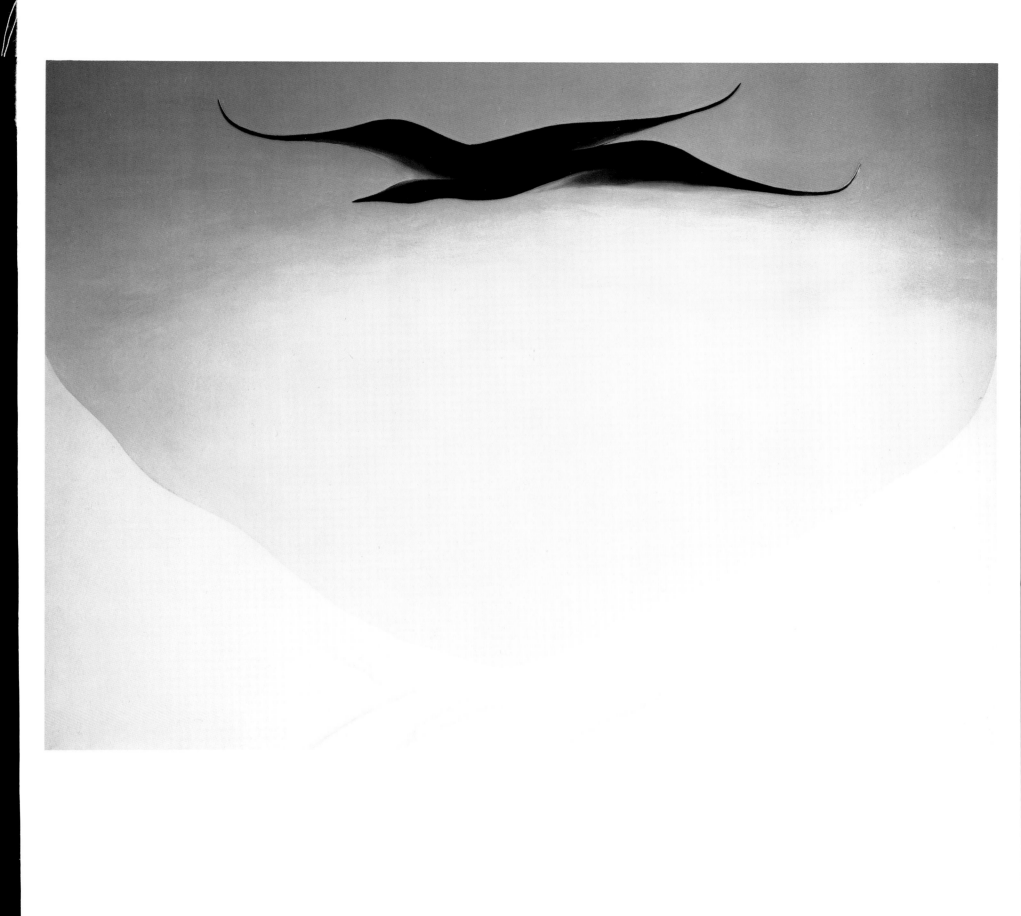

87 *Black Bird Series (In the Patio IX), 1950. Oil on canvas, 30 x 40.*

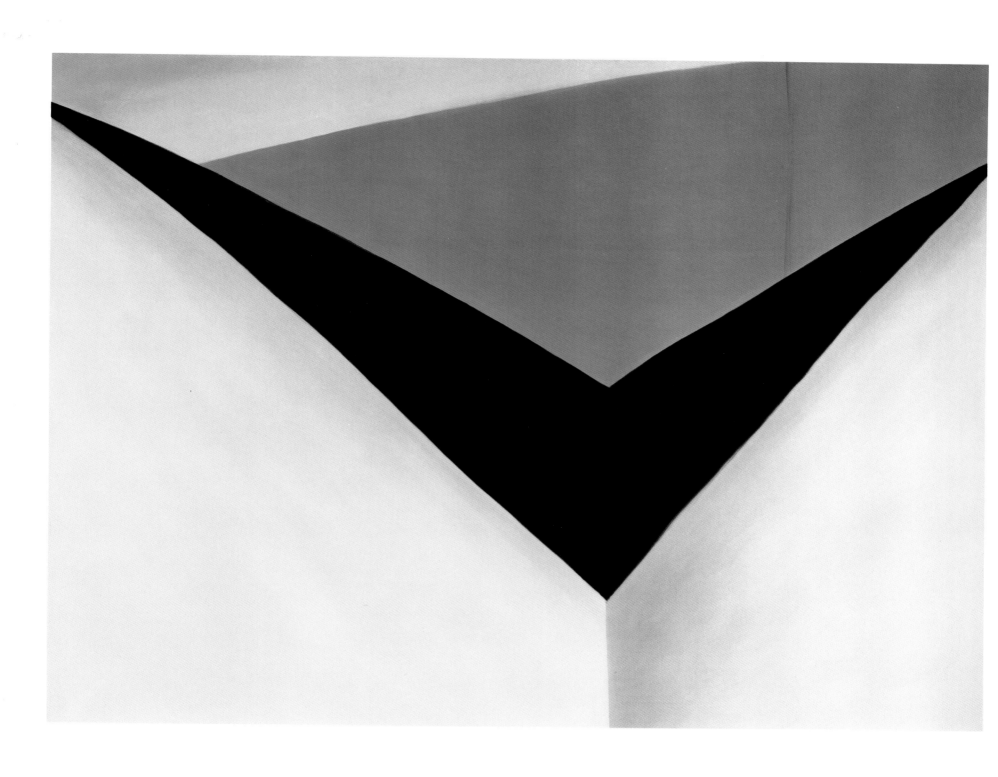

It is surprising to me to see how many people separate the objective from the abstract. Objective painting is not good painting unless it is good in the abstract sense. A hill or tree cannot make a good painting just because it is a hill or a tree. It is lines and colors put together so that they say something. For me that is the very basis of painting. The abstraction is often the most definite form for the intangible thing in myself that I can only clarify in paint.

88 Dark Abstraction, 1924. Oil on canvas, 25 x 21.

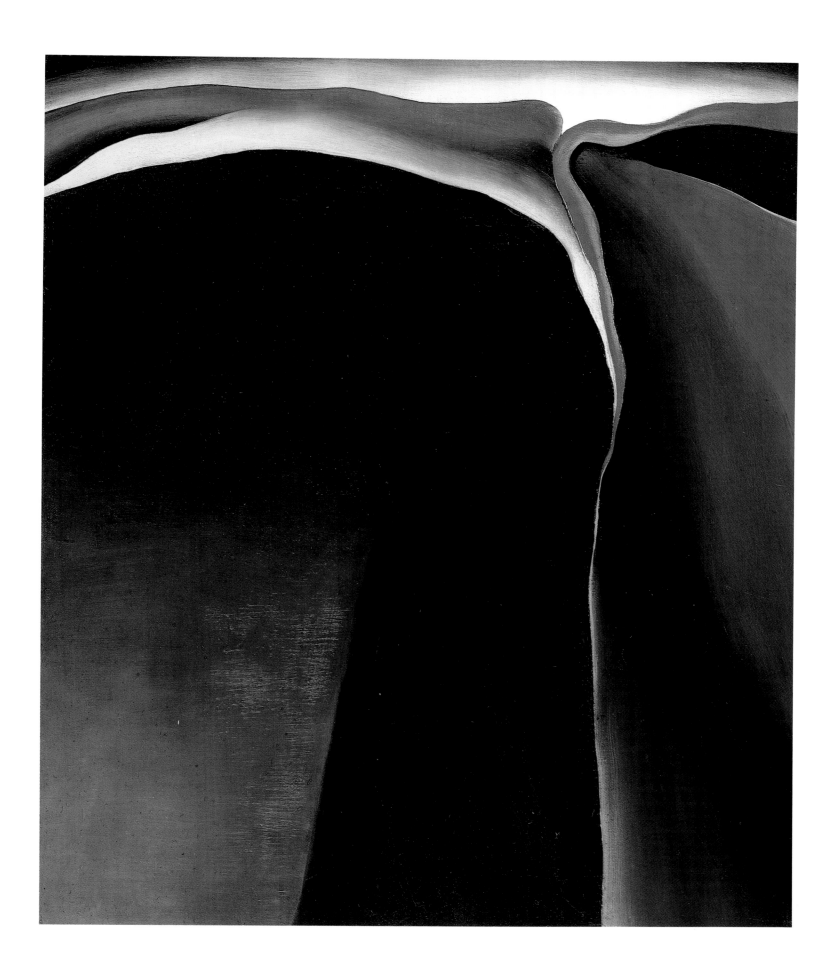

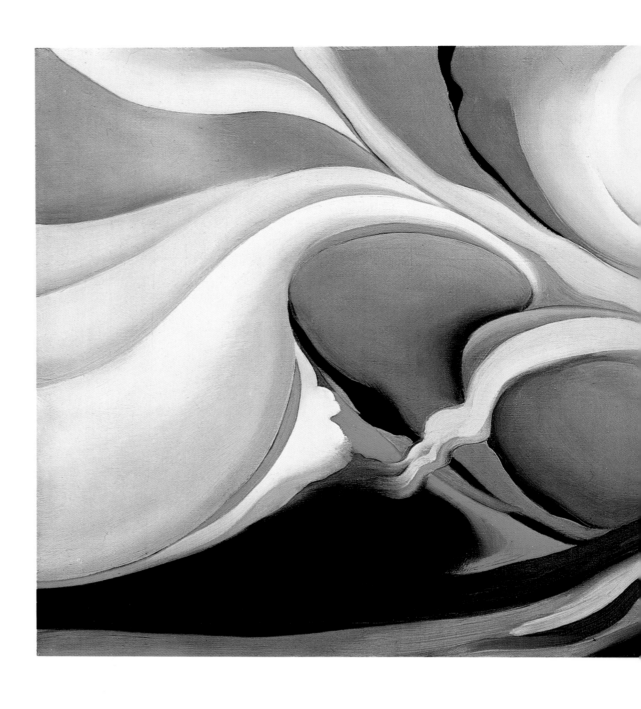

89 *Nature Forms, Gaspé, 1932. Oil on canvas, 10 x 24.*

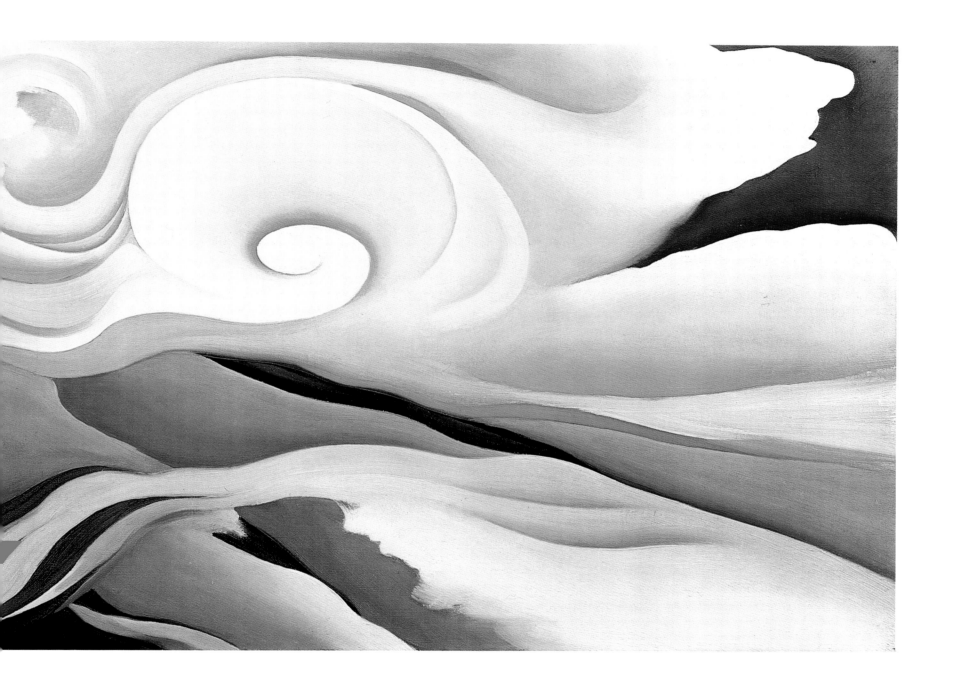

Gerald's Tree was one of many dead cedars out in the bare, red hills of Ghost Ranch. A friend visiting the Ranch that summer had evidently found it and from the footmarks I guessed he must have been dancing around the tree before I started to paint it. So I always thought of it as Gerald's tree.

90 Gerald's Tree I, 1937. Oil on canvas, 40 x 30.

*photographers, at Anderson Galleries, ar-
ranged by Stieglitz.*

1926-1929
*Yearly exhibitions of new work held at Stieg-
litz's Intimate Gallery.*

1927
*Retrospective exhibition held at Brooklyn
Museum.*

1929
*Summer took trip to New Mexico and visited
Mabel Dodge Luhan in Taos.*
*From this time on, spent most summers in
New Mexico.*

1930-1946
*Yearly exhibitions of new work held at Stieg-
litz's gallery, An American Place.*

1932
Summer traveled in Gaspé area of Canada.

1934
*Summer first stayed at Ghost Ranch, near
Abiquiu, New Mexico.*

1939
Painted in Hawaii.

1940
Bought Ghost Ranch house.

1943
*Retrospective exhibition held at Art Institute
of Chicago.*

1946
Bought house in Abiquiu.
*Retrospective exhibition held at Museum of
Modern Art, New York.*
Alfred Stieglitz died.

1947-1949
*Falls and winters spent in New York City,
settling the Stieglitz Estate and preparing
exhibitions of Stieglitz's Collections.*
Summer 1949 began living in Abiquiu house.

1952-1963
*Work exhibited at Downtown Gallery, New
York City.*

1953
Traveled to France, Germany, and Spain.

1959-1960
Winter took trip around the world.

1960
*Retrospective exhibition held at Worcester
Art Museum, Worcester, Massachusetts.*

1966
*Retrospective exhibition held at Amon Carter
Museum of Western Art, Fort Worth; Museum
of Fine Arts, Houston; University of New
Mexico Art Museum, Albuquerque.*

1970
*Retrospective exhibition held at Whitney
Museum of American Art, New York; Art
Institute of Chicago; San Francisco Museum
of Art.*

1973-1983
Traveled to Morocco, Antigua,
Guatemala, Costa Rica, and Hawaii with
Juan Hamilton.

1986
Died March 6 at the age of 98 in Santa Fe,
New Mexico.

1987
National Gallery of Art in Washington,
D.C., held exhibition celebrating
centennial of O'Keeffe's birth.

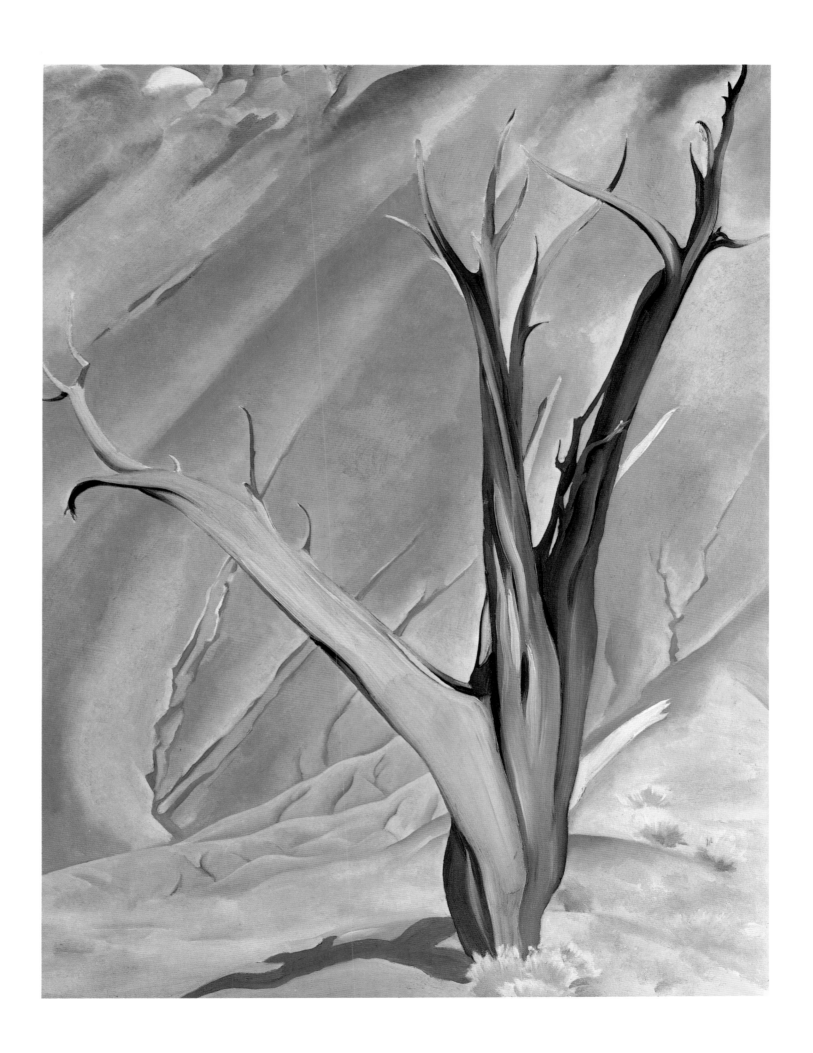

91 Dead Tree with Pink Hill, 1945. Oil on canvas, 30 x 40.

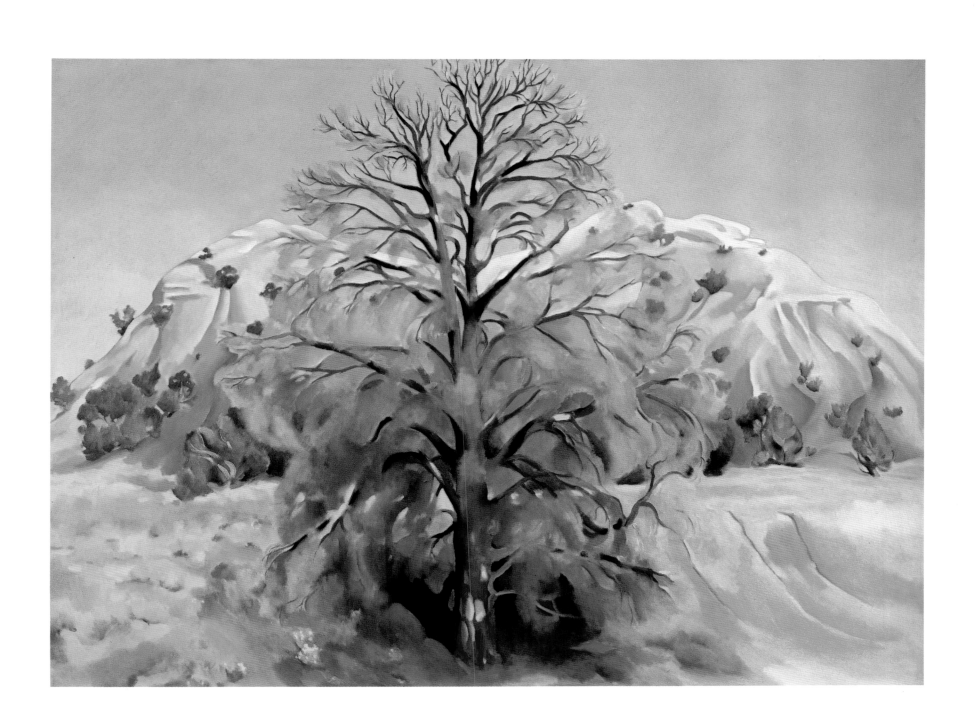

92 *Stump in Red Hills, 1940. Oil on canvas, 30 x 24.*

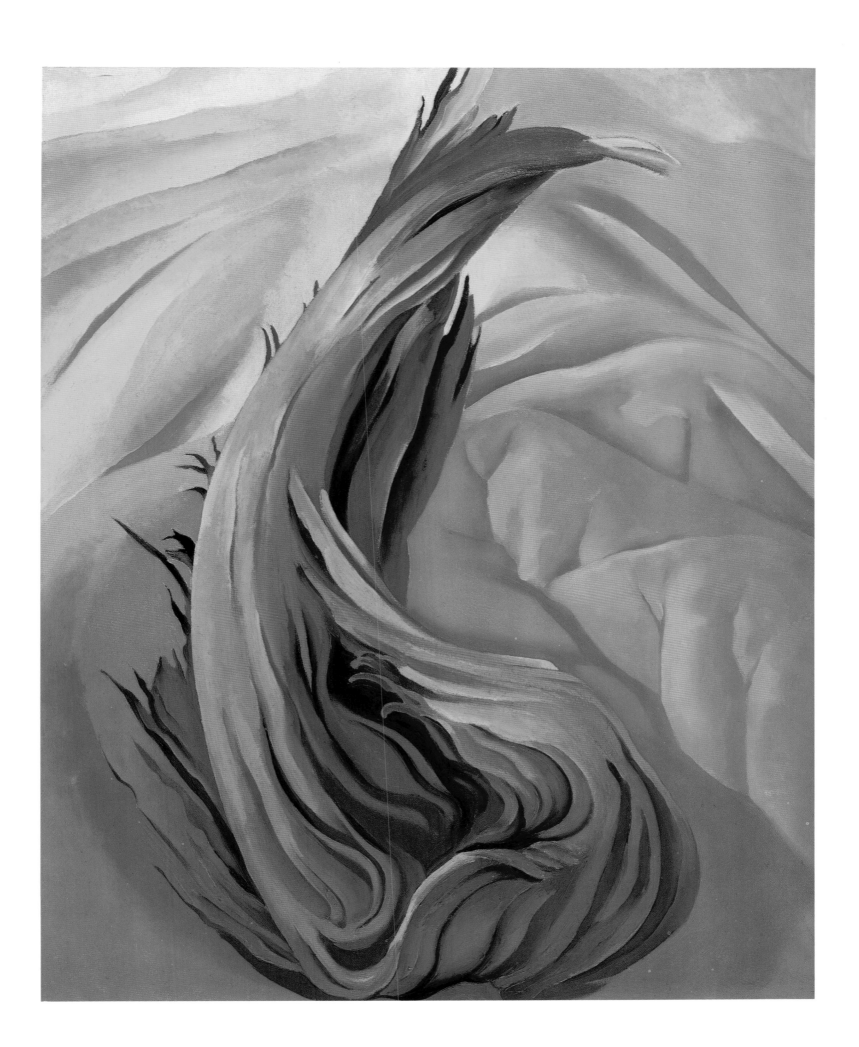

93 *Cliffs Beyond Abiquiu—Dry Waterfall, 1943. Oil on canvas, 30 x 16.*

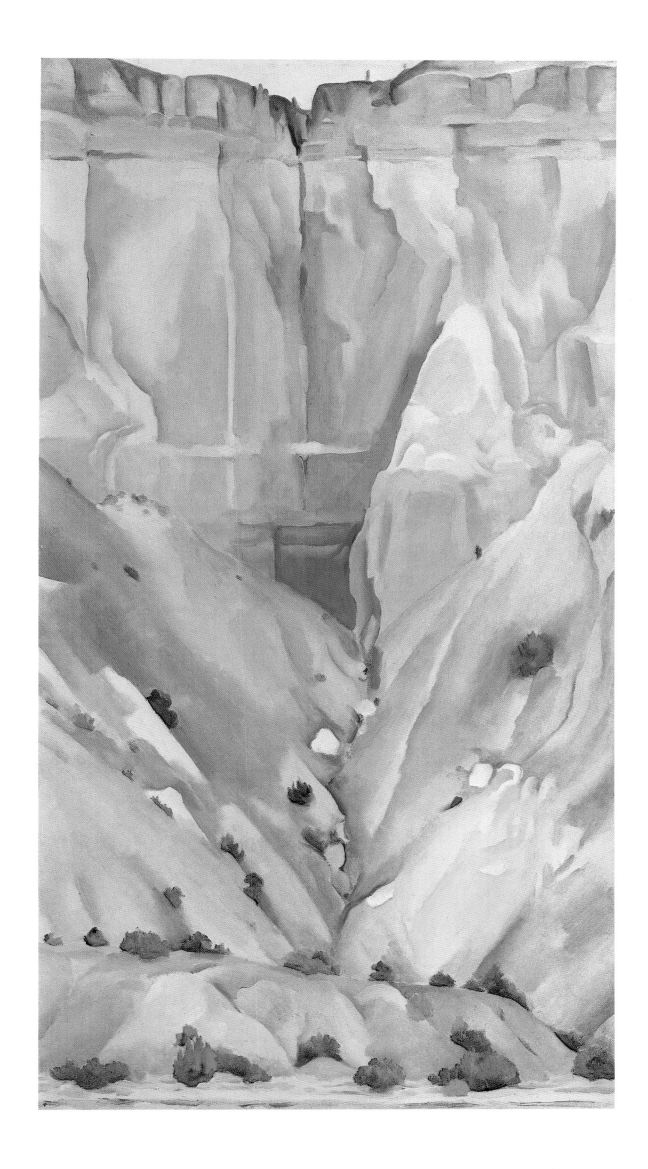

94 Red and Yellow Cliffs, 1940. Oil on canvas, 24 x 36.

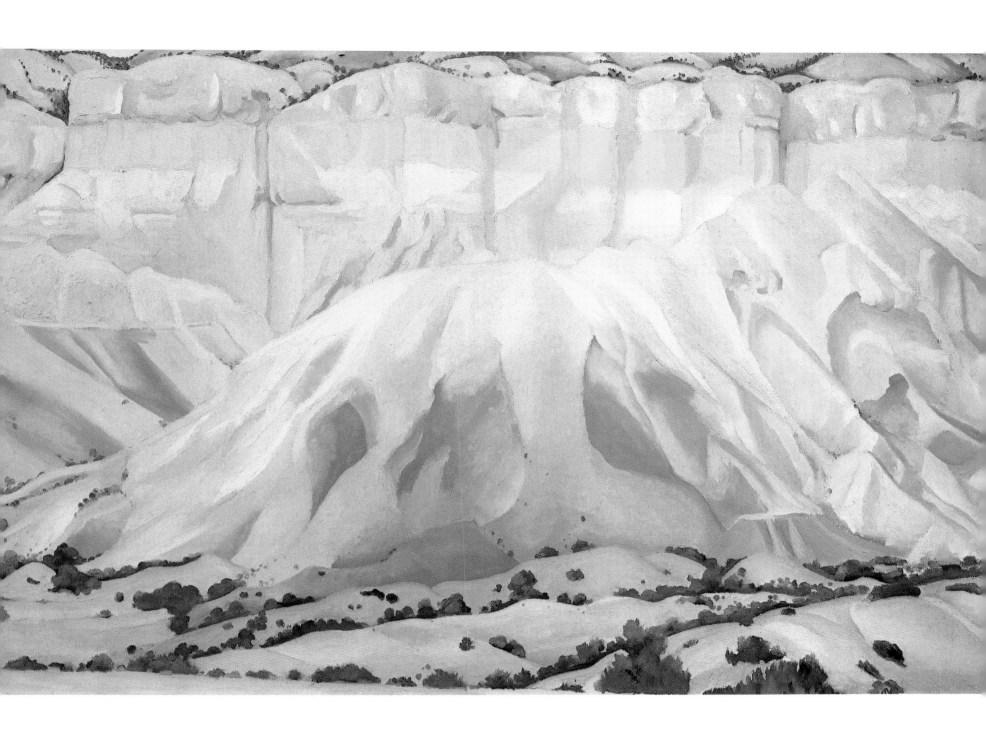

95 *Cliffs Beyond Abiquiu, 1943. Oil on canvas, 30 x 24.*

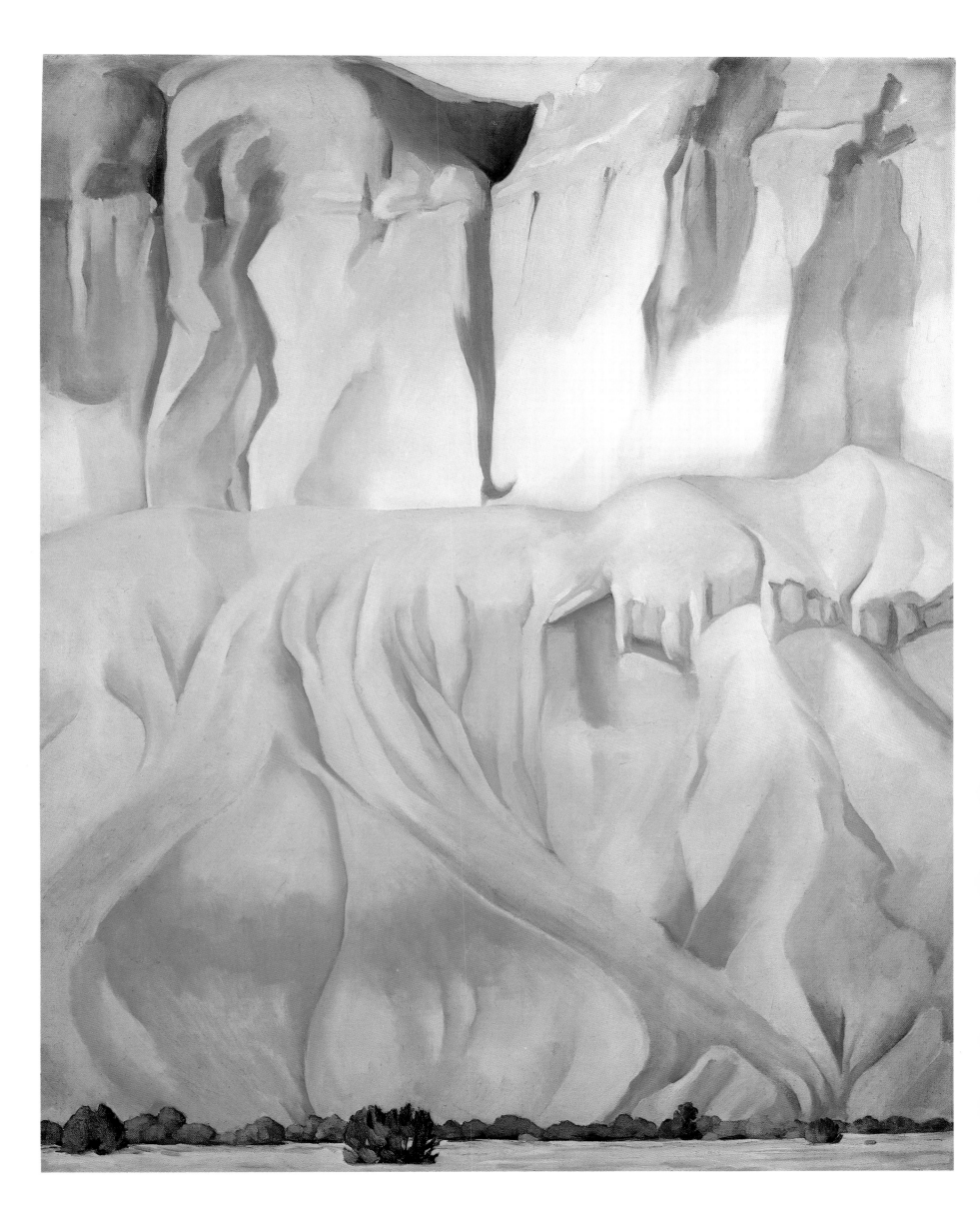

96 *The White Place in Shadow, 1942. Oil on canvas, 30 x 24.*

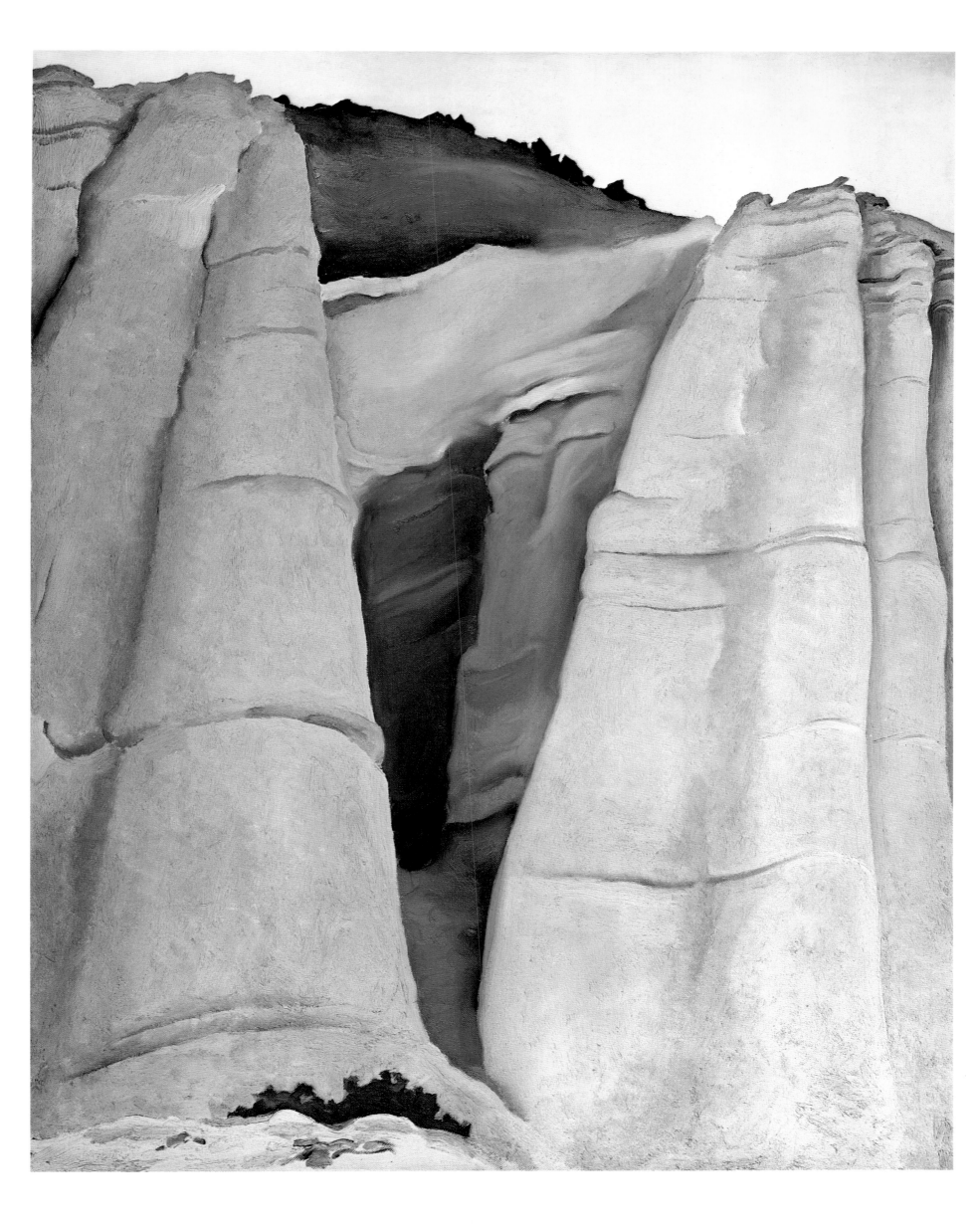

97 Red Hills and Bones, 1941. Oil on canvas, 30 x 40.

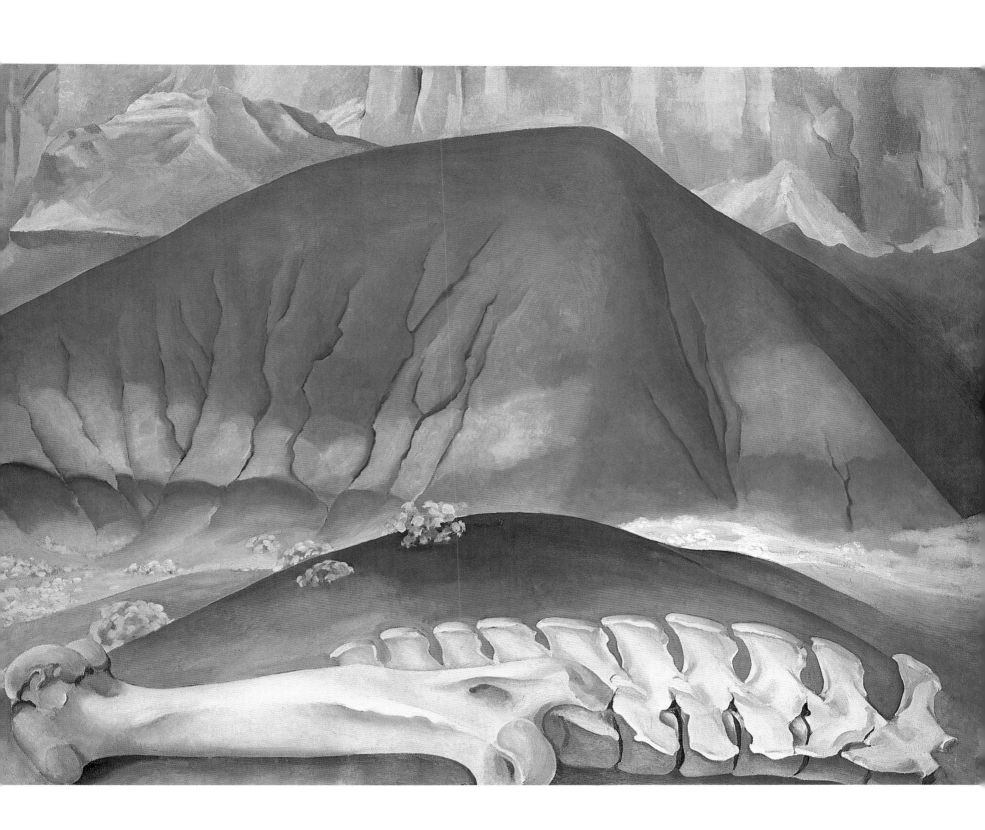

98 Red and Orange Hills, 1938. Oil on canvas, 19 x 36.

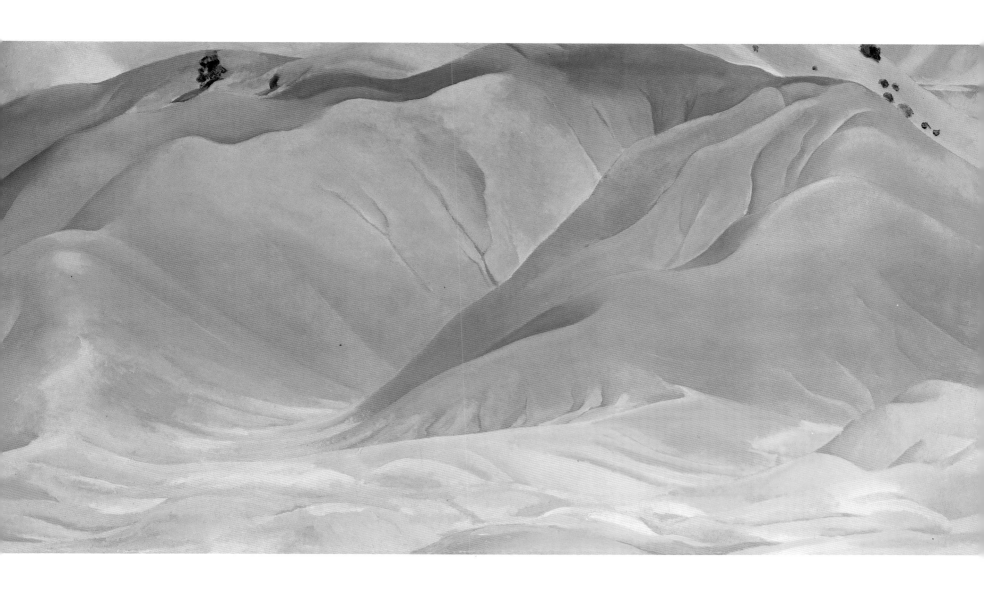

99 *Near Abiquiu , New Mexico, 1941. Oil on canvas, 12 x 30.*

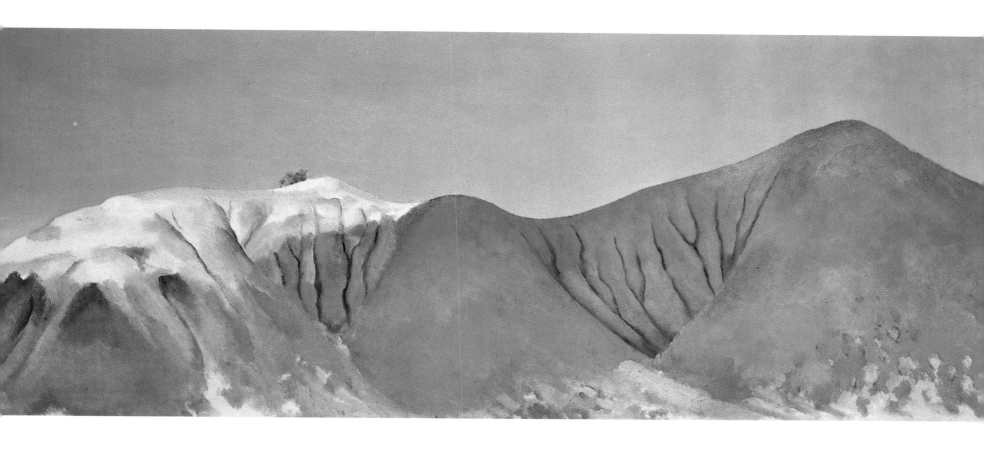

The unexplainable thing in nature that makes me feel the world is big far beyond my understanding—to understand maybe by trying to put it into form. To find the feeling of infinity on the horizon line or just over the next hill.

100 Pedernal and Red Hills, 1936. Oil on canvas, 20 x 30.

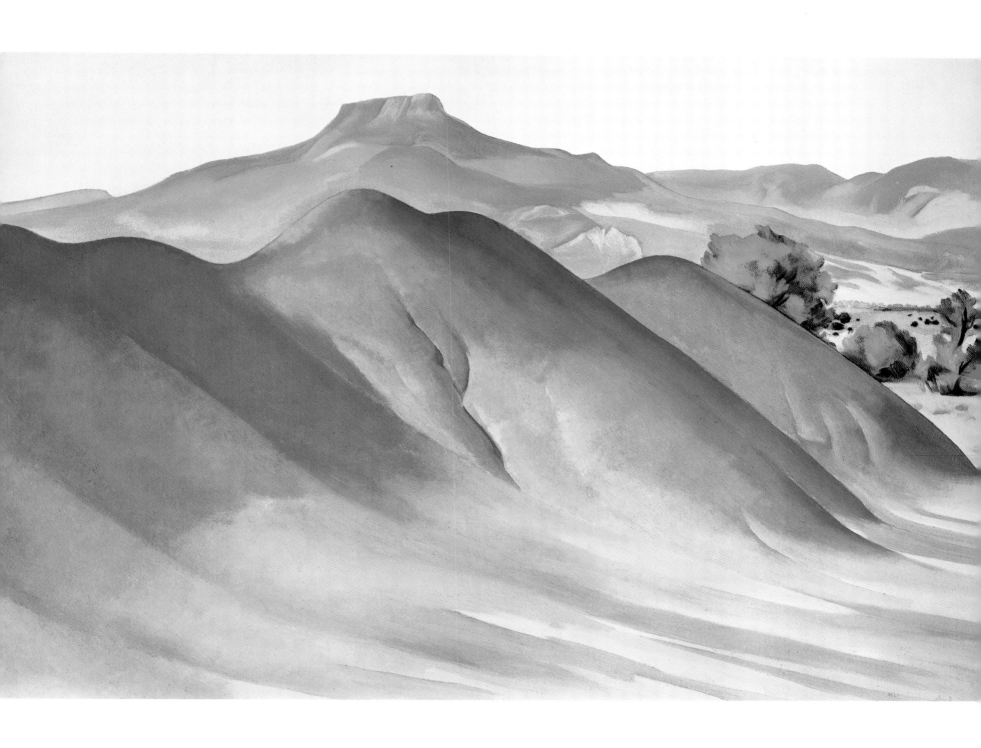

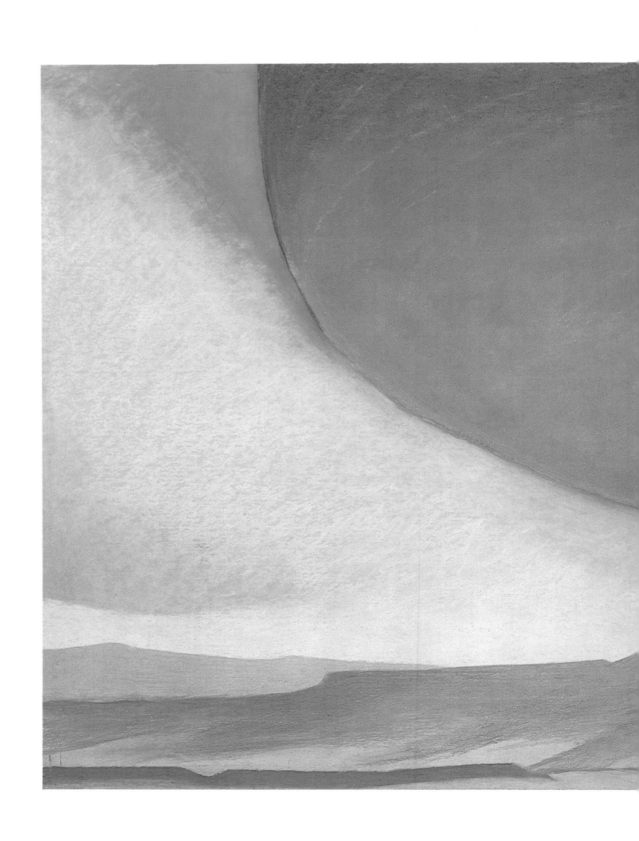

101 Pedernal, 1945. Pastel, 21 x 43.

At the Ranch house there is a strong handmade ladder to the roof and when I first lived there I climbed it several times a day to look at the world all 'round—the miles of cliff behind, the wide line of low mountain with a higher narrow flat top. It is very beautiful—tree-covered with a bare spot in the shape of a leaping deer near the top.

One evening I was waiting for a friend and stood leaning against the ladder looking at the long dark line of the Pedernal. The sky was a pale greenish blue, the high moon looking white in the evening sky. Painting the ladder had been in my mind for a long time and there it was—with the dark Pedernal and the high white moon—all ready to be put down the next day.

102 Ladder to the Moon, 1958. Oil on canvas, 40 x 30.

I am afraid to fly—but after the plane takes off I enjoy what I see from the air and forget the hazards. I once spent three and a half months flying around the world. I was surprised that there were so many desert areas with large riverbeds running through them. I made many drawings about one and a half inches square of the rivers seen from the air. At home I made larger charcoal drawings from the little pencil drawings. Later I made paintings from the charcoal drawings. The color used for the paintings had little to do with what I had seen—the color grew as I painted.

Edith Halpert was still my dealer at that time and she wondered what the paintings were about. She thought maybe trees. I thought that as good as anything for her to think—as for me, they were just shapes. But one day I saw a man looking around at my Halpert showing. I heard him remark, "They must be of rivers seen from the air." I was pleased that someone had seen what I saw and remembered it my way.

103 It Was Yellow and Pink III, 1960. Oil on canvas, 40 x 30.

Two walls of my room in the Abiquiu house are glass and from one window I see the road toward Espanola, Santa Fe and the world. The road fascinates me with its ups and downs and finally its wide sweep as it speeds toward the wall of my hilltop to go past me. I had made two or three snaps of it with a camera. For one of them I turned the camera at a sharp angle to get all the road. It was accidental that I made the road seem to stand up in the air, but it amused me and I began drawing and painting it as a new shape. The trees and mesa beside it were unimportant for that painting—it was just the road.

I made two paintings from the place where we have the view of the road coming down from the ranch. The road goes downhill, then turns and sweeps and curves till it disappears in the hills below the mesa with the Sangre de Cristo mountains on beyond.

104 Road Past the View I, 1964. Oil on canvas, 24 x 30.

105 *The Winter Road, 1963. Oil on canvas, 22 x 18.*

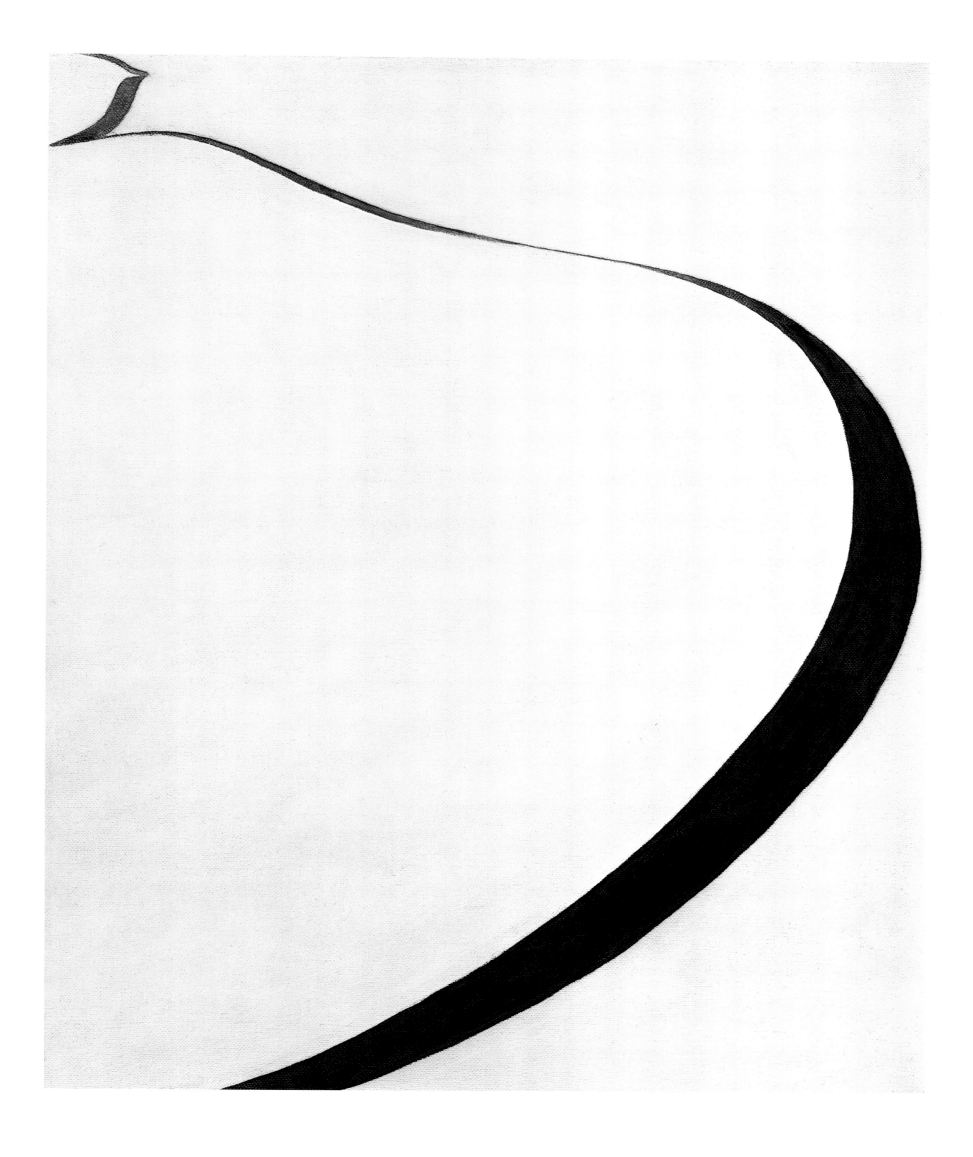

One day when I was flying back to New Mexico, the sky below was a most beautiful solid white. It looked so secure that I thought I could walk right out on it to the horizon if the door opened. The sky beyond was a light clear blue. It was so wonderful that I couldn't wait to be home to paint it. I couldn't find a canvas the right size so it was painted on one I had—one that was too high and not wide enough.

The next time I flew, the sky below was completely full of little oval white clouds, all more or less alike. The many clouds were more of a problem. The first painting was small—the next two were larger. For the final painting my plan seemed so ridiculous that I took a big roll of paper nine feet high and stretched it twenty-four feet across the garage wall. I lost my first small drawing so the large one on that fine-looking paper was simpler than it would have been if I'd still had the drawing.

A friend was here some months later and, seeing the drawing, asked why I didn't paint it. I told him I didn't know how to get a canvas as large as that stretched. "If you get the stretcher and the canvas I will come out and help you in June," he said.

The next time I went to New York I bought the canvas and asked LeBrun, the framer, about the stretcher. Over the telephone he described how he would make it. He made it sound so simple that when I returned to New Mexico I thought I could stretch it myself if I had a pair of strong hands to help me. So I started at it with Frank, who packs and does odd jobs for me. We screwed the stretcher together. Then I opened the big bundle of canvas. That discouraged me. It was rougher than I had ordered. Sending it back and waiting seemed impossible, so I decided to use it as it was. I laid it out on the garage floor and left it there to settle for a few days. After that we laid the stretcher down on it and applied the grommets every six inches all the way around. Then we laced the canvas to the stretcher in both directions with

coarse nylon string. Frank, six feet three, lean and very strong, got down on the floor and pulled the strings until the canvas was fairly well placed on the stretcher. Then he tacked the canvas on. It was a hard job even for a strong man—a man who had been a sheepherder all his life.

I tore down my drawing and we stood the canvas up and hung it about a foot from the wall—with enough extra space at one end so that I could stick my head in and see the back of it. There were wrinkles in the canvas from the folds of packing so I wet it to make it shrink and become taut and flat. I had two ten-foot tables with a board between to be high enough to reach the top of the canvas. First I stood on the tables. Then I sat on a chair on the tables. After that I sat on the tables. Then I moved the tables and stood on a plank on the floor and after that I sat on the floor to reach the bottom.

Next morning I went out to look at it. It was a shambles. It had dried and shrunk until it broke all the uprights of its three stretchers—but the wrinkles were gone. Frank had to go to town and get steel strips eighteen inches long to screw on the stretchers to hold them together. The whole thing had to be put flat on the floor again.

When it was on the wall once more I painted it with glue size. The canvas was so rough that I had to go over it hard a second time to cover places missed the first time. When the glue water dried I gave it two coats of priming. It was a long trip with the brush across that twenty-four feet of canvas—once with water, twice with glue and twice with white paint to prepare it. And then I had to paint the picture. The canvas was rough and coarse and to rub the glue and paint into it was hard work. Between each coat of anything we had to move the tables and chairs and planks to be able to reach up and down. And every time I sat down on the floor I was afraid that the rattlesnakes would come in behind me as I worked.

However, in time I had the canvas smoothly stretched and primed and

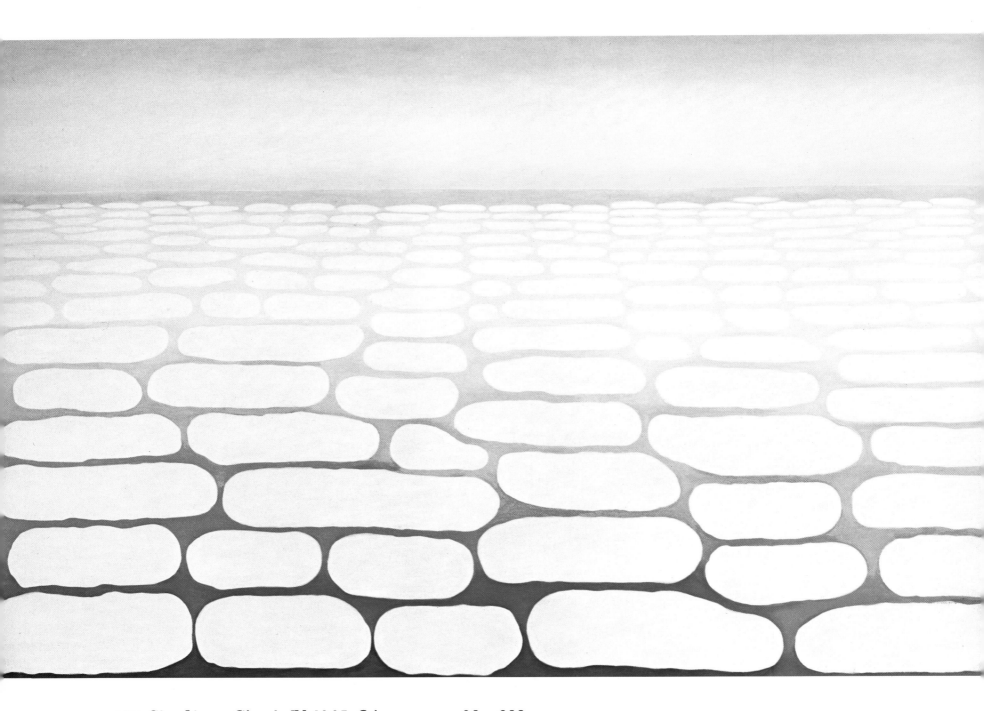

106 Sky Above Clouds IV, 1965. Oil on canvas, 96 x 288.

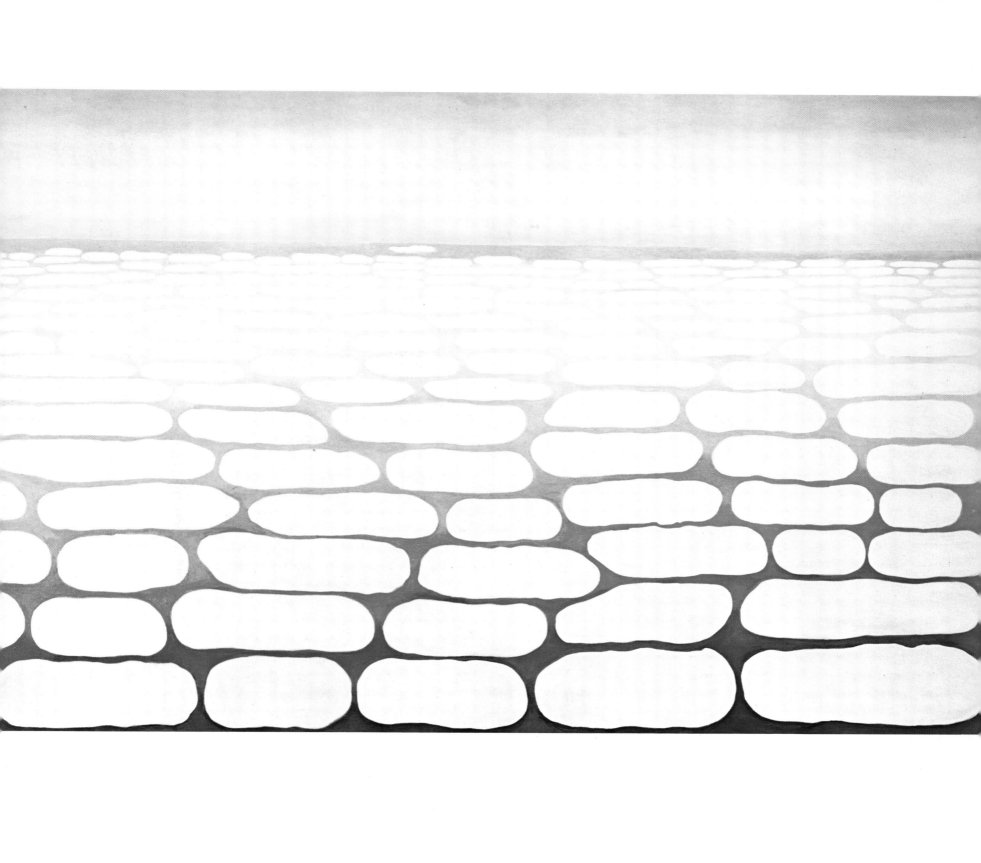

ready to paint. Frank came every morning and mixed paint for me. I had to have piles large enough to be sure I could get across the whole canvas with one color at a time.

I was up every morning at six and at work immediately—and I didn't have my brushes washed until about nine in the evening. A little girl from Abiquiu fed me and took care of me her way as I didn't have time to teach her mine. I had no visitors and went nowhere. I just worked because I had to be finished before cold weather—there was no heat in the garage. I even worked on Sundays. I knew that if I didn't finish before cold weather I would not go back to it the next year. As I worked I could walk back long distances out onto the plain behind the garage to look at what I was doing. There is a short time at sunset when the whole world has a warm glow—and at that time the big painting with its cool light looked quite wonderful from almost any distance—even from a quarter of a mile.

When the painting was finished it stood in the garage until the truck sent by the Amon Carter Museum came to get it for a show I was having there. The truck couldn't cross the nearest bridge because it was too heavy. They had to go back and come in on the other road about ten miles away with a ditch they could barely cross. Finally the thirty-foot truck stood outside the garage and it began to snow—enormous snowflakes. We had to work with the door open because part of the canvas was out of the garage as we had to lay it across the floor at an angle. They had brought a huge drum about five feet in diameter to roll the canvas on. It would be easier to carry it on a large roll than on the stretcher and the paint was new enough not to crack. We had to cover the floor with plastic to protect the painting when we laid it face down. We took the tacks out, picked up the stretcher, took it apart and put it in the truck. Then we had to flatten the edges that had been bent to put the

canvas on the stretcher. There wasn't room to put it flat on the plastic covering —part of it had to be turned over. I didn't know how we were going to turn it without breaking the surface. I finally got all the pillows and quilts in the house and laid them on the canvas to fold it over that. I was running around doing all this in my stocking feet as I had to walk across the picture several times and it was cold—and still snowing. When we got the end turned over we started to roll the painting on the drum. There were several of us working on it and it took all day.

I flew to Fort Worth to be at the Museum when the drum was taken out of the truck. They took it into the basement and unrolled the canvas face down on a piece of plastic on the hard smooth maple floor. Then we screwed the stretcher together again and laid it on the canvas so that it could be screwed back in exactly the same place it had been before. We had to lace it again with the nylon string and with great effort we got it tacked on and stood up. Then someone told us that we couldn't keep it in that room because it had to be stored until time for the show. Finally somebody picked up the edge of the plastic and found that it was so strong that we could use the plastic like a sled, and slide the picture on it into the next room.

Hanging the "Clouds" has always been a problem. At the Amon Carter it had to hang in the hall with part of it reaching into the next room. After the show opened, an electric eye that had been in the way was finally removed and the picture was put on a longer wall where we had wanted to hang it originally. Later, it was part of the 1970 show that went to three museums. When the show arrived at the Whitney we couldn't get the "Clouds" upstairs. It had to be on the ground floor and the rest of the show was on the floor above. If we had taken it to San Francisco it couldn't have gotten through any door—so it still hangs in Chicago.

The black rocks from the road to the Glen Canyon dam seem to have become a symbol to me—of the wideness and wonder of the sky and the world. They have lain there for a long time with the sun and wind and the blowing sand making them into something that is precious to the eye and hand—to find with excitement, to treasure and love.

107 Black Rock with Blue III, 1970. Oil on canvas, 20 x 17.

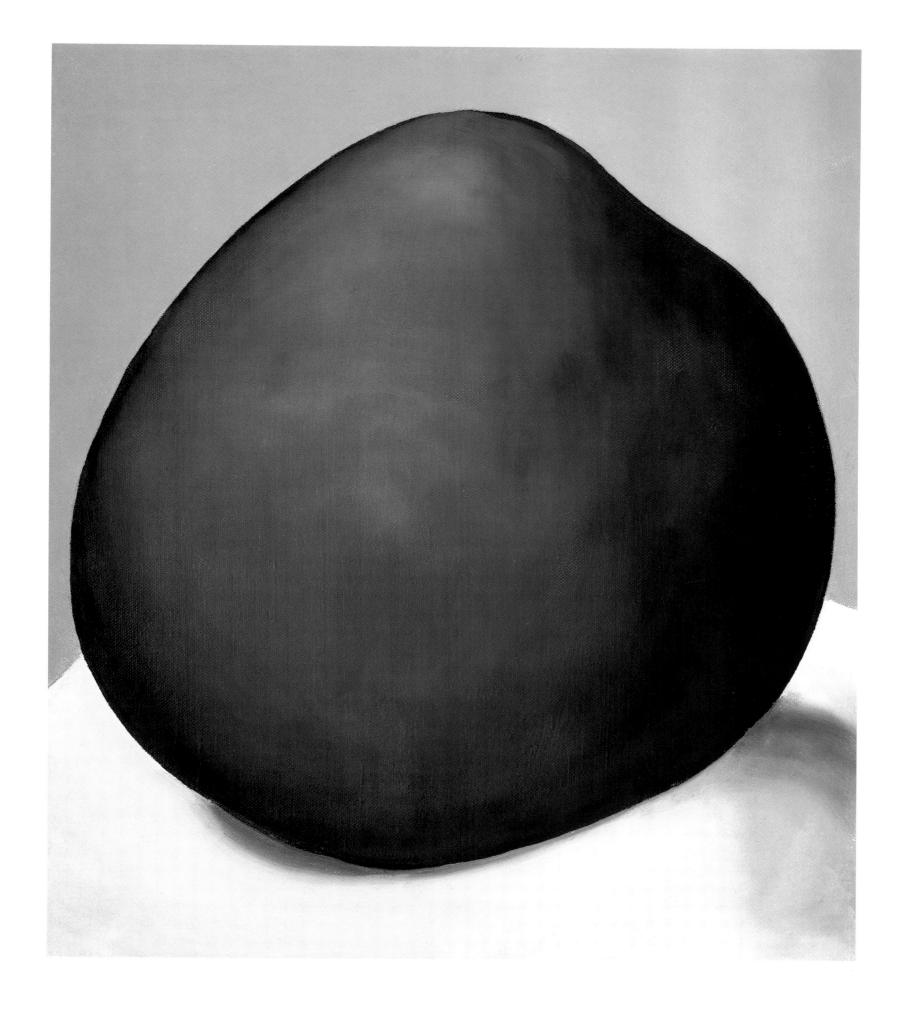

108 *Black Rock with Blue Sky and White Clouds, 1972. Oil on canvas, 36 x 30.*

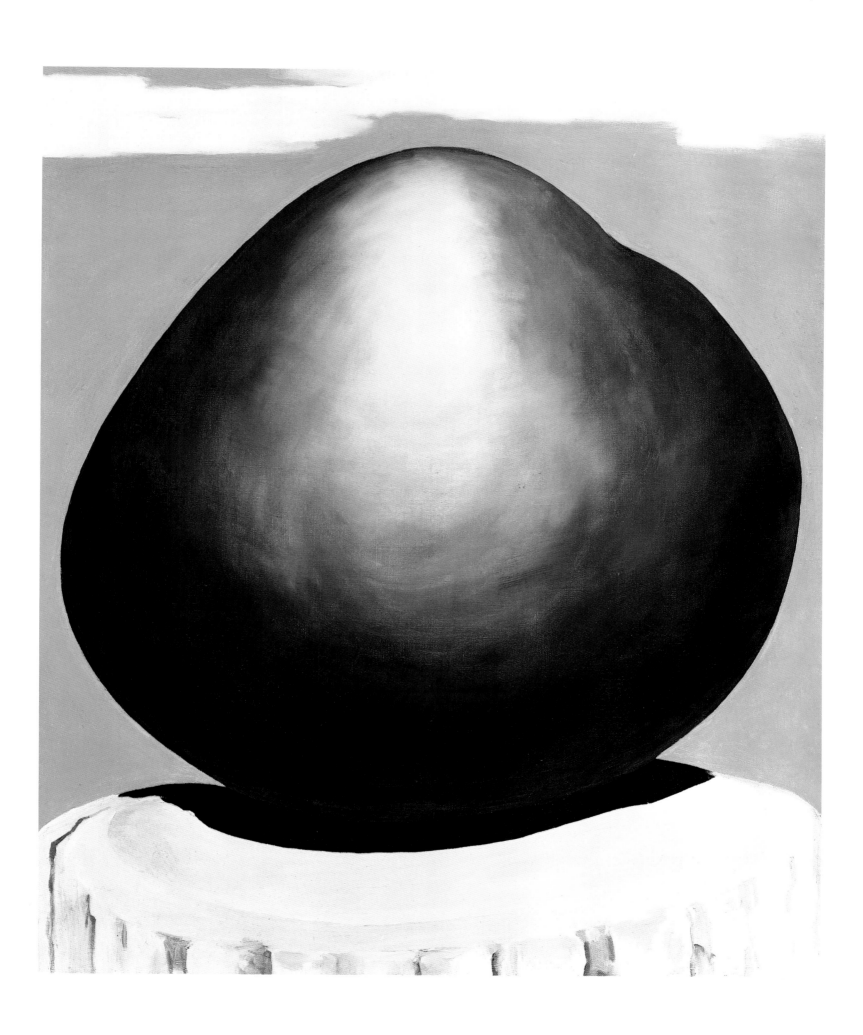

A young potter came to the Ranch and as I watched him work with the clay I saw that he could make it speak. The pots that he made were beautiful shapes—very smooth—near to sculpture. I hadn't thought much about pottery but now I thought that maybe I could make a pot, too— maybe a beautiful pot—it could become still another language for me.

I rolled the clay and coiled it—rolled it and coiled it. I tried to smooth it and I made very bad pots. He said to me, "Keep on, keep on—you have to work at it—the clay has a mind of its own." He helped me with this and that and I finally have several pots that are not too bad, but I cannot yet make the clay speak—so I must keep on.

Georgia O'Keeffe in the pottery studio.

List of Illustrations

*All works are in the collection of Miss O'Keeffe, unless otherwise specified.
Dimensions are in inches, height preceding width, and have been rounded off
to the nearest inch. Plate numbers are in brackets. Unless otherwise noted,
photographs are by Malcolm Varon. The photograph of Georgia O'Keeffe in
the studio with Juan Hamilton's pots is by Dan Budnik.*

Corn, Dark, 1924
 Oil on board, 32 x 12 [34]
 The Metropolitan Museum of Art;
 The Alfred Stieglitz Collection, 1949;
 photograph by Robert Mates

Cow's Skull—Red, White and Blue, 1931
 Oil on canvas, 40 x 36 [58]
 The Metropolitan Museum of Art;
 The Alfred Stieglitz Collection, 1949;
 photograph by the museum

Cross by the Sea, Canada, 1932
 Oil on canvas, 36 x 24 [68]
 The Currier Gallery of Art,
 Manchester, New Hampshire

Cross with Red Heart, 1932
 Oil on canvas, 84 x 40 [67]
 Sacred Heart Church, Margaretville, New York

Dark Abstraction, 1924
 Oil on canvas, 25 x 21 [88]
 The St. Louis Art Museum;
 gift of Charles E. and Mary Merrill

Dead Tree with Pink Hill, 1945
 Oil on canvas, 30 x 40 [91]

East River from the Shelton, 1927-28
 Oil on canvas, 25 x 22 [19]
 Purchased by the Friends of the
 New Jersey State Museum
 with a gift from Dr. and Mrs. Victor D'Arc;
 photograph by the museum

Evening Star III, 1917
 Watercolor, 9 x 12 [7]
 The Museum of Modern Art, New York;
 Mr. and Mrs. Donald B. Straus Fund;
 photograph by the museum

Evening Star IV, 1917
 Watercolor, 9 x 12 [8]

Evening Star V, 1917
 Watercolor, 9 x 12 [6]
 Private collection

Evening Star VI, 1917
 Watercolor, 9 x 12 [9]

Fifty-ninth Street Studio, 1919
 Oil on canvas, 35 x 29 [16]
 Private collection;
 photograph by Robert Mates

The Flagpole, 1923
 Oil on canvas, 35 x 18 [35]
 Whereabouts unknown;
 photograph by Peter A. Juley & Son

Flagpole with White House, 1959
 Oil on canvas, 48 x 30 [36]

A Fragment of the Ranchos de Taos Church, 1929
 Oil on canvas-covered board, 15 x 11 [62]
 Courtesy of the Princeton Gallery of Fine Art

From the Faraway Nearby, 1937
 Oil on canvas, 36 x 40 [72]
 The Metropolitan Museum of Art;
 The Alfred Stieglitz Collection, 1949

From the Plains I, 1919
 Oil on canvas, 27 x 23 [2]
 Collection of Andrew J. Crispo

From the Plains II, 1954
 Oil on canvas, 48 x 72 [3]
 Collection of Susan and David Workman

Gerald's Tree I, 1937
 Oil on canvas, 40 x 30 [90]

Green-Grey Abstraction, 1931
 Oil on canvas, 36 x 24 [55]
 Jane G. Weinberg;
 on loan to The Art Institute of Chicago

The Grey Hills, 1942
 Oil on canvas, 24 x 36 [60]
 Indianapolis Museum of Art;
 gift of Mr. and Mrs. James W. Fesler;
 photograph by the museum

Grey Hills II, 1936
 Oil on canvas, 16 x 30 [59]

In the Patio I, 1946
 Oil on paper, 30 x 24 [81]
 Collection of Mr. and Mrs. Norton S. Walbridge;
 photograph by Professional Photo Service,
 Busco-Nestor

In the Patio IV, 1948
 Oil on canvas, 14 x 30 [80]
 Lane Collection

It Was Yellow and Pink III, 1960
 Oil on canvas, 40 x 30 [103]

Jack-in-the-Pulpit II, 1930
 Oil on canvas, 40 x 30 [39]

Jack-in-the-Pulpit III, 1930
 Oil on canvas, 40 x 30 [38]

Jack-in-the-Pulpit IV, 1930
 Oil on canvas, 40 x 30 [40]

Jack-in-the-Pulpit V, 1930
 Oil on canvas, 48 x 30 [41]

Jack-in-the-Pulpit VI, 1930
 Oil on canvas, 36 x 18 [42]

Ladder to the Moon, 1958
 Oil on canvas, 40 x 30 [102]

Lake George Barns, 1926
 Oil on canvas, 21 x 32 [45]
 Walker Art Center, Minneapolis;
 photograph by Eric Sutherland

Lake George Window, 1929
 Oil on canvas, 40 x 30 [37]
 The Museum of Modern Art, New York;
 acquired through the Richard D. Brixey Bequest

Lake George with Crows, 1921
 Oil on canvas, 28 x 25 [32]
 Photograph by Frank Lerner

The Lawrence Tree, 1929
 Oil on canvas, 30 x 40 [57]

Light Coming on the Plains II, 1917
 Watercolor, 12 x 9 [11]
 Amon Carter Museum, Fort Worth, Texas;
 photograph by L. Lorenz

Music—Pink and Blue I, 1919
 Oil on canvas, 35 x 29 [14]
 Private collection

Nature Forms, Gaspé, 1932
 Oil on canvas, 10 x 24 [89]

Near Abiquiu, New Mexico, 1941
 Oil on canvas, 12 x 30 [99]
 Collection Thyssen-Bornemisza,
 Lugano, Switzerland

New York Night, 1929
 Oil on canvas, 40 x 19 [21]
 Nebraska Art Association;
 in memory of Thomas C. Woods

New York with Moon, 1925
 Oil on canvas, 48 x 30 [17]
 Collection of Mr. and Mrs. Peter Meyer

Open Clam Shell, 1926
 Oil on canvas, 20 x 9 [77]
 Private collection;
 photograph by L. Lorenz

Orange and Red Streak, 1919.
 Oil on canvas, 27 x 23 [4]
 Photograph by Robert Mates

An Orchid, 1941
 Pastel, 27 x 21 [24]

Painting No. 21 (Palo Duro Canyon), 1916
 Oil on board, 13 x 16 [5]

Patio with Black Door, 1955
 Oil on canvas, 40 x 30 [82]
 Lane Collection

Pedernal, 1945
 Pastel, 21 x 43 [101]

Pedernal and Red Hills, 1936
 Oil on canvas, 20 x 30 [100]
 Private collection

Pelvis III, 1944
 Oil on canvas, 48 x 40 [74]
 On loan to The Art Institute of Chicago

Pelvis Series, Red with Yellow, 1945
 Oil on canvas, 36 x 48 [75]
 Collection of Mrs. Anne Burnett Tandy;
 photograph by Lee Angel

Pelvis with Moon, 1943
 Oil on canvas, 30 x 24 [73]
 The Norton Gallery of Art,
 West Palm Beach, Florida

Radiator Building—Night, New York, 1927
 Oil on canvas, 48 x 30 [20]
 The Alfred Stieglitz Collection,
 Fisk University, Nashville, Tennessee

Ram's Head with Hollyhock, 1935
 Oil on canvas, 30 x 36 [70]
 Collection of Edith and Milton Lowenthal

Ranchos Church, 1930
 Oil on canvas, 24 x 36 [63]
 On loan to The Metropolitan
 Museum of Art

Red and Orange Hills, 1938
 Oil on canvas, 19 x 36 [98]
 Collection of Judge and Mrs. Oliver Seth

Red and Yellow Cliffs, 1940
 Oil on canvas, 24 x 36 [94]

Red Hills and Bones, 1941
 Oil on canvas, 30 x 40 [97]
 Philadelphia Museum of Art;
 The Alfred Stieglitz Collection;
 photograph by Alfred J. Wyatt

Red Hills and Sky, 1945
 Oil on canvas, 30 x 40 [85]
 Private collection;
 photograph by L. Lorenz

Red Poppy, 1927
 Oil on canvas, 7 x 9 [29]
 Collection of Daniel Catton Rich

Road Past the View II, 1964
 Oil on canvas, 24 x 30 [104]

The Shanty, 1922
 Oil on canvas, 20 x 27 [33]
 The Phillips Collection, Washington, D.C.

Shell I, 1928
 Oil on canvas, 7 x 7 [79]

Shell and Old Shingle I, 1926
 Oil on canvas, 9 x 7 [47]

Shell and Old Shingle II, 1926
 Oil on canvas, 30 x 18 [50]

Shell and Old Shingle III, 1926
 Oil on board, 11 x 6 [48]

Shell and Old Shingle IV, 1926
 Oil on canvas, 10 x 7 [49]

Shell and Old Shingle VI, 1926
 Oil on canvas, 30 x 18 [51]
 Collection of Mr. and Mrs. Charles E. Claggett

Shell and Old Shingle VII
(Last of Shell and Old Shingle Series), 1926
 Oil on canvas, 21 x 32 [52]

Shell on Red, 1931
 Oil on canvas, 40 x 30 [76]
 Collection of Loretta and Robert K. Lifton

The Shelton with Sunspots, 1926
 Oil on canvas, 49 x 31 [18]
 Collection of Inland Steel Co.

Single Alligator Pear, 1922
 Pastel, 12 x 10 [31]
 Private collection

Sky Above Clouds IV, 1965
 Oil on canvas, 96 x 288 [106]
 On loan to The Art Institute of Chicago

Stables, 1932
 Oil on canvas, 12 x 32 [65]
 The Detroit Institute of Arts;
 gift of Robert H. Tannahill;
 photograph by Joseph Klima, Jr.,
 and Nemo Warr

Starlight Night, 1917
 Watercolor, 9 x 12 [12]

Stump in Red Hills, 1940
 Oil on canvas, 30 x 24 [92]
 Collection of Mr. and Mrs. Burton H. Lyons

Summer Days, 1936
 Oil on canvas, 36 x 30 [71]

Sunflower for Maggie
(Sunflower, New Mexico I), 1935
 Oil on canvas, 20 x 16 [27]

Two Calla Lillies on Pink, 1928
 Oil on canvas, 40 x 30 [28]

Two Jimson Weeds, 1938
 Oil on canvas, 36 x 30 [84]
 Collection of Anita O'K. Young

Wave, Night, 1928
 Oil on canvas, 30 x 36 [46]
 Addison Gallery of American Art,
 Phillips Academy, Andover, Massachusetts;
 gift of Mr. Charles L. Stillman

White Birch, 1925
 Oil on canvas, 36 x 30 [43]
 Collection of Mrs. J. Lee Johnson III;
 photograph by L. Lorenz

White Canadian Barn II, 1932
 Oil on canvas, 12 x 30 [66]
 The Metropolitan Museum of Art;
 The Alfred Stieglitz Collection, 1949;
 photograph by the museum

White Patio with Red Door, 1960
 Oil on canvas, 48 x 84 [83]

The White Place in Shadow, 1942
 Oil on canvas, 30 x 24 [96]
 The Phillips Collection, Washington, D.C.

The White Trumpet Flower, 1932
 Oil on canvas, 30 x 40 [25]
 San Diego Museum of Art;
 photograph by Professional Photo Service,
 Busco-Nestor

The Winter Road, 1963
 Oil on canvas, 22 x 18 [105]

Chronology

1887-1902
Born, November 15, 1887, near Sun Prairie, Wisconsin. Attended local school, then convent school near Madison.

1903-1905
Junior and senior high school years spent at Chatham Episcopal Institute, Chatham, Virginia.

1905-1906
Attended Art Institute of Chicago.

1907-1908
Attended Art Students League, New York City. Visited exhibition of Rodin drawings at Alfred Stieglitz's "291" gallery. Awarded Chase Still Life Scholarship to spend part of summer at League Outdoor School, Lake George, New York.

1909
Worked as commercial artist in Chicago.

1912-1913
Summer 1912 visited art class taught by Alon Bement at University of Virginia. Fall 1912 began two-year tenure as supervisor of art in public schools, Amarillo, Texas. Summer 1913 taught at University of Virginia Art Department.

1914-1915
Fall 1914 went to New York City to study with Arthur W. Dow at Teachers College, Columbia University. Fall 1915 taught at Columbia College, Columbia, South Carolina.

Summers taught at University of Virginia Art Department.

1916
Returned to Teachers College for spring semester. Exhibition of her drawings and watercolors opened in May at "291." Summer taught at University of Virginia Art Department. Fall took position as head of art department at West Texas State Normal School, Canyon, Texas.

1917
First one-woman show opened at "291" in April. Summer semester spent at West Texas State Normal School. Painted in Colorado during the fall vacation and first saw New Mexico.

1918-1928
Lived and painted in New York City and Lake George, with several summer trips to Maine.

1923
Exhibition held at Anderson Galleries, arranged by Stieglitz.

1924
Joint exhibition at Anderson Galleries with Stieglitz. December 11 married Stieglitz.

1925
Work included in "Seven Americans," an exhibition of the work of five painters and two